IMAGES FROM BAMUM

D1452329

IMAGES FROM BAMUM

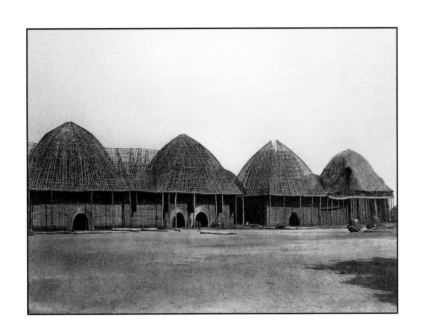

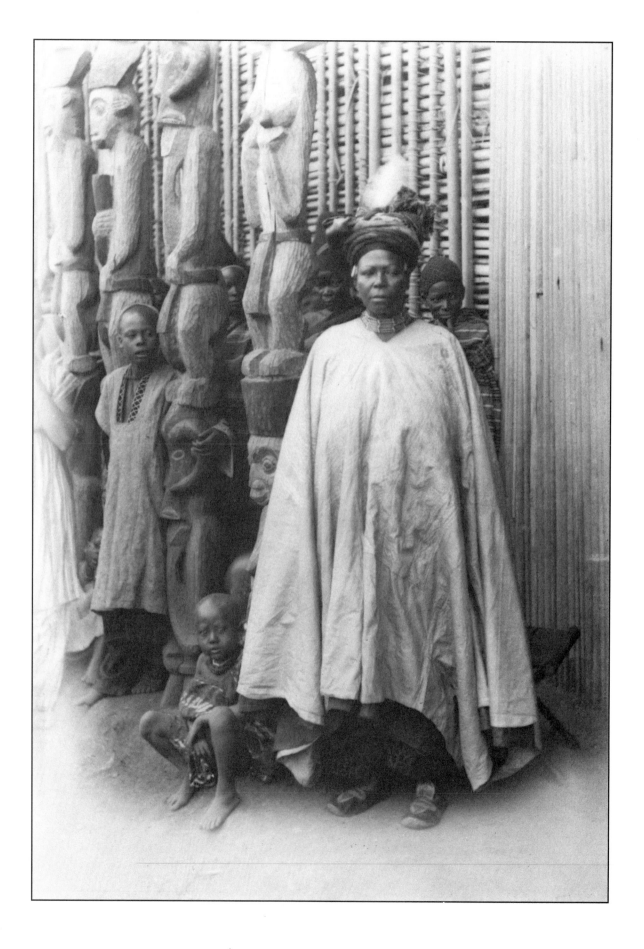

IMAGES
FROM BAMUM

German Colonial Photography
at the Court of King Njoya

Cameroon, West Africa, 1902–1915

Christraud M. Geary

Published for the National Museum of African Art
by the Smithsonian Institution Press

Washington, D.C., and London

DISCARD

PUBLIC LIBRARY
EAST ORANGE, NEW JERSEY

967.11
G292
cop.1

This book has been published in conjunction with the exhibition *Images from Bamum: German Colonial Photography at the Court of King Njoya, Cameroon, West Africa, 1902–1915*, which was organized by the National Museum of African Art.

June 15, 1988–September 6, 1988

©1988 Smithsonian Institution. All rights reserved
Printed in the United States of America

Library of Congress Cataloging-in-Publication Data
Geary, Christraud M.
 Images from Bamum.
 Bibliography: p.
 1. Cameroon—History—Pictorial works. 2. Cameroon—Court and courtiers—Pictorial works. 3. Bamoun (Cameroon)—Court and courtiers—Pictorial works. 4. Njoya, Sultan of Bamoun, 1876?–1933—Pictorial works. I. National Museum of African Art (U.S.). II. Title.
 DT574.G43 1988 967'.1102'0880621 88-600496
 ISBN 0-87474-455-5

The paper used in this publication meets the minimum requirements of the American National Standard for Permanence of Paper for Printed Library Materials, Z39.48-1984.

COVER: King Njoya, c. 1912 *(fig. 26).*

PAGE 1: Renovation of the palace, 1906–7 *(fig. 38).*

FRONTISPIECE: Queen Mother Njapndunke in a costume for the Nja festival. She stands in front of the palace. *(Photograph by Marie-Pauline Thorbecke, January 1912)*

Editor: Dean Trackman
Designer: Christopher Jones

15.95
10-3-88

Contents

DA

Foreword

EARLY PHOTOGRAPHS OF Africa and its people are familiar to us. We have glanced at them in all manner of published material. They have often been used to evoke a sense of environment or ritual or to create a fantasy of the exotic. Such casual and isolated visual encounters may lure us into believing that we have a complete impression of Africa. This book, published in conjunction with an exhibition at the Smithsonian Institution's National Museum of African Art, breaks with the tradition of interpreting the African continent on the basis of brief glimpses.

In September 1986, as the recipient of a one-year postdoctoral Rockefeller Foundation Residency Fellowship in the Humanities at the National Museum of African Art, Dr. Christraud M. Geary continued her work on the use of early photographs from Africa in art historical research. Her analysis of a large number of photographs and her methodology have important implications for all scholars who are studying African visual traditions. During her fellowship, Dr. Geary was asked by the museum to write a book and conceive an exhibition. The result is *Images from Bamum*, a case study of European photography in the Bamum Kingdom in

Cameroon from 1902 to 1915. It is a systematic study of a corpus of images taken in one place over a sustained period of time. With the publication of this book and the opening of the related exhibition, the findings of Dr. Geary's ten years of research both in European photographic archives and in Bamum are available to an American audience for the first time.

As Dr. Geary systematically analyzes the photographs from Bamum, she guides us toward an understanding of the experiences and motivations of both the European photographers and the Bamum people. Here is an important period in the history of the Bamum elite and their visionary king. Here, too, in microcosm is a part of the history of the conquest of a continent. In Africa south of the Sahara, the early explorer, the trader, the missionary, and the fortune hunter were followed by European powers, which later staked their claims and partitioned the continent after the Berlin Conference of 1884–85. These images give us a sense of how traditional authority in one African kingdom changed as a result of the arrival of a European power—a power that would subdue and control. In contrast to the bitter historical realities, the beauty of a people and the resiliency of

their culture also emerge. Dr. Geary places in context the flourishing visual traditions and imposing architectural structures of Bamum. She also provides a sound framework for interpreting cross-cultural photography. Her study takes both photographers and subjects out of the realm of anonymity.

We are deeply grateful to Christraud Geary for giving us a greater appreciation of Bamum history and visual traditions, as well as of historical photography. We also wish to thank the lenders to the exhibition, who generously shared these rare and extraordinary images. Finally, the following members of the museum's permanent staff must be given special recognition: Dean Trackman, editor; Christopher Jones, graphic designer; Philip Ravenhill, chief curator; and Richard Franklin, exhibition designer. Their professionalism, enthusiasm, and diligence brought this endeavor to fruition.

SYLVIA H. WILLIAMS
Director

Acknowledgments

ARLY PHOTOGRAPHS TAKEN in Africa are just beginning to be explored by scholars in the United States, and their publication and exhibition are still a somewhat unusual endeavor. It is with deep gratitude, therefore, that I acknowledge the support I have received from the National Museum of African Art of the Smithsonian Institution. As a fellow from September 1986 to August 1987 in the Rockefeller Foundation Residency Program in the Humanities, I was allowed to devote myself to the study of colonial photography, making this book and the exhibition it accompanies possible. My thanks go to Sylvia Williams, director of the National Museum of African Art, and Dr. Roy Sieber, associate director, for their generous support of this project. I am especially indebted to Dr. Philip Ravenhill, chief curator of the museum. His encouragement and his understanding of the meaning of photography in African history and art history were crucial to the development of the book and the exhibition.

The material presented here was collected, annotated, and researched over many years with the help of friends and colleagues in Cameroon, several European countries, and the United States. I was delighted by the warm reception I received in Bamum when I was doing research there. I express my thanks to His Royal Highness the Sultan Seidou Njimoluh Njoya, who did not hesitate to personally review the photographs with me; to his son Dr. Aboubakar Njiasse Njoya, a historian and a fine musician; and to Emmanuel-Renaudot Ndayou Njoya, the sultan's secretary. Many Bamum men and women helped to identify and explain the photographs. Most heartwarming for me was meeting Princess Nji Mongu Ngutane Pasma, the firstborn daughter of King Njoya, who recognized herself in many photographs. A dignified and delightful lady in her late eighties, she recounted her stay at the missionary school, her memories of the missionaries, and her wedding in 1914, which is captured in several photographs. Finally, I owe thanks to His Excellency Dr. Adamou Ndam Njoya, with whom I wrote a pictorial history of the reign of King Njoya, for sharing with me his vision and his feelings about the photographs of his people. In Yaoundé, Dr. Paul Nkwi, acting deputy director of research at the Ministry of Higher Education and Scientific Research, saw to it that my research could progress as planned. I am also indebted to Matthias Sack, former director of

8

the National Archives of Cameroon at Yaoundé, for his support of my archival studies.

I would like to express my gratitude to the directors, curators, and archivists at those institutions that have provided copies of photographs or accommodated requests for loans of original material for the exhibition. I am particularly grateful to Paul Jenkins, head of the Basel Mission Archive, for his support of my work over many years and for the stimulating discussions we have had about missionary photography. I would also like to thank the following colleagues: Professor Dr. Jürgen Zwernemann and Dr. Wulf Lohse, Hamburgisches Museum für Völkerkunde; Nina Cummings, Field Museum of Natural History, Chicago; Professor Dr. Eike Haberland and Dr. Karl-Heinz Striedter, Frobenius-Institut Frankfurt; Dr. Hermann Forkl, Linden-Museum Stuttgart; Dr. Hans-Joachim Koloss and Dr. Angelika Tunis, Museum für Völkerkunde Berlin; Professor Dr. Lothar Stein and Diplom-Ethnologin Christine Seige, Museum für Völkerkunde Leipzig; Hofrat Professor Dr. Hans Manndorff and Dr. Armand Duchâteau, Museum für Völkerkunde Vienna; Professor Dr. Gisela Völger and Dr. Klaus Volprecht, Rautenstrauch-Joest Museum Cologne; and Dr. Herbert Ganslmayr, Überseemuseum Bremen. Mrs. Hanne Eckardt generously gave me access to the photographs of her father, missionary Eugen Schwarz.

Over the years, my understanding of photography and Bamum has been enhanced by discussions with colleagues and friends who share my interests. Among them are Ricabeth Steiger, a dear friend who wrote her master's thesis on photographs taken of King Njoya that are in Basel and Berlin and who subsequently accompanied me to Fumban, and Peter Heller, an independent filmmaker from Munich who has made several films on Bamum.

Without the dedicated work of the staff of the National Museum of African Art, this project would not have come to fruition. First, I mention Dean Trackman, who edited this book and coped well with the peculiar ways a German speaker puts words into English. My special thanks go to him for his patience and thoroughness. I am grateful for the contributions of Christopher Jones, graphic designer, who created the design for this book, and Richard Franklin, chief of design, who was responsible for the design of the exhibition. My thanks also go to Lydia Puccinelli, curator; Janet M. Stanley, librarian; Judith Luskey, archivist for the museum's Eliot Elisofon Photographic Archives; and Jeffrey Ploskonka, photographer.

Finally, I thank my husband, John C. Geary, for his moral support and assistance in all my endeavors, and my father, Günther Mühle, for his help in transcribing hundreds of pages of material in German script.

Introduction

IN RECENT YEARS, scholarly interest in historical photography, especially early cross-cultural photography, has grown. Numerous books have presented photographs of North American Indians as well as photographs from China, Japan, India, and other parts of the world. Yet photographs taken in Africa, a continent that has captured the Western imagination since antiquity, remain largely unexplored.

Photographs from Africa abound in museums, archives, and private collections. Professional and amateur photographers—both men and women—took hundreds of thousands of photographs in Africa. Their images provided testimony about early explorations and distant peoples and places. To this day, photography is part of the discourse about foreign worlds and foreign peoples, a discourse revealing as much about "us" as it reveals about "them."

In the nineteenth and early twentieth centuries, photography was perceived as a medium of inherent objectivity. With the invention of photomechanical processes for preparing printing plates in the late nineteenth century, photographs soon began to replace drawings in books and magazines. Photography was the medium of choice to bring the foreign and exotic to the parlors of the European bourgeoisie, who were eager for information about the areas of the world that had come under imperial domination. The new medium, however, more often perpetuated long-held stereotypes than it fostered new perceptions of the foreign and the foreigner.

A small but influential group of early photographers was made up of physical and cultural anthropologists, who began the systematic and scholarly exploration of foreign cultures. Their counterparts today continue to observe, record, analyze, and discuss the many ways people organize their lives. Present-day cultural anthropologists distinguish between themselves, embedded in their own cultures, and those they seek to understand. They use the terms *Self* and *Other* to express this distinction.

The relationship between the anthropologist and the Other is inherently problematic, for anthropology has always been part of the existing power structures. The way anthropologists contemplate the Other and construct their theories is influenced by the intellectual milieu in which they work and the political circumstances of the time. It is not surprising, therefore, that during the age of European colonialism in Af-

rica, anthropologists maintained close ties with colonial administrations.

In the anthropologist's effort to depict the Other, visual imagery, particularly photography, has always played a major role. Banta and Hinsley (1986) have traced the many uses of photography in anthropology. They show how the medium became closely linked with particular anthropological research interests. The photography of *racial types*, for example, accompanied studies of human biological evolution, a major concern of anthropology in the nineteenth and early twentieth centuries. At the same time, photography served as an ideal tool for *inventory taking*, the systematic recording of foreign cultures. This activity went hand in hand with colonial exploration. Among German cultural anthropologists, many of whom worked for museums, the collecting and recording of material culture was a major pursuit, and photography lent itself well to the task of documentation. Photography in the service of anthropology has led to extraordinarily large photographic holdings in European and American museums and archives.

Some of the emphases of earlier anthropological research, such as the study of race or material culture, are less important in anthropology today. With shifting interests, the importance of photography as a research tool decreased. The photographs taken within earlier traditions of research, however, have become meaningful for anthropologists in a new way. Early photographs taken for anthropological purposes are now used to explore the history of anthropology and, more importantly, the relationship between the Self and the Other.

In analyzing photographs, the roles played in the creation process by the photographer, the photographic subject, and the viewer need to be considered. A photograph is a cultural artifact that articulates a photographer's visions, biases, and concerns. It also allows the contemplation of the photographic subject. Frequently in cross-cultural photography, little is known about the relationship between the photographer and the photographic subject beyond the observation that the photographer was often powerful enough to coerce someone into being photographed. The interaction, however, was not always so one-dimensional. Photographic subjects sometimes were actively involved in creating images. In addition to the photographer and the photographic subject, a silent participant—the future viewer—influenced the creation of photographs. The viewer's desires and choices had commercial as well as validating capabilities that gave rise to certain genres of highly successful images.

Research on early photographs taken by Europeans in Africa has taken two distinct approaches. The first emphasizes the documentary dimensions of photography. Focusing on the contents of photographs taken in Africa, historians and art historians explore them as valuable documents about the African past. In one of the first scholarly papers published about images taken in Africa, Forlacroix (1970) points out the potential use of photographs for historical research in Côte d'Ivoire, and he develops a brief methodology. The interest in photographs as historical documents has been pursued in more recent publications, among them a photographic history of Burundi (Collart and Celis 1984), a pictorial account of the development of Douala (Soulillou 1982), and a pictorial history of the kingdom of Bamum in Cameroon (Geary and Njoya 1985).

The second approach in photographic research explores how, through their choice of themes, European photographers in Africa reinforced and perpetuated stereotypes of Africa and Africans. The invention of Africa through imagery is the departure point for several recent

works on photography. In a path-breaking study, Alloula (1986) explains that early photographs of beautiful North African women reflected age-old European fantasies about North Africa instead of presenting a realistic depiction of life. Similar concerns with stereotypical themes and their presentation in the form of photographs shaped the book *Africa Then* (Monti 1987).

In the process of inventing Africa through photographs, postcards played an important role. They entered European homes and became cherished collector's items. Postcards disseminated stereotypical imagery and influenced the perceptions of the many people who purchased, received, or collected them. Research on postcards is just beginning. Among the already published works about postcards are two by David (1978, 1982) that contribute to a better understanding of both the processes involved in creating them and their commercial aspects.

Both of the approaches to research on photographs in Africa have tended to be exclusive. A historian or an art historian who is interested in the documentary aspects of photographs may disregard the immense power of photographs to perpetuate stereotypes. When doing research, however, such a scholar must be aware of the implications of the photographer's shaping of the record. On the other hand, a scholar interested in the second dimension, the photograph as fantasy, may totally neglect the unique historical information offered in photographs. Such neglect has sometimes led to the publication of interesting-looking imagery that is left unattributed and unexplained.[1] Neither approach to the images is sufficient by itself. Only a combination of both modes of inquiry will enhance our understanding of historical photographs taken in Africa.

There has been a tendency to generalize about photography in Africa, particularly in works concerned with photographers' conceptualizations of the Other and his world. Africa and African peoples are not monolithic. It is imperative that research on photography of the vast African continent become specific, going beyond broad observations and following the example of systematic and extensive work on photographs taken of North American Indians.[2] A first effort at such specificity ought to be made by exploring and comparing the oeuvres of individual photographers. In this manner, a photographer's style and reaction to the foreign can begin to be understood.[3] This book looks at the roles and views of particular photographers.

More important, researchers need to become concerned with the ways photographers and photographic subjects interact. These interactions, of course, did not unfold in the same way everywhere. Particular times and places and particular forms of contact influence photographic production. Researchers must explore the role not only of the photographer but also of the Africans who were photographed. As a case study of photography in the kingdom of Bamum, this book is such an effort at specificity.

A potentially fruitful area of research on photography in Africa has been almost totally ignored: photography by Africans, including the role of African photographers in early photography. Stephen Sprague (1978a, 1978b), one of the few scholars to take up the topic, wrote a fine article on Yoruba photographers in Nigeria. His promising work was cut short by his untimely death. Vera Viditz-Ward (1985, 1987) at present studies Sierra Leonean Creole photographers. Such research demonstrates how Africans familiarized themselves with the photographic medium and began to create new forms of artistic expression by synthesizing their own visual idioms with adopted conventions of European photography. The research is opening an

exciting new frontier, for photography by Africans represents indigenous testimony about the African experience.

All of the photographs in this book, with the exception of the final one, were taken before the First World War. Most were deposited in archives and museums in the German-speaking countries of Europe, and one found its way into an archives in the United States. Some are in private collections.[4] In this book, the images have been brought together and systematically analyzed for the first time. They have been correlated with writings by the photographers, many of which have never been published. These documents consist of letters and reports to superiors, museums, and missionary societies. Some of the writing is awkward. The writers often lacked the formal education that might have made their sentences more polished. Furthermore, many of the records were never intended for a large audience, so some writers may not have been concerned with their grammar and choice of words. In my translations from German, I have tried to preserve some of the idiosyncracies of their writing styles.

This book is not only based on archival materials and publications discussing the German colonial period. The most gratifying and exciting research occurred when I took approximately four hundred photographs back to Bamum. During several stays in Bamum, in 1977, 1983, and 1984, I showed them to older people who could identify their contents and the people depicted. It was touching to witness their emotional reactions to these photographs. Although several decades had passed, the impact of the images had only increased.

These photographs also have a hold over those of us who, in a different time and place, are often unaware of their original purposes and the meanings. Many of the images are remarkable works of art, provoking an aesthetic response and thus becoming meaningful in yet another way. Objects of study and reflection though the photographs must be, they should be enjoyed equally for their timeless beauty.

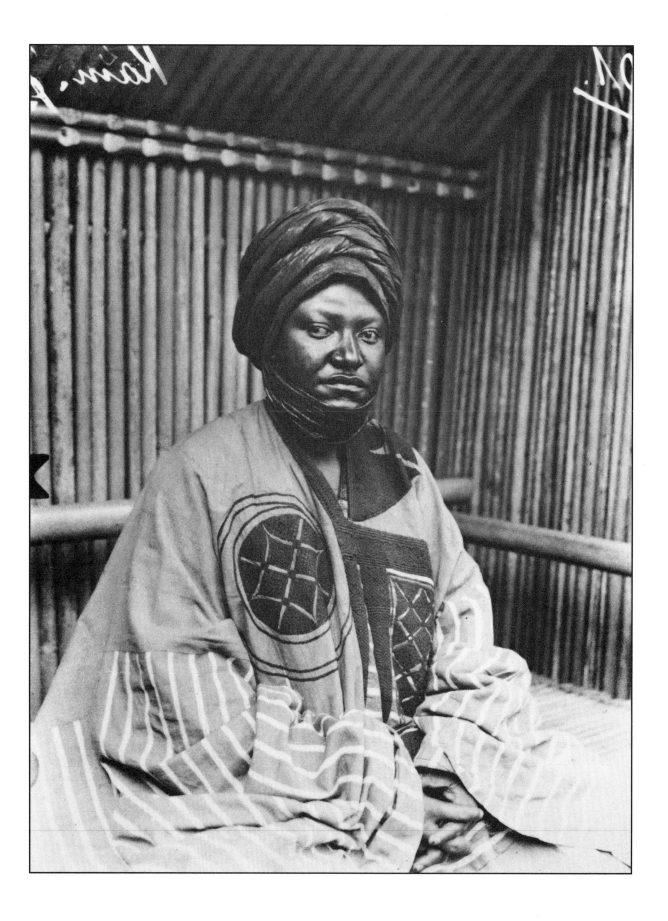

CHAPTER ONE

Bamum before 1900
The History of a Kingdom

THE KINGDOM OF BAMUM IS LOCATED in the western part of Cameroon.[1] Like other African kingdoms that were independent states before the colonial period, Bamum has lost its political autonomy. It is now a prefecture in modern Cameroon. The capital, Fumban, is a bustling modern city. Although the Bamum king is no longer politically independent, he remains the spiritual leader of the people, mediating between the past and the present. The present Bamum king, Sultan Seidou Njimoluh Njoya, has ruled Bamum for over fifty years and once served as a member of the national parliament in Yaoundé, the capital of Cameroon. In the 1980s, at over eighty years of age, he was still presiding as the mayor of Fumban.

Fumban attracts many visitors—Cameroonians from other parts of the country and foreign tourists alike—who come to see the famous artworks in the palace district. The royal court, two museums, and working artists have established Bamum's present-day fame as a center of the arts and creativity.

The palace, where the Bamum king lives to

FIG. 1. *King Njoya. (Photograph by Marie-Pauline Thorbecke, January 1912)*

this day, is located in the center of Fumban. The Bamum designate it the "village of the king," and indeed it resembles a small self-contained village. Through the main gate, the king's residence is to the right. The houses of the royal wives and princesses are on both sides of a main courtyard. The most notable structure in the palace district is a large three-story building erected after 1917 by King Njoya Ibrahim, Seidou's father. Once Njoya's residence and later Seidou's, it now houses the Bamum Palace Museum. The museum contains the treasures of the Bamum kings, the "things of the palace," as they are called. Royal regalia and possessions such as caps, clothes, jewelry, and weapons are found there. The most stunning artworks are wooden sculptures covered with colorful glass beads, among them thrones, stools, figures, and masks.

To this day, Bamum artists—carvers, weavers, embroiderers, brasscasters, and potters—are active in Fumban. The street where they display their works leads to the second museum in Fumban, the Musée des arts et traditions Bamoum. Founded in the 1920s by Mose Yeyab,[2] a Bamum noble, the museum exhibits fine artworks, particularly wooden sculpture

15

and pottery. Many of its objects were created in the villages around Fumban, not in the palace for the Bamum elite.

At the end of the nineteenth century, Bamum was famous both among its neighbors and among peoples who lived far from the kingdom. Neither arts nor royal splendor alone contributed to its reputation. The Bamum people were feared as fierce warriors and envied as successful middlemen in trade. In 1889 a young German explorer named Eugen Zintgraff came close to Bamum when he reached the region that has become known as the Cameroon Grassfields. Although he never went to Bamum, he heard about it from the king of nearby Bali, Garega I. A rival of the Bamum king, Garega told Zintgraff about a ruler whose town was so large that if a battle broke out at one end, it could not be heard at the other. Garega did not want Zintgraff to go eastward to Bamum, fearing that the explorer would forget him and never return (Zintgraff 1895, 202). Deciding to make Bali the location of the first German post in the Grassfields, Zintgraff did not continue on to Bamum. Bamum would not have direct contact with Germany until thirteen years later.

When Zintgraff first heard about Bamum, the kingdom was in turmoil. Sometime between 1885 and 1887, King Nsangu, the Bamum king,[3] was killed by some of his brothers during a battle against the neighboring kingdom of Nso. Njoya, a young prince, had been chosen as heir to the throne by his father. About twelve years old at the time of Nsangu's death, Njoya became the seventeenth ruler of the kingdom (Tardits 1980, 915, 919).

Njoya faced formidable opposition inside Bamum from rival princes vying for power. Two women protected him. Shetfon, Nsangu's mother, and Njapndunke, Njoya's mother, eliminated many of his rivals and safeguarded his rule. Njapndunke, a powerful and shrewd woman, acted as a regent for her son until he was about nineteen years old and had fathered his first child. Njoya was then considered ready to take up the reins of the kingdom.

Succession conflicts like those faced by Njoya had plagued the Bamum kingdom from its beginnings. A detailed history of the kingdom is contained in a chronicle written by King Njoya and his courtiers. In 1900 they began to develop a script for Shümom, the Bamum language, and subsequently created several increasingly refined alphabets (Tardits 1980, 211).[4] After 1910 they began compiling the chronicle of the Bamum Kingdom, finishing during the 1920s in the last years of Njoya's reign (*Histoire* 1952).[5] Njoya and the courtiers meticulously described the reign of each king and the succession conflicts. They also reported about Bamum customs and the changes that occurred during the rule of King Njoya. Several chapters were devoted to the history of many of their neighbors as well as some distant kingdoms.

The chronicle of Bamum is a work of unique vision and grand design. African history is usually written from European sources and oral testimony collected from African peoples decades and even centuries after the events occurred. In the chronicle, the Bamum king and his courtiers speak for themselves, interpreting their own history—the history of the Bamum elite—and letting the reader share their views of themselves and their past. The accuracy of many of the chronicle's descriptions of the events was proven by French anthropologist Claude Tardits (1980), who explored Bamum history during his research in the 1960s. To examine the chronicle, he collected and analyzed oral traditions in many parts of the Bamum Kingdom. He also correlated information gathered in neighboring kingdoms with the information in the chronicle.

Most historians agree that the kingdom of

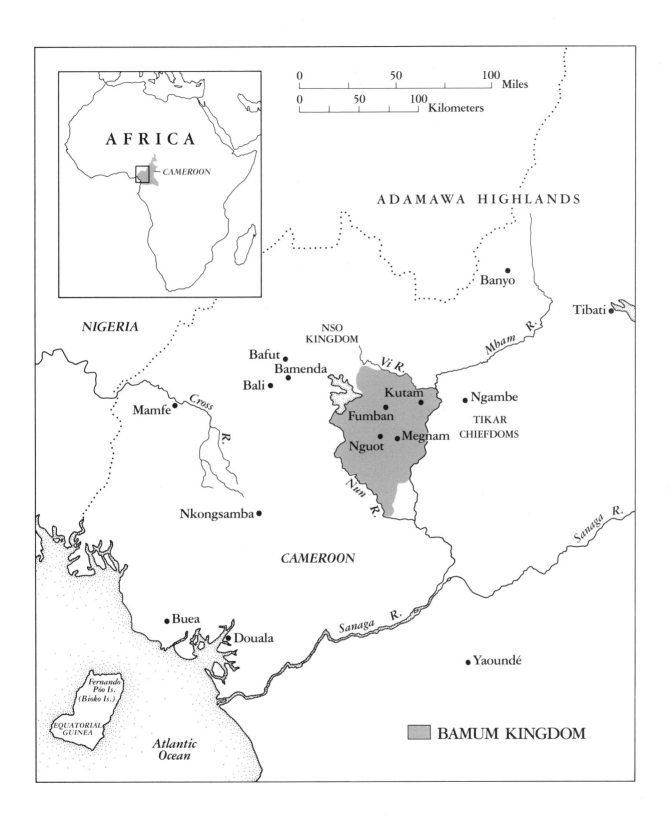

Bamum was founded in the seventeenth century. A prince named Nshare Yen left Rifum, a Tikar chiefdom east of Bamum, after a succession dispute with his father.[6] He moved west to found his own kingdom. Such secessions were a common way of establishing fledgling states in the Grassfields. Nshare Yen and a group of loyal followers subjugated several small chiefdoms, finally settling in the territory of the defeated Mben. They founded Fumban on a plateau and made it the center of their growing state (*Histoire* 1952, 22).[7]

The Bamum defeated eighteen independent chiefdoms during Nshare Yen's reign, according to the chronicle. Sometimes the defeated populations moved to other areas of the Grassfields, often displacing other small chiefdoms. Most defeated states, however, were absorbed into the kingdom, although their origins were not forgotten.[8] Their subjugated rulers were required to fulfill special obligations toward the Bamum king. Able men from these groups were recruited to serve as retainers at the court. From among his followers, Nshare Yen selected seven "councilors of the land" to be his advisers. Their descendants would be at the core of the monarchy for centuries to come. At the time Nshare Yen was murdered on a secret trip back to Rifum, a firm foundation for the Bamum Kingdom had already been laid (*Histoire* 1952, 23–24).

The Bamum kings of the eighteenth and early nineteenth centuries did not achieve the glory of Nshare Yen. In the Bamum chronicle, they are characterized as kings who did nothing, living on what Nshare Yen had accomplished (*Histoire* 1952, 24–25). During this period, the kingdom comprised some four hundred square kilometers and several thousand inhabitants (Tardits 1985, 67). The installation of a new king regularly gave rise to succession disputes among the eligible princes.

About 1820, in the midst of such palace intrigues, a prince ascended to the throne who possessed the combination of qualities that the Bamum cherished in their leaders. He was Mbuembue, who is remembered as a man of great physical strength, remarkable wisdom, and boundless generosity. He could also be cunning and aggressive. During Mbuembue's rule of over twenty years, the Bamum expanded their territory west to the Nun River and east to the Mbam River, defeating forty-eight groups, according to the chronicle (*Histoire* 1952, 27, 43–46).[9] The kingdom also withstood attacks by the Islamic Fulbe that reached Fumban itself. The powerful Fulbe had already established themselves in the neighboring kingdoms of Banyo and Tibati to the northeast after founding several states in the Adamawa highlands (Mveng 1963, 200–208).

The expansion of the kingdom brought about changes in the organization of the ruling class. The vast territories had to be administered and put to use, so Mbuembue gave large tracts of land to members of the royal family and noble palace retainers. Before King Mbuembue's reign, defeated populations were absorbed into the kingdom. Now, inhabitants of newly conquered regions were relocated by force to work the landholdings of the royal family and the noble palace retainers. Subjugated chiefs became servants in the palace; women became slaves or wives of noblemen. Two-thirds of the kingdom's population served as the workforce, while the rest enjoyed the privileges of nobility.

The king was at the apex of Bamum society. As the military leader and as the supreme mediator between the ancestors and the living, he safeguarded the kingdom. The king was also the genitor of noble lineages and the person who bestowed nobility upon his loyal followers. Most of the nobles were of two types: the nobles of the blood and the nobles of the palace. Some

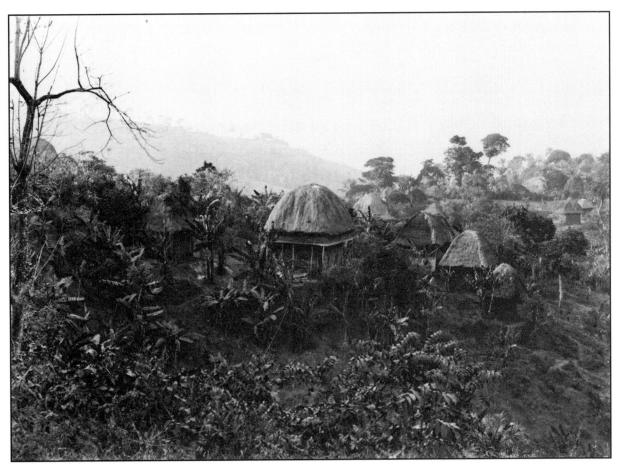

FIG. 2. *A family compound in Fumban. The compound is composed of a large house for the head of the family and smaller houses for his wives. Like all Bamum compounds, it is surrounded by banana groves and gardens. (Photograph by Rudolf Oldenburg, c. 1908–12)*

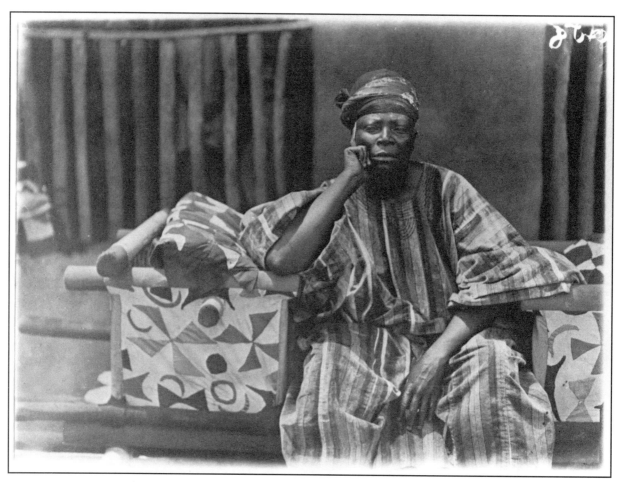

FIG. 3. *Queen Mother Njapndunke.* (*Unknown photographer, c. 1910*)

noble lineages descended from the seven councilors of the land, and a few had maternal links to the royal lineage. By the beginning of the twentieth century, there were about seven hundred noble lineages, with 240 of royal origin and 420 of servant origin (Tardits 1980, 517).

The nobles of the blood descended from kings through the male line. All princes became founders of lineages and took the title *nji,* which was passed on to a chosen son. An *nji* had numerous rights and privileges. He held large domains in the countryside and had slaves to work the land. He was in charge of his lineage's economic activities and gave out land and wives to its members. He also settled disputes and fulfilled ritual duties to assure the lineage's well-being. He wore emblems of high rank, such as prestige jewelry, apparel, and headdresses.

Nobles of the palace acquired their status from the king as a reward for loyal service. If a retainer of even the lowliest origins distinguished himself, the king might bestow upon him the *nji* title. The retainer would also receive wives and land. With the consent of the king, a chosen son of such a retainer could inherit the title and privileges.

The nobles of the blood spent most of their time in residences far from the palace and were economically independent. The noble servants, on the other hand, clustered around the king and relied on his support. Both groups had their own secret societies, which assembled once a week in meetinghouses in the palace.[10] The princes assembled in the house of Ngürri, and the noble servants called the Mbansie society their own. The societies provided networks of interaction and opportunities for socializing and entertaining. Both societies also fulfilled important functions during funerary rituals for members. The king acted as a link between the two groups of nobles, because both were tied to him.

The expansion of the kingdom under King Mbuembue brought economic growth. Bamum gained control over the major long-distance trade routes that linked the area with the Atlantic coast, the Cross River Basin to the west, and what is now northern Cameroon and northern Nigeria. Riches began to pour into the kingdom. From the north came cloth and, later, garments produced by Hausa weavers and tailors.[11] From the west and northwest, the Bamum received iron, highly cherished brass, indigo cloth woven and dyed in the Nigerian weaving centers of the Benue River valley, and glass beads of all types. From the coast and its European traders came more trade beads, European cloth, and guns. The Bamum traded kola nuts, a popular stimulant in West Africa. Kola nuts grew in the temperate climate of the mountainous region to the west of Bamum. The Bamum acquired them inexpensively at their western border and then traded them to the Hausa and Fulbe on the northeastern border at a much higher cost. To the coast, the Bamum sent slaves, unfortunate men and women who had been captured during military campaigns (Tardits 1981, 413–15). The writers of the Bamum chronicle concisely describe these economic developments. Before Mbuembue, they write, the Bamum were not rich. After Mbuembue became king, he made them rich (*Histoire* 1952, 26).

The court arts flourished under Mbuembue's patronage. Stimulated by the increased availability of brass, beads, and cloth, court artists—recruited from subjugated populations—used their creative genius to produce new art forms. Artistic splendor and beauty expressed the power and wealth of the king, the court, and the Bamum state. In addition, art forged links between the subjugated peoples and the court, because artists received high honors for their activities and outstanding ones were raised to noble status. Their works speak at once of

Bamum domination and of the dynamics of integration that drew many different populations into the kingdom (Geary 1983b, 75–95).

Artists were recruited from several groups known for their superb craftsmanship. South of Fumban, for example, the people of Nguot were skilled in brasscasting and wooden sculpture. Artists from Megnam specialized in beadwork. They covered wooden sculptures with raffia cloth[12] or burlap and stitched small round glass beads and highly valued tubular beads onto it. They also applied white cowrie shells,[13] which served as a currency in nineteenth-century Bamum.

Nji Nkome was the most outstanding sculptor among the Nguot. A son of the defeated Nguot king, he took up residence near the palace. He and the members of his workshop carved some of the most impressive thrones and sculptures owned by Bamum kings.[14] Expert brasscasters as well, they also made tobacco pipes, fine jewelry, and prestige weapons. To this day, Nji Nkome's descendants cast brass objects in Fumban.

When Mbuembue died of old age about 1840, the kingdom had developed into the most influential state in the region. After he died, however, conflicts immediately broke out. His successor, Gbetnkom, is remembered as an excessively cruel king who eliminated all of his rivals. About 1850, palace servants, believing that the king was not properly guiding the kingdom, killed Gbetnkom (*Histoire* 1952, 31). Once more, a successor from the royal lineage ascended to the throne. He was a mere boy, but the servants, fearing retaliation, killed him only days after he had begun to rule. This event marked the usurpation of the kingship by high-ranking palace servants, who had traditionally been staunch supporters of the kings against their rival brothers. The servants put Nguwuo, a man of their ranks, on the throne. Although

he maintained the kingdom well and even waged several successful wars, he was ousted by Nsangu, a legitimate heir from the royal lineage.

Nsangu took the throne about 1860 and proved to be an effective king who was able to control the retainers. He led successful military campaigns, increased the wealth of the kingdom, and rebuilt and expanded King Mbuembue's palace, which had fallen into disrepair. Among his wives was Njapndunke, a daughter of the lineage of Nji Monkuob, a descendant of an early king. They had one child, a boy named Njoya, who was chosen to be heir to the throne.

Sometime between 1885 and 1887, King Nsangu was killed in a war with the neighboring Nso, but not by the enemy. Several of his brothers used the opportunity provided by the battle to assassinate him. The Bamum army was devastated by the Nso (Tardits 1980, 194–99), an event that shook the kingdom and the court. Many royal wives and servants killed themselves, following the king in death. In this chaotic situation, young King Njoya and Queen Mother Njapndunke began to rule Bamum.

The greatest challenge of Njoya's reign came in 1894 when one of the highest ranking servants at the court, Gbetnkom Ndombu, rebelled against the young king and enlisted a huge army of followers (Tardits 1980, 205–9). The rebels were able to cut off the food supply to Fumban. King Njoya, about twenty years old, and his mother were helpless. In this situation, Njoya's great talent as a politician and diplomat became evident for the first time. Njoya decided to ask the Fulbe for help, even though they had been an enemy of the Bamum for many decades. He approached Ardo Umaro of Banyo[15] and offered him ample remuneration for his support. He also promised that he and his court would convert to Islam. Between 1895 and 1897,

Ardo Umaro's troops quelled the rebellion. Consequently, King Njoya and most of his courtiers converted to Islam. Five marabouts, Muslim holy men, were sent by Ardo Umaro to instruct the Bamum court in the teachings of Islam.

In a detailed analysis of this conversion, Aboubakar Njiasse-Njoya, a Bamum historian and son of the present sultan of Bamum, explains that the various strata of the Bamum population reacted differently to the new faith (Njiasse-Njoya 1981, 49–67). Only a small number of Bamum people, primarily those among the elite, converted to Islam. The Bamum elite perceived the new religion essentially as a religion of war, because it seemed to lend military strength to its adherents. Initially, therefore, it was adopted by warriors.

The Bamum elite embraced only some of the religious doctrines of Islam. Although the new Muslims studied the Koran and acquired amulets for protection, for example, they did not give up their traditional form of burial or stop drinking palm wine. Some of the visual aspects of Islam were more readily adopted. Ardo Umaro had sent Njoya two boubous (floating gowns), a sheepskin, and prayer beads before his troops intervened on Njoya's behalf, and with these objects Ardo Umaro had symbolically initiated the conversion (Njiasse-Njoya 1981, 57). Soon the Bamum court took on the outward appearance of the Islamic courts as Hausa and Fulbe dress, horses, and weapons became fashionable. They were visual declarations of the new religion and the new alliance.

As a result of Fulbe support, King Njoya took firm control of the kingdom. At the beginning of the twentieth century, he ruled a territory of approximately eight thousand square kilometers. Fumban, the prosperous capital, had fifteen to twenty thousand inhabitants (Tardits 1985, 67). But the events that would shape King Njoya's destiny and the future of the kingdom were taking place elsewhere—in the capitals of Europe and the coastal cities of the African continent.

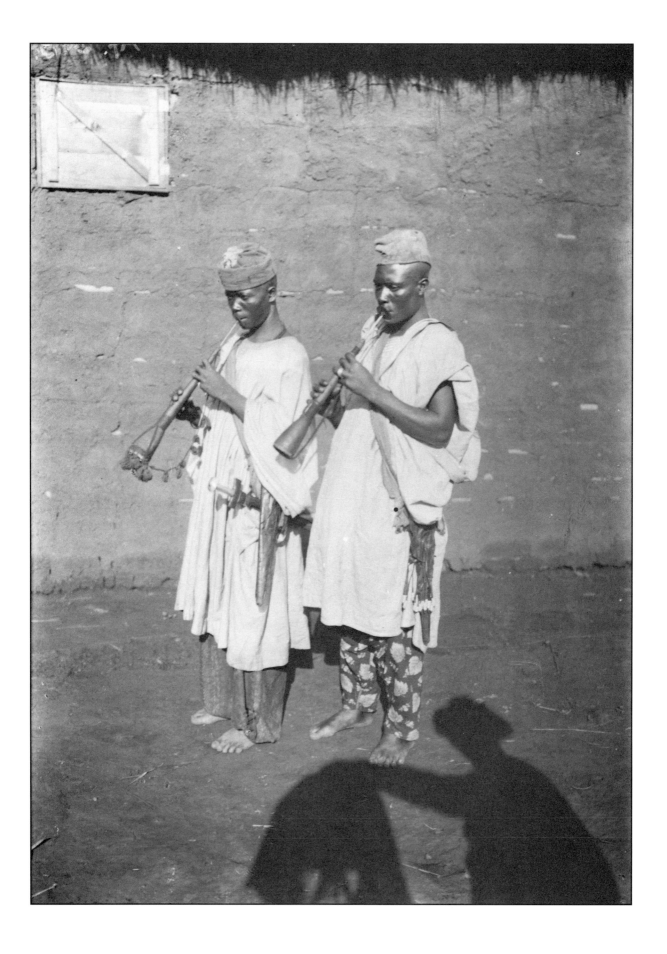

CHAPTER TWO

Photography in Cameroon
Applying a New Technology

IN THE SECOND HALF of the nineteenth century, unknown to the Bamum Kingdom, the European powers divided Africa among themselves. From November 1884 to March 1885, at about the same time that King Nsangu's rule was ending in catastrophe in Bamum, fourteen European countries and the United States deliberated Africa's fate at the Berlin Conference. The partitioning of Africa concluded a period in which Europeans had rushed to secure large parts of the continent. They recognized its economic potential and wanted to safeguard and promote their interests. Once their boundary disputes were settled, systematic exploration, the establishment of administrative systems, and increased economic exploitation could begin. At the conference, not only the countries that had actually acquired territories had vested interests. The high economic, political, and strategic stakes—such as freedom of trade on the Niger and Congo rivers—affected all of the

major powers in attendance, including the United States.

The German Empire was a latecomer to the scramble for colonial territory. Chancellor Otto von Bismarck doubted the economic benefit of having colonies and therefore waited until the last moment before claiming the parts of Africa that would become Cameroon, Togo, German Southwest Africa, and German East Africa (Gann and Duignan 1969; Gründer 1985, 79–106).

Large areas of the interior of Africa were still unknown to the Europeans, and Cameroon—which extends from the Atlantic Ocean to Lake Chad and south to the Congo Basin—was no exception. Few had ventured beyond the coast, where mangrove swamps and thick rain forest made travel difficult. Some had explored the arid Adamawa highlands by traveling south from Lake Chad in northern Cameroon. But no German had ever crossed Cameroon from the southwest to the north. This was Eugen Zintgraff's goal, which he finally achieved during several expeditions from 1888 to 1892 (Chilver 1966).

Explorers and military men recounted their exploits for the German public in word and

FIG. 4. *Trumpet players in Ngambe, a neighboring Tikar chiefdom. The photographer and his tripod-mounted camera cast a shadow.* (*Photograph by Rudolf Oldenburg, c. 1908–12*)

Die Phototechnische Industrie- u. Kunstanstalt
Georg Seltmann
G. m. b. H.
3 Grunaerstr. **Dresden-A.,** Grunaerstr. 3,
offeriert unter Garantie:

Statif- und Reise-Apparate.

Rapid-Schrot-Mühle.

Paul Behrens, Magdeburg (Deutschland).

FIG. 5. *A 1907 advertisement for the Dresden photographic firm of Georg Seltmann. It shows cameras suited for the tropics.*

image. Zintgraff was typical in this regard. After he had returned from his travels, he published a lengthy account of his experiences and illustrated it with his own photographs. In the foreword to his 1895 book *Nord-Kamerun,* he apologized for the quality of his pictures, explaining that he had developed the glass plates under difficult conditions in Africa (Zintgraff 1895, vi).

At the turn of the century, photography was still a technical challenge and often a frustrating experience for those who tried it. The earliest photographic processes, which date to the 1840s, required that photographers be optical engineers, physicists, chemists, and artists. The equipment was cumbersome, the preparation of the light-sensitive plates was complex, and the results were often unsatisfactory. However, it was such an exhilarating experience to produce a likeness of nature on a photographic plate that creative minds did not rest until they had improved the process.[1] Photographers soon established booming businesses taking studio portraits. Unfazed by technical impediments, photographers also roamed the globe and brought back images of distant realms and foreign peoples (Banta and Hinsley 1986, 38–47).

In the 1880s, several technical breakthroughs facilitated the spread of photography, among them the development of the dry-plate process and smaller, lightweight cameras.[2] With more sensitive emulsions and hand-held cameras, photographers could capture moving subjects and take instantaneous shots. This had been impossible with the long exposure times of the more cumbersome earlier technology. Equally revolutionary was the invention of cellulose nitrate film in 1887. Although such film was chemically unstable and deteriorated rapidly, it was not as fragile or as heavy as glass plates. As photographic equipment and film became more portable, increasing numbers of people began to take up photography. Photography gained in respect as well. Alfred Lichtwark, an eminent professor of art education in Hamburg, praised the new photographers for their originality and artfulness (Lichtwark 1894).

At the turn of the century, most of the photographers in Cameroon were amateurs, although they were often very accomplished. A thriving photographic industry in Germany supplied colonial photographers with equipment that promised to withstand the climate. In the *Deutsches Kolonialblatt,* an official gazette for residents of the German colonies, companies regularly advertised their cameras as the most

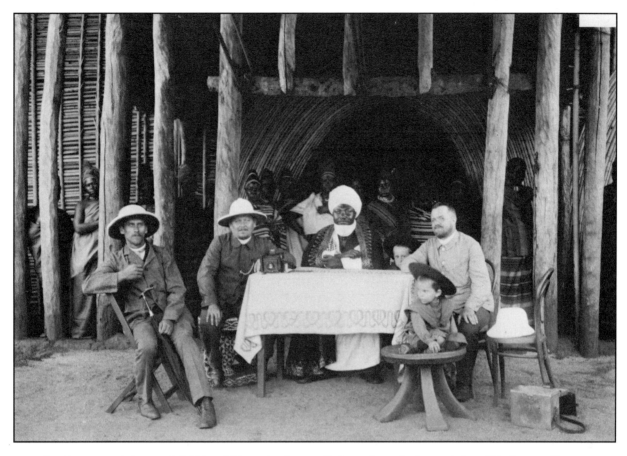

FIG. 6. *German visitors with King Njoya in front of the palace.* Left to right: *Missionary Eugen Schwarz; missionary Friedrich Lutz; King Njoya; Fonyonga Göhring, named after the king of Bali; an unknown missionary; Njoya Göhring, named after the king of Bamum. A small hand-held camera is on the table, and a carrying case for a larger camera is on the ground to the right.* (Photograph by Martin Göhring, c. 1909–11)

advanced available. The Georg Seltmann firm in Dresden, for example, recommended its tripod and travel cameras in 1907 (fig. 5). The Seltmann hand-held models accommodated standard glass plates of 9 by 12 centimeters (3.6 by 4.8 inches) and 13 by 18 centimeters (5.2 by 7.2 inches), as well as rolls of cellulose nitrate film. They often weighed no more than two pounds and allowed exposures from one hundredth of a second to one second.

In tropical countries, where climatic conditions threatened the delicate photographic ma-terials, special skills and equipment were needed. Rudolf Pöch, an Austrian physical an-thropologist, offered some technical advice in a paper whose title translates as "Photographing during Anthropological Research Trips" (Pöch 1910). He recommended, for example, that photographers always carry at least two cameras of the highest quality: a large tripod camera for long exposures and a small hand-held camera for instantaneous shots. Pöch further advised own-ing at least one "portrait" lens and one "group" lens.[3] He also gave detailed instructions cover-

ing everything from the camera case to the chemicals for developing plates in the field.

Good advice and expensive equipment were useless, however, when ill fate befell the photographer in the tropics. Archival records contain many angry letters by those who endlessly struggled with malfunctioning cameras and ruined plates. The letters of Adolf Diehl and Alfred Mansfeld are good examples.

Adolf Diehl was a colonial agent who worked for the trading concession Gesellschaft Nordwest-Kamerun. He was stationed in the Cross River area and began to supply the Museum für Völkerkunde Leipzig with collections in 1902. Diehl was a very active collector until he left Cameroon in 1910, and he was also an avid photographer. In one of his early letters to Leipzig, he decried the "miserable box" that had been delivered to him in West Africa. He complained about its flimsy construction and the out-of-focus close-ups it produced. He hoped, however, that the poor-quality images could still be salvaged once he returned to Germany (Diehl 1903a).[4]

Alfred Mansfeld, a doctor who collected for the Museum für Völkerkunde Berlin, fared no better than Diehl. The museum had sent him a high-quality camera, oddly enough named Kamerun. According to a letter by Mansfeld, the camera did not function because its parts had warped in the humidity. He complained that it was not even comparable to the cameras used by amateurs in the colony (Mansfeld 1905). Unfortunately, the photographic firm refused to take back the camera, and the ensuing dispute fills page after page in the correspondence folder on the Mansfeld expedition.[5]

Photographers who had mastered the technology began to record life in the colonies, including Cameroon. Their photographs are as much cultural and social artifacts as they are technical artifacts. They express the photographers' visions and aesthetic choices as well as represent people and places frozen in time and space. The photographs are visual texts that tell about the photographers and the photographic subjects. In addition, they reflect and articulate the particular political and societal milieu from which their creators came.

The view that photography is a subjective medium conflicts with the common notion that photography is objective, a notion that originated in nineteenth-century thought and persists today. Scholars have challenged the assumption of objectivity in recent interpretive work on photography in general and on cross-cultural photography in Africa in particular.[6]

If photographs are treated as visual texts, a third group must also be considered: the viewers, who imbue what they see with meaning. A viewer may approach an image by exploring its aesthetic dimensions. Working within the technical limitations and stylistic conventions of their time, some photographers in Cameroon created superb works of art transcending the particular and speaking eloquently of the human condition. A portrait of a young Bamum mother and her child is an image of exquisite composition, beauty, and impact (fig. 7).

A viewer may also contemplate photographs as cultural and social artifacts. If this approach is taken, the photographs from Cameroon must be understood within the context of European imperial domination. The photographers were actors in the colonial world, and their photographs were both inspired and constrained by their own motivations and by the demands made upon them by their contemporaries. Within the setting of domination, photographs

FIG. 7. *Nji Mongu Ngutane, firstborn daughter of King Njoya, with Amidu Munde, her first child. (Photograph by Anna Wuhrmann, 1915)*

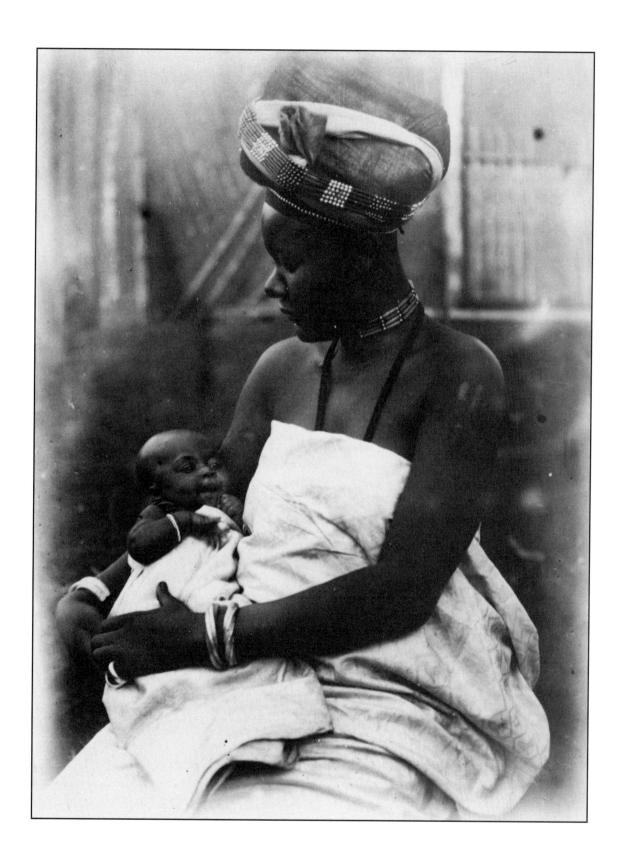

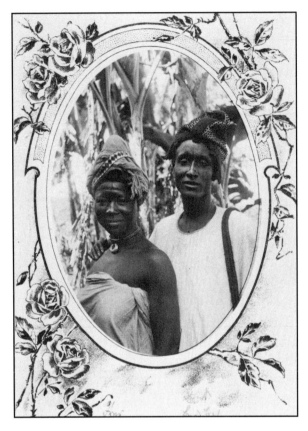

FIG. 8. *King Njoya's brother Nji Pepuore, baptized Paulo, and his wife, Christina. Christina wears a brass ring on a bead necklace to indicate she is married. A decorative frame was added to the photograph, and then the enhanced image was rephotographed. (Photograph by Anna Wuhrmann, c. 1914)*

also reflect the encounter between the photographer and the photographic subject, as well as the encounter between distinct cultures.

The photographic records of individual photographers in Cameroon were shaped by the goals and interests of their particular professions. Missionaries were prolific photographers, a phenomenon reflecting the general importance of imagery in their work. When missionaries went to foreign lands, they brought the Bible and pictures of biblical scenes. If images were important in missionary work abroad, they were

equally necessary for work at home. Photographs helped popularize the missionary effort and raise support from benefactors and congregations. The viewers at home sought proof of success and accounts of the moral betterment of people they viewed as heathens. No medium could communicate more convincingly than photographs.

Many missionary photographs document the successful conversion of Africans. Typical before-and-after images show people first as "unenlightened pagans" and later as educated, Westernized people. This photographic genre demonstrated to the public the civilizing success of missionaries and other colonials and were a favorite theme of colonial propaganda. Often the adoption of the new faith visually manifested itself in the European-style dress of the converts, in the settings where they were photographed, and in their poses (fig. 8). The missionaries recorded milestones in the development of their congregations: the first Sunday service, the first baptism, the first Christian marriage. They pictured other activities, such as preaching, caring for the sick, and instructing children in school. The archives of the Basel Mission in Switzerland contains thousands of these types of photographs (Jenkins and Geary 1985). The Basel Mission, which was the most prominent missionary society in Cameroon, used the images to lavishly illustrate its missionary journals and books. Besides the conventional photographs, missionary archives may also contain depictions of African life, for some missionaries were intrigued by African culture. They portrayed Africans, and recorded their architecture, arts and crafts, rituals, and festivals.[7]

Many amateur photographers in Cameroon were motivated by recognition and fame at home. There were also financial rewards for appropriate photographic production. Some mer-

chants and colonial agents started small businesses, providing ethnographic museums, publishing houses, and popular journals with their photographs.[8] Museums in particular acquired large photographic collections of ethnographic interest. Several museums often purchased the same images, such as sets of African landscapes, African men and women, and art objects.

The Austrian merchant Rudolf Oldenburg was a supplier of photographs. He lived in Africa for many years, first in Guinea and then, from 1908 to 1913, in Cameroon, where he represented the Deutsche Kamerun Gesellschaft in Bamum. He sold his photographs not only to major institutions such as the Linden-Museum Stuttgart, the Museum für Völkerkunde Hamburg, the Museum für Völkerkunde Leipzig, the Reiss Museum Mannheim, and the Rautenstrauch-Joest Museum Cologne but also to the state library of Lower Saxony in Hannover. In 1928 the Museum für Völkerkunde Vienna purchased Oldenburg's ethnographic collection of 654 objects and the original negatives of his photographs. Of Oldenburg's 1,126 gelatin dry plates in the collection, 716 were taken in Cameroon (Lang 1925; Ankauf 1929).[9]

Another group of photographers was composed of members of the military and colonial administrators. They were bound by official regulations concerning the distribution of photographs, especially after the German government recognized their propaganda value. Initially, the Colonial Office in Berlin did not allow official photographs of strategic installations to be given to magazines and publishing houses. Later, it encouraged the colonial government in Cameroon to provide photographs of roads, bridges, railroads, experimental gardens, landscapes, and trading stations in order to demonstrate the success of the colonial administration.[10] The Colonial Office had to be in-

formed of each transaction, and copies of photographs had to be sent to Berlin so that it could also supply publishing houses, teachers, and writers. Considering such regulations, it is not surprising that colonial troops and administrators preferred to send their photographs to semiofficial organizations. One such organization was the Kolonialkriegerdank, a benevolent organization for colonial military members and their dependents. It sold photographs to individuals and institutions.[11]

Finally, a relatively small but prominent group of photographers deserves attention: cultural and physical anthropologists who used photography as a recording device in their scientific work. Their photography was directly influenced by the scholarly research interests and theories of the time (Banta and Hinsley 1986). One of the most important subfields of anthropology was biological anthropology. The concern of its practitioners with people as organisms that had undergone biological evolution led to studies of race. Anthropologists tried to classify races according to an evolutionary scheme. It was also thought that the level of biological evolution might correspond to the level of cultural evolution. Rudolf Pöch, an Austrian anthropologist and devoted photographer, summarized this emphasis in research.

An important branch of anthropology, which we generally want to define as the scientific study and exploration of man, is the examination of primitive peoples, that is, those peoples who have stopped on a lower step of cultural evolution, those whom we also call, using another term, primitive or savage people, or "savages" for short. The study of these peoples provides us with important insights into questions about the evolution of mankind in general and the origin of culture. (Pöch 1910, 108, my translation)

In the effort to sort humankind and create racial taxonomies, photography proved invaluable because of its ability to objectify people. "The most important object of the photographic activity of the anthropological researcher is, of course, man himself," Pöch wrote (1910, 110). Anthropologists developed standard procedures for photographing racial types, which were strikingly similar to the procedures for police photography advanced by Bertillon (1895). The procedures were dehumanizing, robbing people of their dignity. A set of images required at least three shots. The person was placed in front of a plain background, often a blanket, and taken in frontal, three-quarter, and profile poses (figs. 10–12). The entire person had to be photographed, in the nude if possible, from the front, the side, and the rear. The standardization of the camera angle and poses allowed anthropologists later to take measurements directly from the photographs. The endless series of racial-type photographs now in the archives of ethnographic museums resulted from this use of photography in physical anthropology.

A second current in anthropological research, inventory taking, was closely linked with the exploration of foreign peoples. In Germany at the turn of the century, for example, ethnographic museums were particularly active in this field, sending out anthropologists who would describe unknown peoples and collect anything tangible they had produced in order to document and inventory humankind. Photography became a major tool in this endeavor, for it allowed the systematic picturing of architecture, dress and adornment, crafts, and, to a lesser degree, ritual activities and festivals. Depicting festivals often depended on the ability to capture movement, which at the turn of the century was difficult.

Cultural anthropologist Bernhard Ankermann, curator and later director of the Africa department at the Museum für Völkerkunde Berlin from 1896 to 1924, did fieldwork in Cameroon with his wife from October 1907 to May 1909. He photographed extensively, believing that all written descriptions had to be complemented with illustrations. Even the most accurate verbal description, he reasoned, transmitted a clear picture only if one already knew the same or related things. Ankermann preferred photography to drawing because it provided more objective, and thus more reliable, pictures. He also felt that although not everyone could learn to draw, everyone could learn to photograph (Ankermann 1914, 14).[12] His photographic oeuvre includes the typical photographs of racial types, but it is more notable for the inventory approach. His collection of photographs is made up of images showing architecture, craft production, and objects. Ankermann's emphasis on material culture reflected the growing interest among German scholars in the diffusion of cultures in Africa. They explored this, among other ways, through looking at the geographical distribution of particular objects and craft techniques.

In his guidelines for ethnographic observation and collecting, which were directed at the layperson in the colonies, Ankermann recommended that

one should photograph all objects one cannot take along, in particular . . . processes and activities, for example, dances, ceremonies of religious character, workers farming, craftsmen's activities, musicians playing their instruments, domestic scenes, etc. The shots must be done in such a manner that one can clearly recognize the process, thus, for example, the way a musical instrument is handled by the player, the procedure of the weaver while weaving, the potter when making a pot, etc. One should not let people pose, but photograph

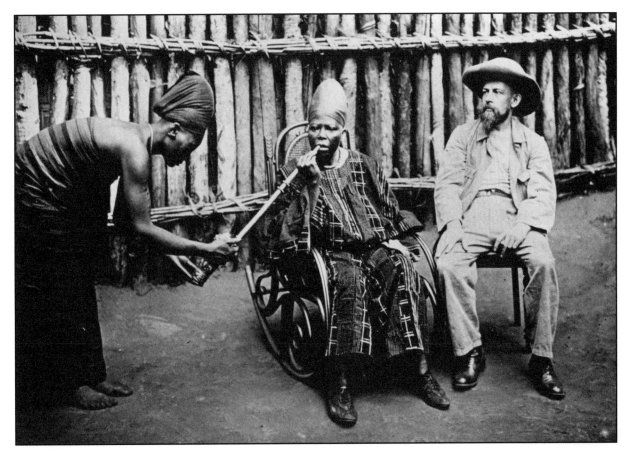

FIG. 9. *Queen Mother Njapndunke sits in a German rocking chair next to Austrian merchant Rudolf Oldenburg. A servant lights Njapndunke's brass pipe.* (Photograph possibly by Helene Oldenburg, c. 1912)

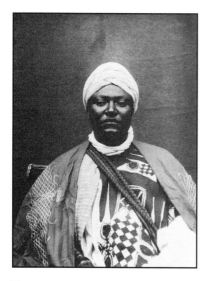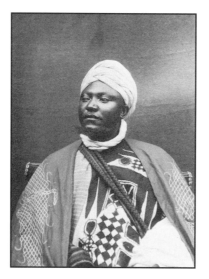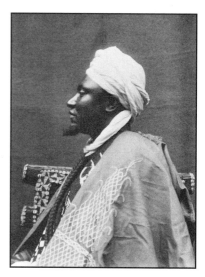

FIGS. 10–12. *King Njoya in frontal, three-quarter, and profile poses. He wears Hausa-style attire. A blanket provides a neutral background for these anthropological photographs.* (*Photographs by Bernhard Ankermann, April–May 1908*)

them in their natural bearing and at their regular workplace. Also, the complete sequence of the process must become clear; one should thus take several exposures in sequence. (Ankermann 1914, 14, my translation)

Ankermann followed his guidelines while in Cameroon. He brought back an enormous number of photographs, which he deposited in the Museum für Völkerkunde Berlin. He used eleven of his images in a short paper describing his research in the Cameroon Grassfields, one of two publications to result from his trip there (Ankermann 1910a). The second short essay dealt with the religion of the Grassfields inhabitants (Ankermann 1910b). Unlike his colleagues who filled volume after volume with their scholarly findings during expeditions,[13] he never wrote a monograph. When the Berlin museum's archives was destroyed during the Second World War, his glass negatives, many of the prints, and the documentation were lost, with the exception of 584 images that had been

stored in another part of the museum.[14] Of these, 243 were taken in Bamum. Unfortunately, the documentation can never be replaced; only through research can some of the information contained in the photographs be salvaged.

Did photographers in Cameroon share common visions and preoccupations, even though their professional backgrounds determined different photographic interests? Their oeuvres do display commonalities. The thousands of photographs taken in Cameroon demonstrate that the conventions of ethnographic photography influenced the photographic style of most photographers, partly because they desired to contribute to the exploration of the colony and partly because such images were much sought after. Besides the scientific modes of representation, the idioms of exoticism and fantasy permeated colonial photography.

Exoticism has a long history in European thought about the Other. Since the Middle Ages, imagery of Africa has created powerful

stereotypes. Eurocentric visions of the Other in distant and wondrous realms served to define the Self (Pollig 1987, 16). They also served as formulas to explain the Other.[15] Among the most pervasive exotic stereotypes are the noble savage and the ignoble savage, sexual innocence and animalistic sexuality, and paradisiacal wealth and impoverishment. Each pair of stereotypes, with one the reversal of the other, aroused curiosity and hidden desire often accompanied by fear and disgust. Photography's verisimilitude, its assumed objectivity, reinforced the acceptance of stereotypical visions of Africa as truth.

Although the elements of fantasy and subjectivity in early drawings of Africa could easily be recognized—artists clearly rendered their own visions—it was more difficult to recognize such subjectivity in photographs. Intentionally or unintentionally, the photographer chose what to present and how to present it. A photographer's selection of content and composition were often meant to evoke responses from viewers, especially if the photographs were intended for a larger public. In making these choices, the photographer could be equally inspired and constrained by the conventional forms of representing the Other. Few colonial photographers were able to transcend the established photographic conventions. The search for the exotic has affected the breadth of documentation and the documentary value of the images.

An examination of the photographs taken in Cameroon before the First World War must take into account a critical parameter: the relationship between the photographers and the photographed—between the powerful and the powerless—in the colonial situation. Often enough, the fearful faces of those photographed speak of coercion. Sometimes there is a bundle of clothes next to a person that betrays the photographer's effort to objectify that person in front of his probing camera. A person became a specimen who was stripped of individuality and dignity (Steiger and Taureg 1985, 121). If, as Banta and Hinsley (1986, 58) point out, the relationship between photographer and photographic subject is inherently problematic even within a single culture, it is more so in a cross-cultural encounter that takes place in the context of colonial dominance and oppression.

In addition to images that allow insights into the relationship between the photographer and the photographic subject, some written descriptions of the photographic encounter are available. Photographers at times referred to the fear of their subjects. Diehl, for example, complained bitterly that the people he photographed did not remain still and often ran off (Diehl 1903b). It would be an overgeneralization, however, to state that colonialism always led to an aggressive, dehumanizing photographic interaction. In the majority of cases, certainly, the relationship was dehumanizing, but there were a few notable exceptions. The nature of the relationship depended on the photographer, the photographic subject, and the cultural and historical circumstances of both. The images from Bamum provide a case in point.

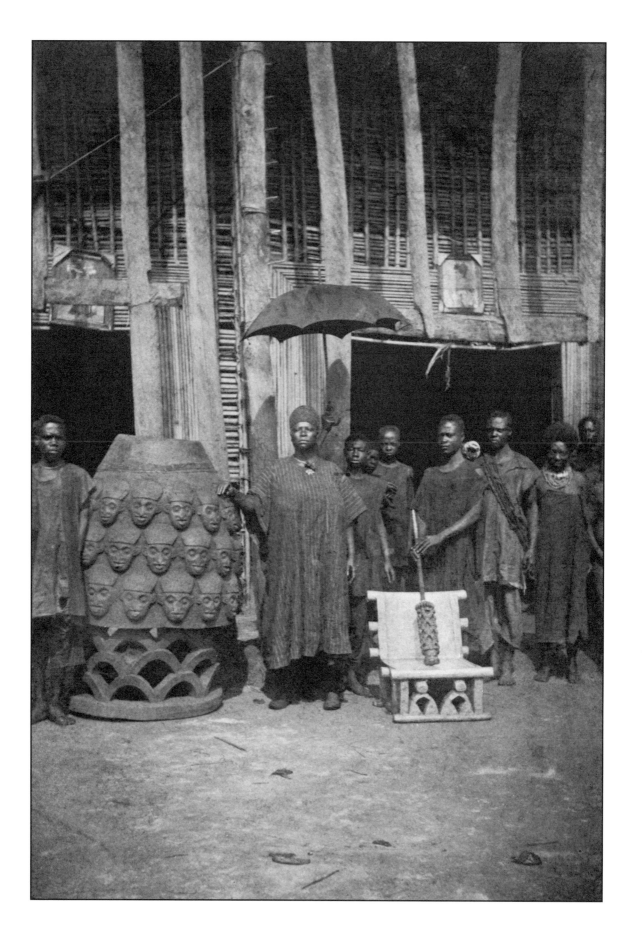

Prestigious Images
The Acceptance of Photography in Bamum

THE FIRST GERMANS TO REACH the Bamum Kingdom arrived in Fumban on July 6, 1902. One of them, former captain turned colonial agent Hans von Ramsay, brought a camera. Ramsay and his trading expedition had joined a military detail, led by First Lieutenant Sandrock, that was traveling from Banyo to Bamum. The detail was made up of twenty-five African soldiers, twenty African porters, three Hausa guides, and a German merchant by the name of Habisch. In his report, Sandrock wrote that when they approached Fumban, two of King Njoya's Hausa servants met them and presented two impressive elephant tusks, two cows, and palm wine. The messengers advised the expedition not to enter Fumban until the next day, because the king wanted to prevent the gather-

FIG. 13. *Queen Mother Njapndunke and her entourage in front of the palace. Two photographs of German royalty hang over the doorways:* left, *either Emperor Wilhelm II or Prince Heinrich;* right, *Queen Luise. Njapndunke poses with her wooden European-style prestige stool and a prestige pipe. She rests a hand on the drum that was sounded every morning when the king began his audiences. (Photograph by Martin Göhring, November 1905)*

ing of threatening crowds that might suggest the Bamum wanted war (Sandrock 1902, 42). This report is corroborated by Njoya's account in the Bamum chronicle of the first encounter with the Germans.

> One day the whites appeared in the land. The Bamum said to themselves, "let's wage war against them." "No!" said Njoya, "for I had a dream that the whites would do no harm to the Bamum. If the Bamum go to war against them, it will be the end of their race as it will be of my own. There would be only a few Bamum survivors. It would not be good." Njoya tore the arrows, spears, and rifles out of their hands. The Bamum obeyed him and did not oppose the arrival of the whites. Njoya aided the Bamum and they remained in peace. (*Histoire* 1952, 134, translated in Geary 1983b, 64)[1]

The following day, the German expedition marched into Fumban, where it was met by King Njoya himself. According to Sandrock's report, Njoya grandly celebrated the arrival of the expedition and declared "his total submission to German rule." Ramsay and Sandrock gave Njoya a German flag in the name of Emperor Wilhelm II.

37

With his strategy of accommodation, Njoya, an astute diplomat, established the foundation for a peaceful relationship between the Bamum and the Germans. He was aware of the devastation suffered by neighboring groups that had resisted German occupation.[2] Njoya believed that if he could prevent full-scale German intervention, the Bamum Kingdom had a chance to survive and maintain a degree of autonomy.

Bamum, located in a colonial district without a German civilian administration, came under the authority of the military station at Bamenda, which was several days away from Fumban. Germans, first merchants and then missionaries, were present in Fumban soon after the initial contact with the kingdom. No military representatives, however, were ever permanently stationed there, assuring Njoya a large degree of autonomy. The distance between Fumban and Bamenda in addition to the small number of Germans in the area determined the style of German interaction with Bamum.[3] The German administration worked indirectly, relying completely on King Njoya to collect taxes, provide labor, and act as the legal authority in his kingdom. Although in the long run the German colonial authorities were neither benign nor ineffective, Bamum was initially spared from direct interference.[4] From 1912 on, a major restructuring of the colonial administration changed the relationship between the Germans and Bamum. The kingdom was intended to become a major administrative center, which no doubt would have meant the end of King Njoya's relative autonomy. Because of the First World War, however, the colonial reforms were never fully carried out. On December 5, 1915, the British captured Fumban, and all of the Germans living there became prisoners of war (Jeffreys 1947, 38; Schwarz 1917, 182).

The Germans in the first expedition to Bamum immediately took a liking to the young, handsome King Njoya and his capital. They reported that Njoya was modest, intelligent, and tactful. In addition, they noted, he spoke with an orator's flair (Sandrock 1902, 42a). Fumban, with its well-kept avenues, reminded Ramsay and Sandrock of a German city. Equally impressive were the large buildings, courtyards, and passageways of the palace district. The Germans felt they were suddenly living an old European fantasy. They had reached a fabled kingdom in the interior of Africa, had met the noble savage in the person of King Njoya, and had found beauty and abundance (Ramsay 1925, 292–93).

In their reports, Ramsay and Sandrock unwittingly began to create the myth about Bamum. The myth told of the loyal King Njoya and his court, of a people superior to all others in Cameroon, and of splendid artworks. At a time when humankind was viewed in evolutionary terms, German eyes saw the Bamum as having reached the highest level outside Europe. This opinion of Bamum and King Njoya was disseminated in colonial literature, and photography was an important tool in creating and maintaining the myth. For the German public, the images from Bamum brought the myth of the kingdom to life. The Bamum photographs were also well-suited for colonial publicity purposes. Besides physical beauty, places such as Bamum offered economic returns, justifying the high investment in the colonies.[5]

By the time the German expedition left Bamum on July 10, 1902, Ramsay had taken a number of photographs, fourteen of which are now in the Museum für Völkerkunde Leipzig. The two earliest photographs of King Njoya show him sitting on the magnificent beaded two-figure throne of his father, King Nsangu (figs. 14, 20). These photographs were the first of well over a hundred showing Njoya during the German colonial period.[6] Ramsay's report

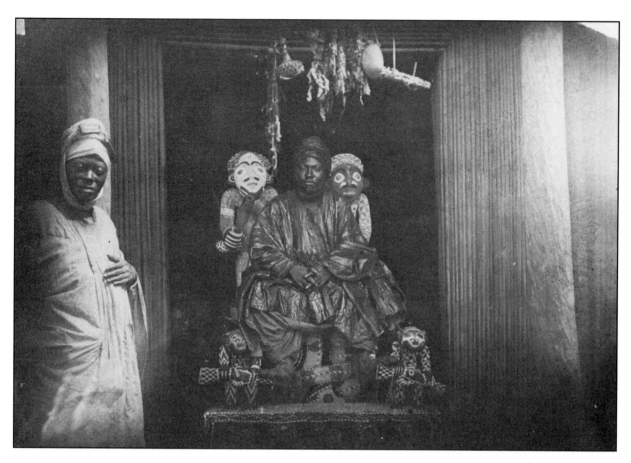

FIG. 14. *King Njoya on his beaded two-figure throne in front of the palace. His feet rest on the guns of two warrior figures. The protective medicines hanging over the entrance do not appear in photographs taken after 1903.* (Photograph by Hans von Ramsay, 1902)

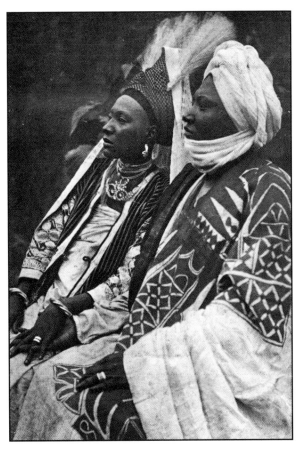

FIG. 15. *King Njoya with his wife Ndayie. Their pose breaches the Bamum prohibition against touching the king in public.* (*Photograph by King Njoya, c. 1912*)

merchants soon arrived in Fumban, despite long distances and difficult travel. Many of the visitors brought cameras to capture this exotic place and its king.

How did King Njoya react to photography? Oral and written accounts, as well as the great number of portraits of Njoya, attest to his acceptance, and even encouragement, of photography. Old members of the royal family and palace servants living in present-day Bamum remember Njoya as being so intrigued with photography that he took pictures himself. In the 1920s, Njoya owned a camera, and some of his photographs are still in the Bamum palace, which holds a large collection of photographs showing King Njoya and Sultan Seidou Njimoluh Njoya, the present king. Unfortunately, many of the early images have deteriorated or have been lost.[7]

The earliest published attribution of a photograph to Njoya is in a 1913 issue of the *Evangelischer Heidenbote* (1913, 4). The stunning image depicts an elaborately clad Njoya and his wife Ndayie, who has her left hand in his right (fig. 15). This is a most unusual pose, because by custom no one is allowed to touch the king in public. On viewing the photograph, people in present-day Bamum immediately commented that the pose is a serious breach of Bamum etiquette. An identically posed photograph of Njoya and an unidentified wife was recently discovered in the archives of the Überseemuseum Bremen (fig. 16).[8] Another photograph that seems to belong to the same series was published by missionary Anna Wuhrmann (fig. 17). She notes that the photograph, a frontal view, was taken by Njoya (Rein-Wuhrmann 1925, 155, 159). The photographs are puzzling from a technical point of view. Njoya is in the photographs and also credited as the photographer. Perhaps he used a timer or ordered one of his servants to release the shutter of the camera.

about Bamum and his photographs, two of which were later published in a 1905 article in the German journal *Globus,* caused a sensation in both the colony and Germany. In the *Globus* article, Ramsay stressed the good relationship Njoya had with the Germans and remarked that Bamum cultural possessions merited an in-depth study (Ramsay 1905, 273). King Njoya and his beaded throne immediately aroused the curiosity of both the public and the museum directors who competed for objects from Cameroon (Geary 1983b, 46–49). When word of Bamum spread in the colony, visitors and eager

Wuhrmann describes an incident that sheds more light on Njoya's appreciation of photography. When Queen Mother Njapndunke died in July 1913, Njoya sent a messenger to ask Wuhrmann to photograph the burial. Excited about this royal request, she rushed to the palace but found that Njoya's advisers opposed the king's wish of having the burial photographed. According to Wuhrmann, the advisers felt that photographs of a deceased person would cause sadness even many years after the death (Rein-Wuhrmann 1948, 58–59).[9] Nevertheless, she was allowed to take several pictures during the funerary dances (Geary and Njoya 1985, 103).

The photographs taken in Bamum focus on the elite; few show slaves or the Bamum people who lived in the countryside. This bias in the photographic record reflects the German infatuation with the Bamum court (Geary 1986, 101). Additionally, the classes within Bamum society reacted differently to being photographed. The Bamum elite enjoyed the new medium because it allowed them to present themselves and their wealth. Poor people, who were unfamiliar with the process, avoided it. Two remarks by Wuhrmann indicate that she was aware of both responses to photography.

Often I thought: You could actually open a photographic studio in Bamum country, because the people really liked being photographed, and everyone who desired to see his face captured on a glass plate was thoroughly convinced of his or her beauty. It was not really difficult to make pictures of the blacks. Mostly they knew how they wanted the picture, determining the pose and background, and making a proper photographic face. I enjoyed very much doing it and brought home beautiful pictures. (Rein-Wuhrmann 1931, 132, my translation)

Another time, however, Wuhrmann wrote that

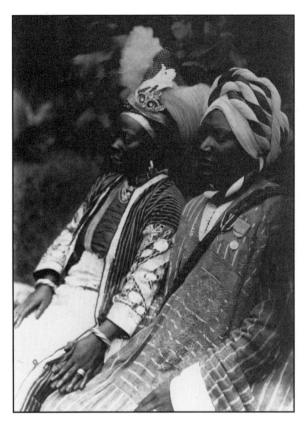

FIG. 16. *King Njoya with an unidentified wife. Similar in composition to figure 15, the photograph is probably one of a series arranged and photographed by King Njoya himself.* (*Photograph by King Njoya, c. 1912*)

many ordinary people in Bamum did not want to be photographed, because they believed that the camera contained spirits that might capture one's soul and take one's life (Rein-Wuhrmann 1948, 28).

Wuhrmann usually photographed members of the Bamum elite, but she did create a portrait of a woman who was a slave (fig. 18). It was first published in the *Evangelischer Heidenbote* with an essay that criticized the arrogance and cruelty of the Bamum ruling class, which Wuhrmann felt contradicted the teachings of Christianity (Wuhrmann 1917, 185). Her essay reflected the

disillusionment of the missionaries after they realized that Islam had become entrenched at the Bamum court.

Among the few images portraying ordinary inhabitants of Bamum are photographs by Rudolf Oldenburg, who lived and photographed in both Fumban and Kuti, a German experimental farm and settlement. Many of his pictures depict men, women, and children whom no one at the present-day Bamum palace recognized. Most of the Bamum elite portrayed by missionaries and visitors to Fumban, however, were identified.

The Bamum response to the new medium must be understood in relation to other forms of visual representation in the kingdom, including imported imagery. Photographs, prints from magazines, and biblical images became cherished possessions at the Bamum court soon after their introduction. As a photograph of Queen Mother Njapndunke and her entourage demonstrates, pictures were displayed in prominent places (fig. 13). Three framed pictures, two visible in the photograph, hung over the entrance to her residence when German missionaries visited in late 1905 and took the photograph. According to a written report, the pictures showed the Emperor Wilhelm II, Prince Heinrich, and Queen Luise (Stolz 1906a). The colonial administration customarily gave pictures of German royalty and the colonial governors to African rulers as rewards for loyal service (fig. 28).

Another source of imagery were the missionaries in Fumban. Shortly after Martin Göhring and his wife, Margaretha, arrived in Fumban in May 1906 as members of the Basel Mission, they delighted the king and the queen mother with a magic lantern.[10] Martin Göhring's report offers a rare glimpse of the Bamum elite's exposure to European imagery, which no doubt created familiarity with the new medium.[11]

I told him [the king] then that I had a magic lantern, and if it arrives from Bali, I will show him some holy pictures. He now waited for it with great desire. He had barely returned from the war against Nso when he came to us already the following day. His first question was: Master, have the pictures arrived? I said yes. Now he did not relent until I promised to show them to him. He had about twenty soldiers with him; in total he has a bodyguard of about one hundred men. After dinner, to which we invited him, I arranged the performance. He was totally beside himself about the pictures and wanted everything explained to him in detail. In Bali I have also shown the pictures, in the presence of the Bali king. I was therefore very interested in comparing the impression that the pictures made there and here. In Bali everybody was amazed with the technical aspects of the matter— that the white is able to project a picture on the wall where none has been before. In Bamum the pictures were the most interesting and the explanations tied to them. . . . The next day after I had shown the pictures, in the evening when it was already dark and we sat at the dinner table, a soldier arrived and announced the visit of the queen mother. . . . She arrived with a large entourage, carried on her palanquin. . . . And what was the purpose of her visit? She wanted to have the biblical pictures shown with the magic lantern. I enjoyed fulfilling her wish. Afterward, she was totally beside herself and moved, also her entourage. (Göhring 1906a, 17–18, my translation)

The emphasis on visual representation in Bamum culture perhaps promoted the acceptance of photography as a new means of serving traditional purposes. The Bamum court was oriented toward using visual forms to express individual status, political structure, and Bamum

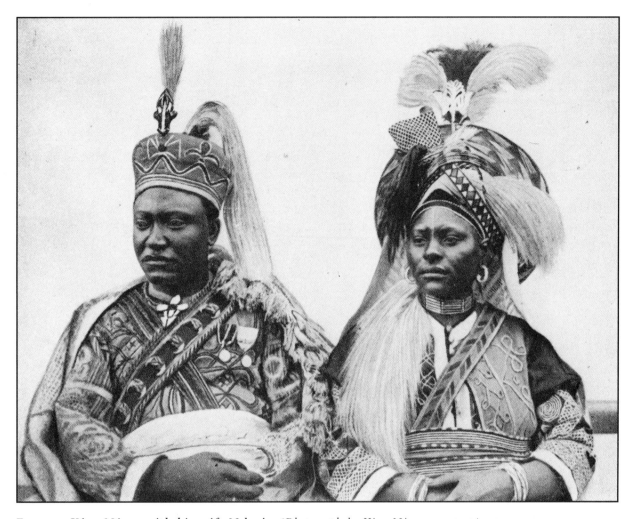

FIG. 17. *King Njoya with his wife Ndayie. (Photograph by King Njoya, c. 1912)*

history. Social and political differentiation were articulated by a hierarchy of restricted media, by a strict etiquette at the court and elsewhere, and by spatial form, requiring, for example, elaborate seating arrangements (Geary 1981, 39). Splendid architecture, lavish displays, and masquerades alluded to the kingdom's wealth and power. Members of the elite employed visual means, such as dress and jewelry, to display their rank and distinguish themselves from ordinary Bamum. The materials people used and the icons they displayed placed them in particular social groups. The king held a monopoly over prestige goods. Certain kinds of beads, brass, elephant tails, horsetails, leopardskins, leopard claws, and high-status cloth, for example, could be used only if the king granted permission. The use of icons, such as the serpent, the frog, and the spear, was equally restricted. Bamum history was in effect objectified, and visually accessible, through the preserved regalia of former kings and mementos of historical events.

Artists working for the Bamum court created figurative art. There is some evidence that Bamum kings, like their counterparts in the Cameroon Grassfields, commissioned sculptors to create portraits (Harter 1986, 54–61).[12] Such formal portraits—large wooden figures that were occasionally beaded—did not aim at physical likeness, although emblems of rank, such as high-status headdresses, loincloths, and jewelry, were used to individualize the sculpture (Borgatti 1980). Photography may have served similar purposes. It provided another means for presenting a person in a formal pose and in appropriate dress. Similar to a carved portrait, a photographic portrait could be displayed.[13] Indeed, in present-day Bamum, the display of photographs on the walls of houses and in photograph albums has become a feature of popular culture.

Responses by other African peoples to the introduction of photography may provide insights into the acceptance of photography in Bamum. In a paper about Yoruba photographers, Sprague (1978a) suggests that Yoruba aesthetic values and needs for representation promoted the introduction and success of indigenous photography in the late nineteenth century. Unfortunately, no one has yet explored how the Yoruba initially responded to photographs taken by foreigners. Further research on the introduction of photography may find that certain African peoples had a predisposition to integrate photographs into their visual repertoire, and thus they enjoyed being photographed. Such a predisposition would provide one explanation for why the photographic record of some areas, even though produced by Europeans, is so much larger than for others.

Other factors also contributed to the amount of photographic coverage of particular regions and peoples in Africa. The presence of photographers in a region is one obvious reason for an extensive photographic record. In the Grassfields, for example, resident photographers produced a rich record on Bamum and Bali. The type of relationship between the colonials and those dominated is another factor that determined whether Europeans made an effort to photograph in certain areas. Photographers were less attracted to regions that resisted colonial domination. A case in point is the lack of photographs from the kingdom of Nso, which was defeated by the German military in 1906. Very few photographers ventured there, even though the kingdom, like Bamum, had a powerful king, splendid palace architecture, and impressive court arts (Geary 1986, 100).

FIG. 18. *A woman who was a slave owned by Queen Mother Njapndunke.* (*Photograph by Anna Wuhrmann, c. 1912–15*)

CHAPTER FOUR

A Myth Comes to Life
King Njoya in Photographs

MOST REMARKABLE among the photographs from Bamum are the many images taken of King Njoya between 1902 and 1915. They are complex visual texts that reveal the roles of the photographer, the subject, and the viewer in the photographic process. In the photographs, Bamum cultural notions about presenting oneself seem to have been synthesized with European views and expectations. The photographs are also historical documents that speak of the photographic conventions of the time, the developing Bamum attitudes toward the new medium, and colonial domination.

Curiosity and a hope for profit brought photographers to Fumban before the Basel Mission officially opened its station in 1906 and resident missionary photographers arrived. In the earliest pictures, taken by Hans von Ramsay in 1902, King Njoya seems somewhat uncomfortable and hesitant. He was not yet familiar with the peculiar exercise of posing for a European photogra-

FIG. 19. *King Njoya and his servants display a weaving sampler made from narrow strips of cloth. (Photograph by Marie-Pauline Thorbecke, January 1912)*

pher. For example, in figure 20, unlike most later photographs, he looks away from the camera. Another early image, taken by a military doctor named Dietze, dates to 1903 (fig. 21).[1] It seems to be a snapshot capturing King Njoya and Nji Monkuob, Queen Mother Njapndunke's brother, as they emerge from the palace. Compared with most other photographs of King Njoya, it is not carefully posed, as if Njoya were still unaware of both the implications of the new medium and the ways he could most impressively present himself to the camera. Finally, another early Njoya photograph, probably by a merchant named Schultz, was taken before 1905 (fig. 22).[2] The photographer depicted King Njoya and a retainer in German-style uniforms. Njoya's face seems to express displeasure, although he takes a dignified pose befitting a king. Sitting with legs spread is the privilege of high-ranking men in the Cameroon Grassfields.[3] This pose does not conform with European photographic conventions, confirming Wirz's observation that if given the freedom, a non-European may assume a pose that is unusual by European standards (Wirz 1982, 52).

One aspect of figure 22 illustrates a problem regarding the use of photographs as documents.

47

FIG. 20. *King Njoya sits on the footrest of his two-figure throne in front of the palace. This is one of the earliest photographs of the king.* (*Photograph by Hans von Ramsay, 1902*)

By Bamum custom, a king did not sit on chairs made from the ribs of raffia fronds; they were used only by women. In the photograph, however, Njoya sits on such a chair. Had it not been for the photographic occasion, Njoya would certainly have chosen a more appropriate chair. Props used in photographs may actually falsify the ethnographic record—a well-known occurrence in North American Indian photography.[4] Because research on photographs taken in Africa is only beginning, the ethnographic accuracy of the photographs has yet to be tested.

In later years, Njoya became quite adept at posing and presenting himself, his court, and his inventions. Njoya knew the wishes of the

photographers and had ample opportunity to study the final product, because photographs were developed in Fumban and paper prints were sometimes given to him. He had his own aesthetic preferences to which the final photograph had to conform. When the German painter Ernst Vollbehr went to Fumban in 1911, he decided to do several watercolor portraits of King Njoya.

> Soon Njoya appeared before my tent to model for a frontal portrait and a profile portrait. Since [in his eyes] I could do everything, he quietly and uneasily whispered into my ear that I should paint him with a mustache, because he did not have a [full] beard. I refused and expressed my amazement about this incomprehensible demand, which embarrassed him, because he noticed that he had acted out of character. Motionless he sat for me, only now and then taking a long, smooth pull at his ancient inherited chief's pipe, which a well-groomed young man always carried after him and kept lit by blowing into it. Matter-of-factly, he chose the best portrait for himself, the frontal view. "This is not me" (he was pointing at the picture with the profile view). "Don't I have two eyes?" During the session, one of his retainers had to tell him what I painted at every moment. He left very happily with his portrait, and when he heard from the commander of the [Bamenda] station that European emperors and kings also have their portraits done, he was twice as proud. (Vollbehr 1912, 94–95, my translation)

Like Njoya, the photographers had certain expectations. They tended to take photographs that conformed to their views of King Njoya and Bamum. The viewers at home expected to see particular types of Njoya images as well. Later photographs of King Njoya, therefore, reflect a few general themes, which are similar

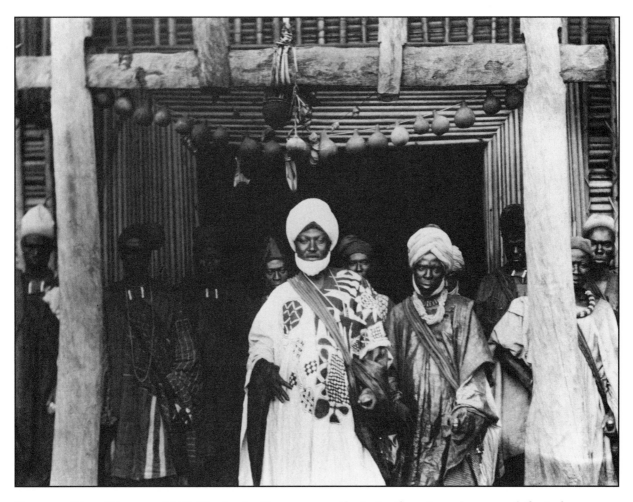

FIG. 21. *King Njoya and Nji Monkuob, the queen mother's brother, in a doorway of the palace.* *(Photograph by Dr. Dietze, 1903)*

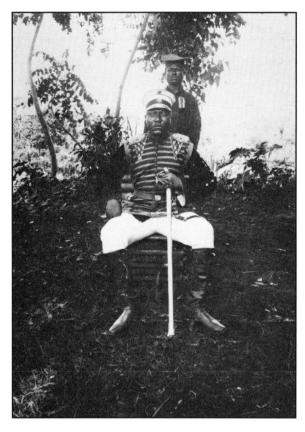

FIG. 22. *King Njoya and a servant in military uniforms. Njoya's boots, pants, and hat were made in Germany. The striped cloth jacket with beaded epaulets, based on a hussar uniform, was tailored in Bamum.*
(*Photograph by Schultz, c. 1904*)

to the themes in written reports about Njoya and his kingdom.

The most prominent theme in photographs was "Njoya, the powerful and intelligent king." It successfully combined Njoya's desire to present himself in photographs and German expectations of the regal, the exotic, and the foreign. Marie-Pauline Thorbecke, the wife of geographer Franz Thorbecke, created perhaps the best-known picture of Njoya (fig. 23).[5] Taken in January 1912, it shows Njoya seated on his lavishly beaded two-figure throne in front of the palace. A servant listens to royal commands with his head bowed and his hands in front of his mouth. This is the typical posture all Bamum people assumed in front of the king because they were not allowed to speak directly to him. The appeal of the photograph for foreign viewers lay in the exotic display of wealth and splendor. The throne, the pose of the king, the demeanor of the servant, and the elaborate palace façade reinforced general notions about royal splendor and etiquette. Outside the kingdom, this beautifully photographed image became a visual metaphor for Bamum and King Njoya.

The scientific expedition of Marie-Pauline and Franz Thorbecke reached Fumban on January 13, 1912, and moved on seventeen days later to Tikar country further east, where the couple established a research site. They met Njoya on two occasions. The first time, Njoya came to visit them, and later the Thorbeckes spent a morning in the palace (M. P. Thorbecke 1914, 49–50). In the official expedition report, the chapter about Bamum is written by Marie-Pauline Thorbecke in the scholarly style of the time. She describes Njoya as "one of the few Negroes who possess a pronounced intellectual independence" (F. Thorbecke 1914, 20). Yet her picture of Njoya and a servant has a generic caption: "Bamum Negroes in Fulbe dress" (F. Thorbecke 1914, pl. 10). The treatment of the people in the photograph as anonymous serves to present them as ethnic types rather than individuals. Thorbecke's assessment of Njoya and the photograph caption are typical of the taxonomic and objectifying glance of scholars at the time. Scholars were, of course, the intended audience for the book. The picture itself, however, conveys a perspective that is not just scientific. In her own memoir of the trip, *On the Savanna,* Marie-Pauline Thorbecke drops the scholarly attitude. Wanting her book to appeal

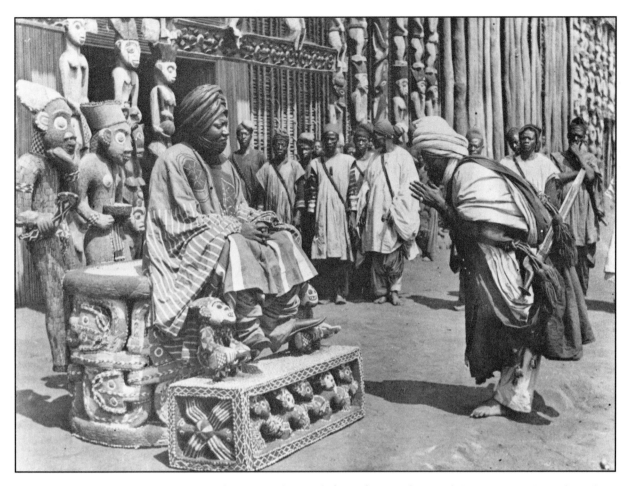

FIG. 23. **King Njoya giving an audience in front of the palace.** *(Photograph by Marie-Pauline Thorbecke, January 1912)*

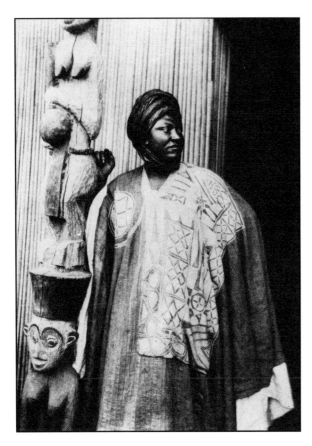

FIG. 24. *King Njoya in front of the palace.*
(Photograph by Marie-Pauline Thorbecke, January 1912)

The first impression, which has been strengthened during each get-together, is that of a lively, extraordinarily gifted human being. It is even more remarkable that one arrives at this judgment the first time one sees him, since his facial features are somewhat stiff because one of his eyes is almost blind and does not move much. (M. P. Thorbecke 1914, 49, my translation)

As an illustration for her book, she did not choose the formal picture of Njoya on his throne, but a more intimate portrait of the king in a beautiful Hausa-style robe, simply captioned "Njoya" (fig. 24).[6] In the book, Thorbecke's brief visits with Njoya during her short stay in Fumban take on the quality of exalted cross-cultural encounters between kindred spirits. "His behavior," she writes, "is so unaffected, and at the same time so nobly restrained, so completely free of curiosity and greed for European things, that one soon talks to him as a human being talks to a human being" (M. P. Thorbecke 1914, 53, my translation).

This image of the noble savage created by German colonials and adopted by the German public is evident in the exceptionally conventional portraits of Njoya. At the same time, the portraits convey Njoya's facility with the photographic medium; the king was adept at striking regal poses. In 1912 a German merchant and collector named Schröder took a somewhat distant yet dignified portrait of Njoya standing in the courtyard where he held audiences (fig. 25).[7] In many formal portraits, Njoya sits on either his state throne or other high-status stools and chairs. In figure 26, whose photographer is unfortunately unknown, Njoya sits on a beaded stool in a stately pose, which is accentuated by the low camera angle. If this serene image is juxtaposed with a description of Njoya by Hans Dinkelacker, a missionary who visited Bamum in 1911, the parallels between written text and

to the public, she reiterates the sentimental view of Bamum, which by 1914 was firmly entrenched in Germany. Like most of her contemporaries, she wrote in the paternalistic tone of the observer convinced of his or her superiority. She begins the chapter on Bamum with the following words: "This is the fourth day we have been in the legendary Bamum, the country of perhaps the most intelligent Negroes in Cameroon, in which milk and honey truly flow for the European" (M. P. Thorbecke 1914, 45, my translation). She goes on to describe her encounter with King Njoya.

visual image become strikingly obvious, demonstrating the consistency of German visions of King Njoya.

> Njoya is of an imposing appearance, especially since he has given up the European-style clothing that was not befitting and clothes himself in Bamum, that is, Hausa dress. He is exceptionally tall and broad-shouldered. Intelligence and energy mark his face. If he sits there with his billowing, finely embroidered gown, the huge turban on his head, he is indeed a regal figure. His mien shows great benevolence and friendship. He can be very lively in conversation, and with childlike pleasure he will tell about his inventions and his plans. (Dinkelacker 1911, my translation)

Other portraits of Njoya show him on horseback (fig. 27). Horses, imported from the north, were prestigious possessions of the Bamum elite and symbols of status in the display and presentation of oneself in photographs (see also fig. 33).

A second theme in photographs was "Njoya, the German ally." The Germans perceived King Njoya as a dutiful ally of the German Empire. The perception was misleading, however, for it was a far more complex relationship. Njoya's strategies in dealing with the Germans were deeply influenced by his desire to maintain Bamum's autonomy. Actions that the Germans interpreted as supportive often emanated from Bamum political necessities rather than from Njoya's desire to serve the Germans.

No photograph expresses the ally theme in all its ambiguities better than the image of Njoya and his soldiers receiving a framed photograph of the German emperor (fig. 28). The occasion for this grand ceremony was the successful completion of a German punitive expedition against the neighboring kingdom of Nso, which had

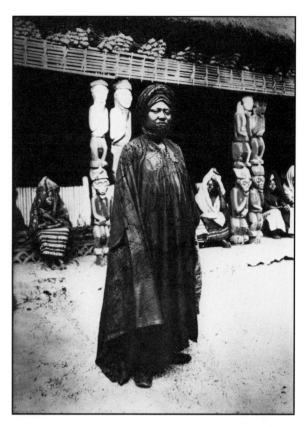

FIG. 25. *King Njoya in the audience courtyard of the palace. (Photograph by Schröder, c. 1912)*

lasted from April 18 to June 5, 1906. Njoya himself had joined the expedition and had provided two hundred auxiliary troops.

The king's eagerness to participate in the German campaign against the Nso Kingdom must be understood within the framework of Bamum history. The Bamum had suffered a major defeat at the hands of the Nso in the 1880s, and King Nsangu, Njoya's father, had been killed by his own brothers in one of the battles during that war. The Nso had captured King Nsangu's head and kept it in the Nso palace. Without a head, a Bamum king's body could not be given a proper royal burial.

The German officers who led the troops described the event at length in their reports,

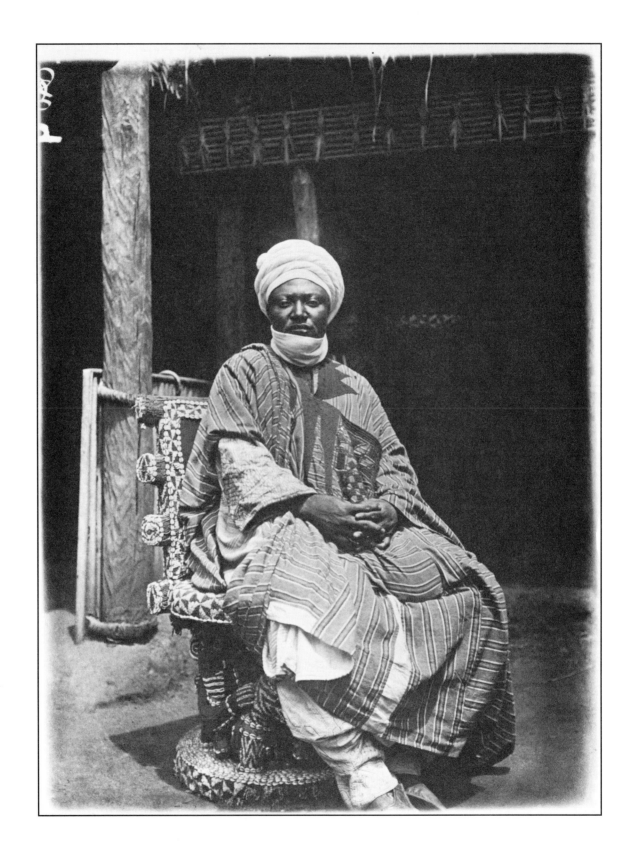

stressing the invaluable help and military effort of the Bamum (Glauning 1906). In the Bamum chronicle, Njoya also wrote about the campaign.

> The Bamum thought that they could not take vengeance for the death of their parents, their fathers, their king so long as their heads remained in the land of the Nso. But Njoya avenged these deaths by triumphing over the Nso. Captain Grared [Glauning] gave a medal to the king, saying that he was a valiant man as were the Bamum. Some time later, the Emperor, through his intermediary the governor Epomaya [Ebermaier], gave me, Njoya, a medal, congratulating me very much. The Bamum were satisfied to see that the king had avenged those who had fallen on the field of battle in the land of the Nso and they expressed their satisfaction to the Germans for the decorations, the works, and the good they had done for them.[8] (*Histoire* 1952, 135, translated in Geary 1983b, 68)

In the photograph of the ceremony, Njoya's soldiers wear the breastplates and elaborate helmets of the Imperial Garde du Corps and the cuirassier guards, both elite regiments of the German military. Why these prestigious uniforms rather than lesser military regalia were selected as gifts for King Njoya remains a mystery. Although the photograph was not published in contemporary literature, it was distributed as a lantern slide, which demonstrates its popularity among viewers in Germany.[9]

Many photographs depict Njoya and his soldiers wearing either authentic German uniforms or Bamum-made uniforms patterned after those of various German military units. Until 1909

FIG. 26. *King Njoya on a beaded throne that is supported by male figures. The backrest is adapted from European chairs.* (*Unknown photographer, c. 1912*)

the German uniform was the dominant visual symbol of the alliance between the Bamum and the Germans. The Germans regularly gave uniforms to Njoya. He received uniforms, for example, in return for a large shipment of ivory that he sent to the coast. These uniforms became treasured possessions, which Njoya frequently displayed in photographs. For Njoya's regular guards, tailors in the palace made garments resembling German uniforms (Rohrbach 1907, 7). The king himself also wore these creations (figs. 29–31). Beaded epaulets, belts, and medals decorated the jackets, translating the German uniform into a Bamum form of expression. Bamum tailors even successfully copied some of the headgear (Geary 1983b, 203–5).

Initially, the Germans found these displays of apparent loyalty delightful. Rohrbach (1907), for example, comments on the neat appearance of Njoya's troops. In a 1910 book on the German colonies, which includes figure 28, the anonymous authors praise Njoya's regal appearance whether he wore white Hausa garments or a brilliant dress uniform similar to that of the German cavalrymen known as hussars (*Eine Reise durch die deutschen Kolonien* 1910, 51). Even after the First World War, imagery of Njoya the ally had not lost its appeal. Ramsay used a picture of Njoya in a hussar uniform (fig. 30) for his 1925 essay on Bamum (Ramsay 1925, 293), and the same image even appeared in a recent critical book about the German colonial period (Petschull 1984, 143).

After 1908, however, the Germans increasingly worried about weapons in the hands of Africans. They forbade Africans to purchase or carry firearms and ordered Njoya and his troops to stop "playing soldier" (Menzel 1909, in Geary and Njoya 1985, 192). The idea that Njoya's military endeavors were not serious may have been reinforced by the lighthearted poses that Njoya assumed with his soldiers in photo-

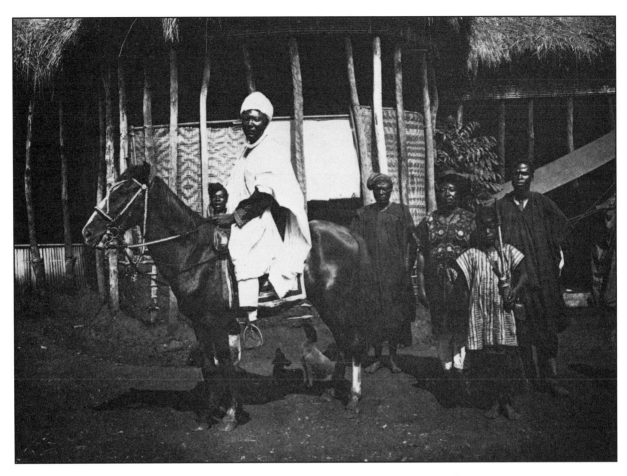

FIG. 27. **King Njoya, on horse, in front of the German rest house in Fumban. A young servant carries his pipe.** (*Photograph by Adolf Diehl, c. 1906*)

FIG. 28. *King Njoya receiving a photograph of Emperor Wilhelm II for his support of the German military campaign against the Nso Kingdom. He also received breastplates and helmets for his soldiers. Left,* **Captain Hans Glauning, commander of the Bamenda military station.** (*Photograph possibly by Lieutenant von Putlitz or Martin Göhring, 1906*)

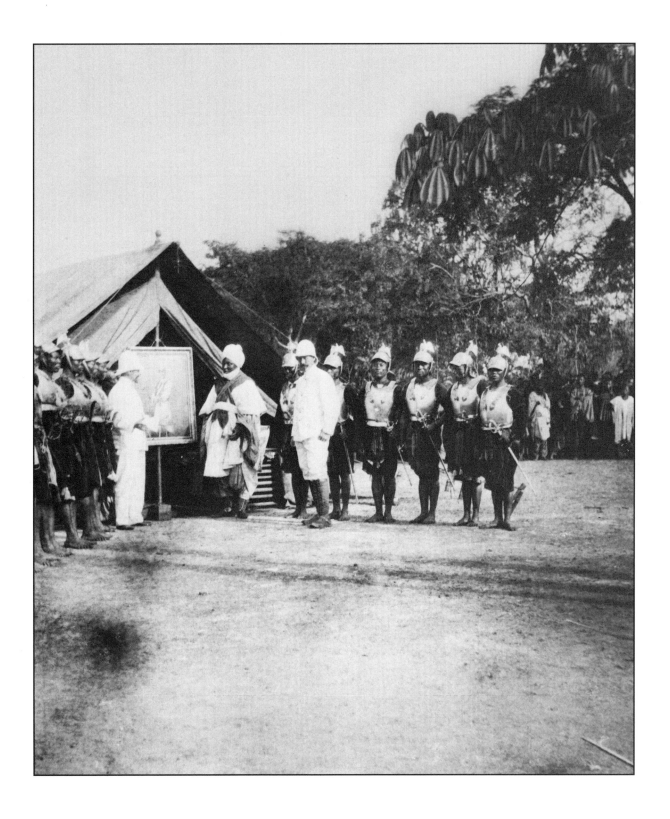

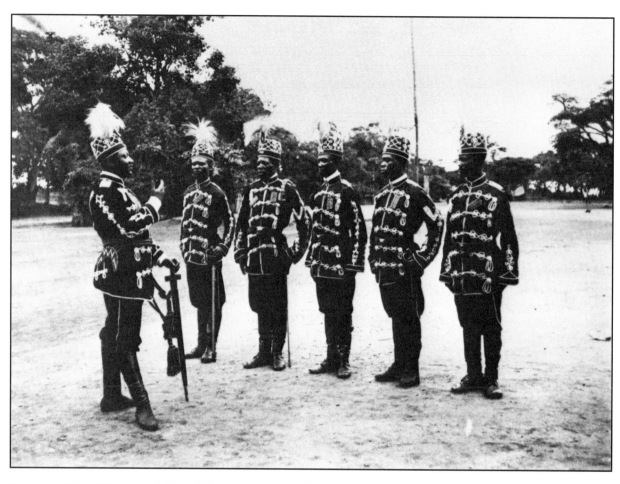

F<small>IG</small>. 29. *King Njoya and his soldiers in hussar-style uniforms made by palace tailors and beadworkers. Njoya holds a Fulbe sword. (Photograph by Rudolf Oldenburg, c. 1908)*

graphs (fig. 31). Photographs of Njoya in German-style uniforms cease after 1909, documenting both the policy change of the colonial administration and the hesitancy of German photographers to record "militant" Africans. The king and his soldiers in German uniform no longer conformed to the exotic notions of Bamum.

From the Bamum point of view, King Njoya's decision to forgo German uniforms and wear only Hausa-style attire was a deliberate statement of new political alliances. Throughout Bamum history, elite Bamum men had defined themselves as warriors, visually expressing their warrior status by wearing military accoutrements, such as elaborate swords. After the Germans found the wearing of German military regalia unacceptable, King Njoya lost hope that the German colonial administration would allow him to pursue his military goals, which had been kindled by Bamum participation in the campaign against the Nso Kingdom. Njoya began moving closer to the Islamic rulers of the states to the northeast of Bamum, expecting that they would be more supportive of his plans.

The German images, as well as written texts, from the colonial period reverberate with another theme, "Njoya, the creative thinker, the inventor, and the educator of his people." This is a role in which Njoya saw himself, and much of the Bamum chronicle reports about his inventions and his plans for social reform (Njoya 1977).

One of the major reforms that influenced the production of art was the abolition of the royal monopoly of the use and display of certain materials (*Histoire* 1952, 125−33). Court artists consequently gained independent access to prestige media, such as beads, brass, and fabrics. Later they established themselves outside the palace and began working for a new clientele: foreign visitors to Fumban.

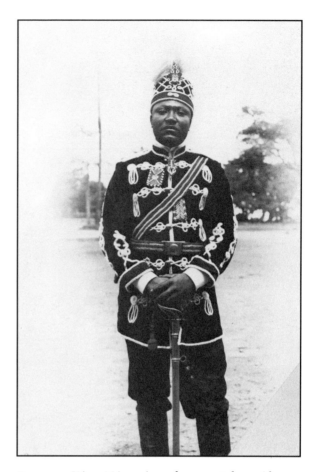

FIG. 30. *King Njoya in a hussar-style uniform made in Bamum.* (*Photograph by Rudolf Oldenburg, c. 1908*)

Among Njoya's many inventions, the Bamum script most puzzled and amazed the Germans in Fumban (fig. 32). Martin Göhring, the founder of the missionary station at Fumban, wrote the first reports about the script for the *Evangelischer Heidenbote* (Göhring 1907a, 1907b). The inception of the script probably predates the arrival of the Germans. Most likely, the invention of the first Bamum alphabet was stimulated by a knowledge of Arabic writing acquired through close contact with the Fulbe of Banyo during the last decade of the nineteenth century. The first alphabet was in-

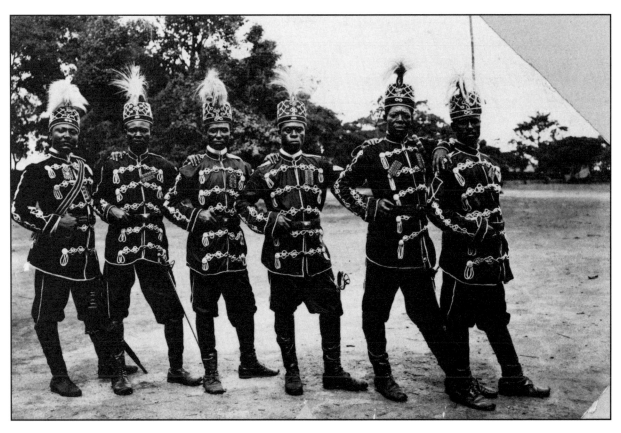

FIG. 31. *King Njoya,* left, *and his soldiers in hussar-style uniforms with German sabers. The photograph, according to its archival caption, was posed to resemble a photograph of the German crown prince with his comrades. (Photograph by Rudolf Oldenburg, c. 1908)*

FIG. 32. *The Lord's Prayer in Bamum script. Written in 1911, the prayer is an example of a revised version of the Bamum alphabet. The script is called* a ka u ku, *a name derived from its first four characters.*

vented between 1895 and 1903, and the last of six revisions occurred in 1916 (Tardits 1980, 38–39). References to the Bamum script and the works written in it appeared regularly in scholarly and popular German literature. Njoya founded his own school at the palace, modeled after the mission school, where princes and noble servants were instructed in Bamum writing. Later, the princes and servants began to keep records of births, deaths, and marriages in the Bamum script. In addition, they kept judicial records, wrote down Bamum history, and compiled medical knowledge. These writings are precious sources of information about Bamum life that are only now being systematically studied (Tardits 1980, 36–52).[10]

Another area of innovation was textile production. Njoya introduced new weaving and dyeing techniques, embroidery, crocheting, and tailoring. In doing so, he adopted ideas from the Hausa, the Germans, and neighboring peoples (Geary 1983b, 146–52). Njoya and his assistants created a rich assortment of textiles and clothing styles, evidence of which survives in the photographs. During a morning visit to the palace in January 1912, Marie-Pauline Thorbecke captured Njoya displaying the results of one of his favorite enterprises. In an animated pose, he presents weaving samples sewn together in a long strip (fig. 19). To this day, the weaving sampler is preserved in the Bamum Palace Museum (Geary 1983b, 201). According to several observers, Njoya established large weaving workshops where up to three hundred weavers produced cotton weaves on horizontal looms.[11]

The comments of Bernhard Struck, a professor of geography who had never been to Bamum, best exemplify the German reaction to Njoya the inventor. Struck's remarks were inspired by Njoya's achievements as a cartographer. The king had directed the drawing of maps of Fumban and Bamum country.[12]

By now one has become used to being surprised by each letter [from Bamum]. King Njoya of Bamum is no doubt one of the most intelligent and energetic West Africans. His government is more and more tied to the growing economic value of our colonies and, in particular because of the invention of the Bamum script, with intellectual advancement in Bamum country. (Struck 1908, 206, my translation)

What do these images of King Njoya from a distant time and place tell present-day viewers? Some facets of Njoya's complex personality, refracted by the lenses of foreigners' cameras, are surely revealed. The elegant and dignified portraits of Njoya attest to his view of himself and to his diplomacy, political savvy, and creativity. The attitudes of the photographers are equally revealed in the images. They searched for the exotic and the beautiful to confirm their fantasies of Bamum. As a result, their depictions of Njoya almost always omit aspects of his life beyond his formal role as king. The consistency and narrowness of foreigners' perceptions of Njoya, both written and visual, is striking. The conventionality of the Njoya imagery, however, reflects not only the photographers' limited vision but also the careful policy that King Njoya adopted toward foreigners.

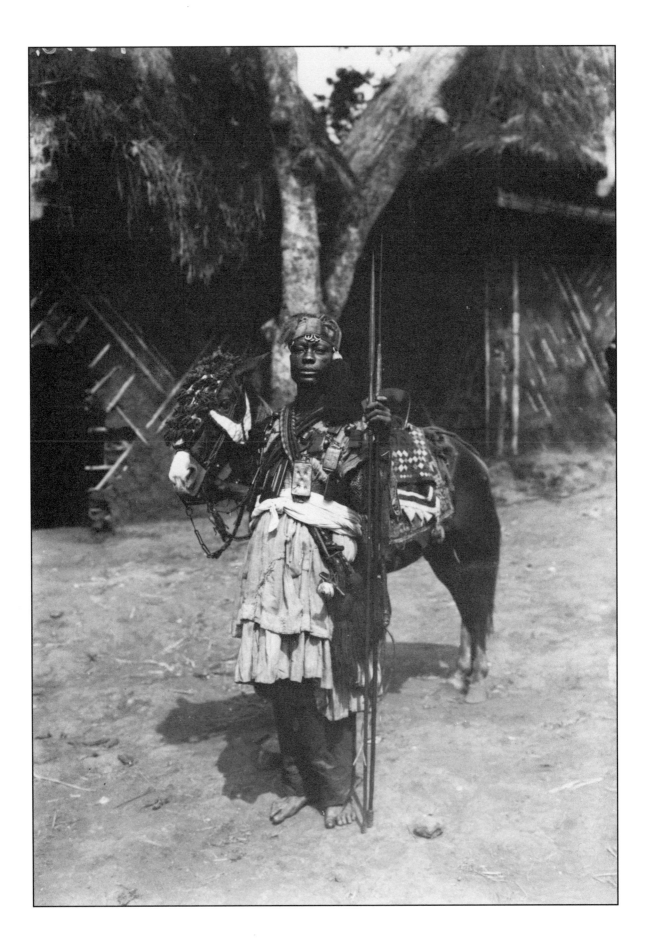

Glimpses of Reality
The Palace and Its Inhabitants

The myth about the Bamum Kingdom that evolved in the colony and in Germany, like every story, had its setting and its characters. The setting was the splendid palace, and the protagonists were King Njoya and his mother, Njapndunke. They were surrounded by the king's wives, brothers and sisters, sons and daughters, and servants (fig. 34).[1] The setting and the characters were developed in written accounts and photographs. These words and images reveal both the foreigners' visions of the palace and its inhabitants and the Bamum royals' ways of presenting themselves to the foreigners. Additionally, photographs taken at the Bamum court are documents that facilitate the reconstruction of past forms of architecture and artistic expression.

Historical photographs are valuable because they record change over time. Yet their documentary strength depends mainly on the researcher's ability to place and date photographs and to establish locations and datelines for

whatever is shown in the images (Geary 1986).[2] Thus, accurately dated photographs contribute historical information—for example, documentation of changes in the old Bamum palace and the sequence of later royal buildings—that is not contained in written works or narratives. Another equally important aspect of a photographic corpus is what the photographs do not show. The unphotographed is often as revealing as the unsaid and unwritten.

When studying the written and photographic records on Bamum, it becomes apparent that foreigners relied primarily on images rather than words to document the impressive palace buildings. Numerous palace photographs exist, but verbal descriptions are rather sparse. Further, there is confusion about the various palaces in the literature. Written accounts contain many references to "old" and "new" palaces and to other royal buildings; the sequence of these buildings is difficult to disentangle.

Hans von Ramsay took the first photograph of King Njoya's palace, which was later published in his 1905 *Globus* article (fig. 35; Ramsay 1905, 272). It shows the central complex of the royal residence and is accompanied by the following description.

FIG. 33. *Nji Montien, a brother of King Njoya, with his horse. He wears Hausa-style attire and many protective amulets.* (*Photograph by Rudolf Oldenburg, c. 1908–13*)

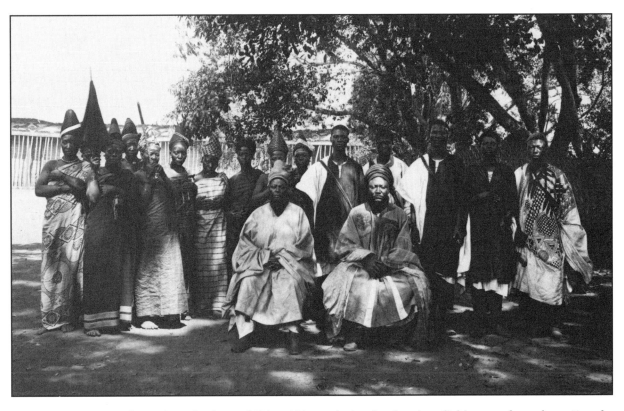

FIG. 34. *Queen Mother Njapndunke and King Njoya sit in the dancing field near the palace. Royal wives and high-ranking servants stand behind them. Njapndunke's umbrella and prestige pipe are held by royal wives.* (*Photograph by H. Reimer, 1912*)

Very cleanly kept paths, several meters wide, lead to the slightly higher, very vast main square, which is occupied on one side, by the 70- to 90-meters-long house of the chief. . . . At its side (left on the picture) lies a large drum under a protective roof. The house itself is a very stately building in excellent condition, with several domelike protrusions. The front, facing the square, has a veranda, which is supported on the outside by slender wooden pillars. Under the main entrance, the king gives an audience [sitting] on his stately throne. (Ramsay 1905, 273, my translation)

Most later reports on the palace are similar to Ramsay's account. All authors mention the

wide, clean streets leading to the palace, the monumental size of the palace district, and the unusual and splendid palm-rib architecture of the palace buildings.[3] The photographs provide more varied information than the written accounts. They attest to King Njoya's continual striving to make the palace more impressive and to create material manifestations of his power and wealth.

The palace Ramsay photographed and described dated to the 1860s, when King Nsangu, Njoya's father, began to construct this residence on the ruins of King Mbuembue's smaller palace.[4] The palace grounds covered over seventy thousand square meters. It included four distinct areas. Three of the areas formed a rectangle

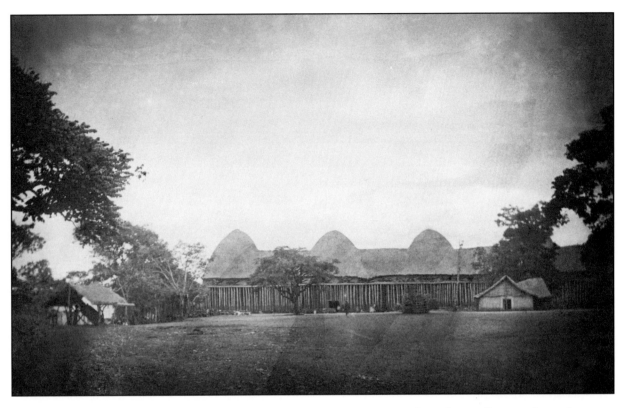

FIG. 35. *The palace and the large marketplace in front of it.* **Far left,** *a large slit gong is under a shelter. (Photograph by Hans von Ramsay, 1902)*

of about 300 by 150 meters: a central core of houses and courtyards fenced with high walls connecting the houses, rows of women's houses lining two sides of the central core (fig. 36), and a large dancing field in front of the main entrance of the central core. The fourth area of the palace grounds was a forested valley below the palace buildings. It was the location of granaries containing food supplies for the palace inhabitants. During Njoya's reign, two to three thousand people lived in the palace area or attended to it on a regular basis. There were about twelve hundred royal wives, who bore Njoya 350 children, and some two thousand male and female servants. Not all of them, of course, resided or worked in the palace district all the time (Tar-

dits 1985, 69).

The core of Nsangu's palace, which later became Njoya's residence, was situated on a hillside and divided into an upper section and a lower section. "Upper" and "lower" indicated more than the altitude of the terrain. They signified public and private spaces, although the distinction was not clear-cut. The public could enter the upper section, which ended at the royal audience courtyard, or *liimu*. Sometimes the public area extended into the lower section. Most of the time, however, only palace occupants and a few selected outsiders had access to the area below the audience courtyard, where all of the private spaces were located. The secret societies of the princes and the retainers, as well

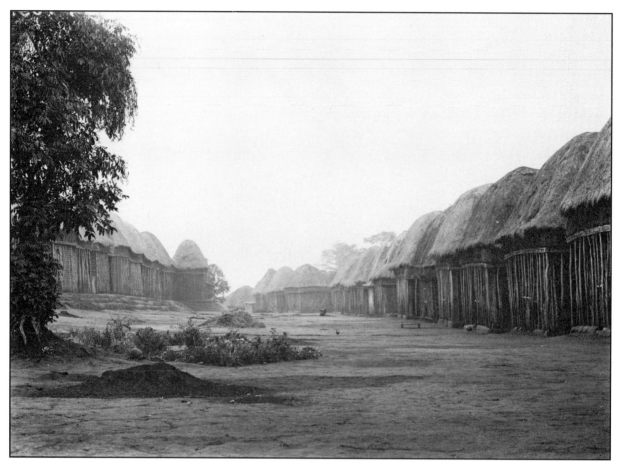

FIG. 36. **Left,** *the palace;* right, *houses of the royal wives.* (*Photograph by Rudolf Oldenburg, c. 1910*)

as other societies, had their meetinghouses in the lower section. Several buildings contained royal treasures, such as garments, masks for the royal masquerades, tobacco pipes, and other paraphernalia. The king lived in the lower section, spending time with his wives and his trusted servants. He fulfilled ritual duties in the "house of the land," the most sacred place in the Bamum Kingdom, which was located in the heart of the lower section. A permanent sacred fire burned there, and two of the eldest royal wives guarded the skulls of the king's ancestors and the bags containing the ancestors' drinking horns. The remains of the kings were buried in a royal graveyard, also in the lower section of the palace.

When Captain Hans Hutter visited Fumban in June 1905, he reported that this palace, although still very impressive, looked somewhat dilapidated and that King Njoya was to move into a just-completed residence, built in the traditional style, some fifteen minutes walking distance from the old buildings. The dimensions of the front of the new palace, according to Hutter, were not as imposing as those of the old one. Hutter found the interior of the new palace remarkable, however, and praised the large reception hall, the first room a person entered.

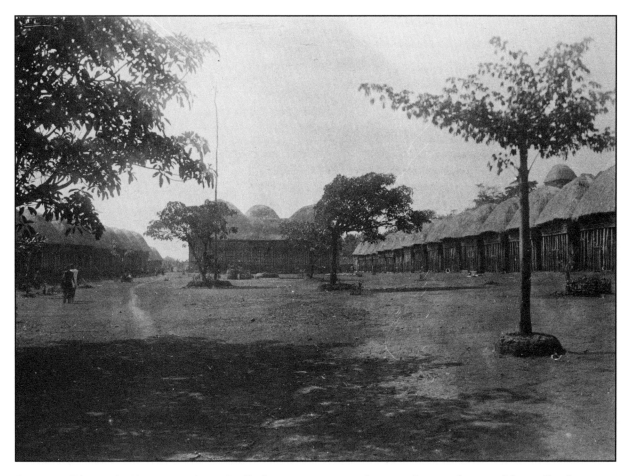

FIG. 37. *King Njoya's new palace. Built between 1904 and 1905, it was destroyed by a fire in 1909. Rows of houses for servants border a large courtyard. (Photograph by Martin Göhring, November 1905)*

Abundant wall decorations included decorative weapons, numerous splendid saddles, harnesses, saddle blankets, whips, riding boots, sandals, elephant tusks, calabashes, dishes, and bags of various kinds. The centerpiece of this hall was the beaded two-figure throne of King Nsangu (Hutter 1907, 32).

A few months later, in November 1905, a group of Basel missionaries, Karl Friedrich Stolz, Friedrich Wilhelm Lutz, H. Leimbacher, and Martin Göhring, spent three days in Bamum. They hoped that King Njoya would agree to the opening of a mission station in Fumban. Göhring, an avid photographer, took several photographs while there (figs. 13, 37, 56).[5] The missionaries' observations corroborate Hutter's report about Njoya's move to a new residence (Lutz 1906, 34–42; Stolz 1906b). In those years, the old palace was the residence of some of the king's wives and Queen Mother Njapndunke, who lived in an impressive house (Baumann and Vajda 1959, 280; Geary and Njoya 1985, 96). Göhring's photograph depicting the new building is correctly identified as "Njoya's palace" in the records of the Basel Mission Archive (fig. 37). None of those who saw this photograph in present-day Fumban remembered the existence of such a building—

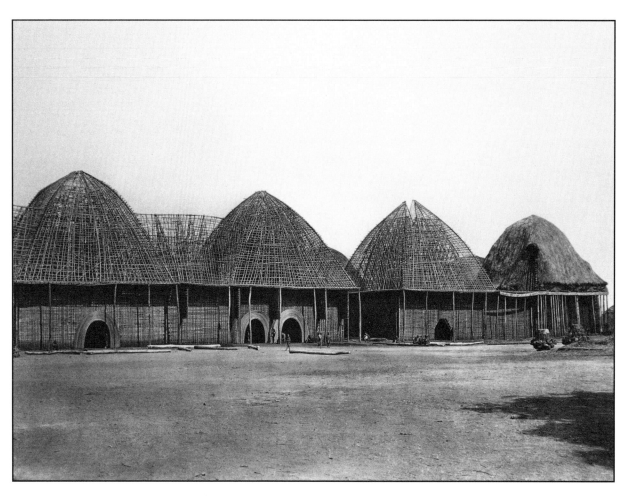

FIG. 38. *Renovation of the palace. The framework is constructed from raffia-stem panels. Rounded doorways replaced the rectangular doorways seen in earlier photographs.* **Far right,** *the leather membrane of a royal drum is stretched with heavy stones.* (Photograph by Adolf Diehl, December 1906– January 1907)

probably because it lasted only about four years. According to a handwritten note on the cardboard-mounted photograph, this palace burned down in 1909. An interesting detail of this palace is preserved in several pictures taken of King Njoya standing in front of it and displaying the throne of his father (fig. 56; Geary and Njoya 1985, 33). The slender pillars supporting the grass roof were finely decorated with alternating light and dark sections.

This new palace was only one of several palaces and royal compounds that Njoya constructed over the years. From buildings that combined elements of Bamum, Islamic, and German colonial architecture to European-style buildings, he never stopped making architectural statements about his power, his delight in innovation, and his creative abilities (Geary and Njoya 1985, 70–71). About 1906, besides having embarked on an ambitious building program, Njoya decided to renovate and embellish Nsangu's palace. The process was never recorded

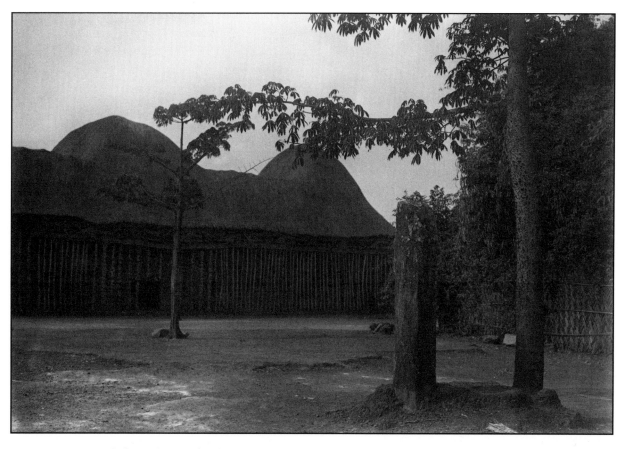

FIG. 39. *Front of the palace. The figurative pillars were commissioned by King Njoya in 1911. Right, a monolith marks the grave of a king of the Mben, a people who lived in the region before the Bamum. (Photograph by Marie-Pauline Thorbecke, January 1912)*

in writing by the Germans in Bamum. Some photographs, however, show the reconstruction of the façade (fig. 38). The rounded doorways, a rather unusual detail, are the most notable feature in these images (see the older types of rectangular doorways in fig. 20). According to the diary of Bernhard Ankermann, King Njoya had been inspired to construct such doorways by a picture he had seen in an illustrated magazine (Baumann and Vajda 1959, 281). In photographs Ankermann took upon his arrival in Fumban in April 1908, the renovation of the palace was already completed, which dates the renovation to 1906 or 1907.[6] It should be noted

that the doorways became rectangular again in 1912, illustrating the continual transformations of the old palace (fig. 54).

In January 1912 Marie-Pauline and Franz Thorbecke found Nsangu's palace to be a masterwork of African artistry (fig. 39). Marie-Pauline Thorbecke took several fine photographs of the palace façade. The façade also served as a backdrop for some of her exquisite images of King Njoya and the queen mother (figs. 24, 68, frontispiece). Her description is one of the best contemporary accounts of the palace.

In those instances in which the Bamum have combined their skills in building and their

art in woodcarving, as in the case of the chief's palace, a magnificent, beautiful building has resulted. It may have a length of 100 hundred meters and a width of 70 meters, and it consists of a large number of very high, square Bamum houses built together in a close complex. At the outside walls of the palace, the houses stand in long, straight rows, always connected with saddlelike bridges between the dome-shaped roofs. A long gallery of white wooden columns supporting the roof encircles them [the outside walls] here, too. Many of them are carved, always with human figures, one standing on the head of the other. They always represent men and women alternating; the motif of the pregnant woman is especially popular here, too, like in so many other Negro representations, and it is stylized in a peculiar, touchingly naive way. From time to time, the chief has some of the smooth columns replaced with new carved ones; he intends to decorate all of the palace with carvings. The frieze shows the ancient, always recurring lizard motif.

In the interior of the palace, high, dimly lit, almost empty rooms, in which there are at least a few beds, pots, drums, and weapons, alternate with narrow, pitch dark passageways and wide, airy courtyards. The honor court of the chief, in which he receives visitors or sits in court . . . , is reminiscent of our cloisters in a monastery, with the wide, shady passageway marked toward the side of the courtyard by decorated columns carved from wood, with a semicircular domed building whose columns are double as high as the others and which juts out at one of the shorter sides, and with the bright, sunny courtyard in the middle. In it, between the shiny green trees and low shrubs, stand gray stelelike gravestones of the ancestors. (F. Thorbecke 1914, 17, my translation)

Thorbecke's photograph of the palace front shows that numerous plain pillars had been replaced with carved ones (fig. 39). According to oral testimony recently collected in Fumban, King Njoya employed carvers from nearby areas of the Grassfields and several Bamum carvers to sculpt these columns. As Thorbecke reported, the frieze made from grass displays a lizard motif.[7] To the right stands a monolith, erected by the previous inhabitants of the area, the Mben, as the grave marker of their last king (Baumann and Vajda 1959, 280; Tardits 1980, 576).

Photographs taken inside the palace are less frequent. In 1907 Rudolf Oldenburg photographed what appear to be palace houses on a hillside, although it is not known exactly where they were located (fig. 40).[8] The houses have atypical rounded roofs but display the familiar meandering configuration of the Bamum serpent icon on their friezes. This image bewildered elderly Bamum in present-day Fumban. They considered the grass roofs so uncharacteristic of Bamum architecture that they thought the picture showed a Bamileke palace. Because Bamum palace architecture and architecture in general has undergone dramatic changes over the last few decades, the use of photographs as mnemonic devices to identify past forms at times proved problematical, clearly demonstrating the limits of this method.[9]

After 1911 the royal audience courtyard—the interior courtyard dividing the public and private sections of the palace—was the most frequently photographed area inside the palace. King Njoya spent much of his day there receiving his servants, his wives, and foreign visitors.

FIG. 40. *Buildings in the palace compound. These are probably houses for royal servants and,* center, *a large meetinghouse. (Photograph by Rudolf Oldenburg, c. 1908)*

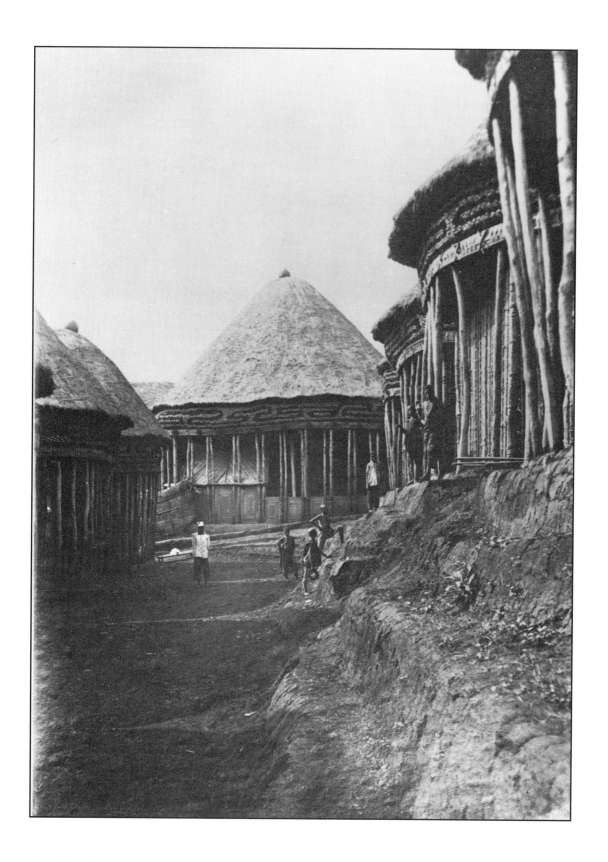

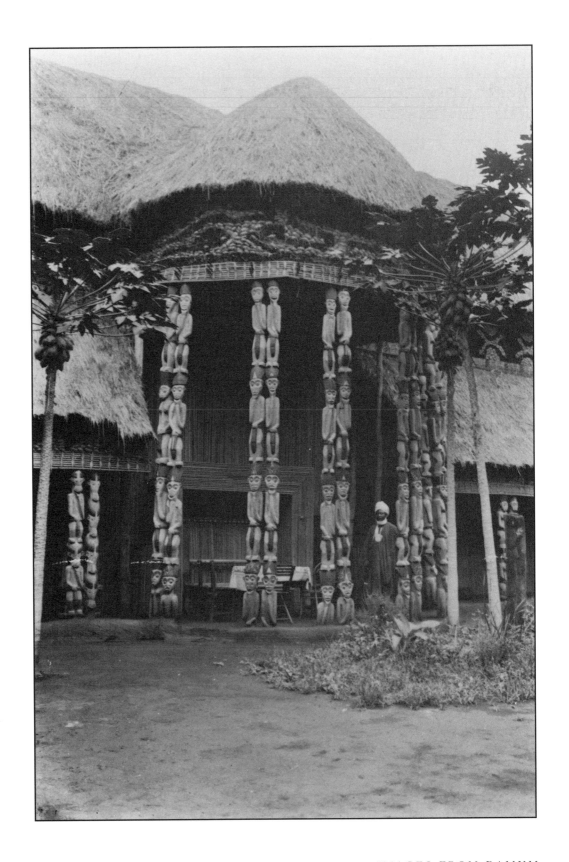

FIG. 42. *Entrance to a woman's house in Fumban.* Lower left, *side of a wooden bed carved with a stylized frog motif.* Right, *a collection of gourds. The finely incised round bowls were probably imported from the Adamawa region. The gourd containers were made locally.* (Photograph by Bernhard Ankermann, April–May 1908)

FIG. 41. *King Njoya in the audience courtyard of the palace. He stands in the roofed area where he received visitors.* (Photograph by Rudolf Oldenburg, c. 1912)

Many photographs of the audience courtyard show either the arcades under which the courtiers and other Bamum sat (Geary and Njoya 1985, 64) or Njoya's sitting area under a dome-shaped semicircular building. Oldenburg took perhaps the most compelling photograph of the king's sitting area (fig. 41). It depicts King Njoya standing next to European-style chairs and a table with a tablecloth. Double pillars with slender, angular male and female figures in high-status headdresses and loincloths support the high grass roof. A frieze above the pillars displays a serpent motif. On the left are shorter columns with unusual forms representing two masqueraders with buffalo masks to the left and buffalo heads to the right. In the center of the courtyard, papaya trees[10] surround the stone setting referred to by Thorbecke as gravestones of previous kings, an interpretation that cannot be substantiated. Tardits mentions that the courtyard was also the site of a sacred banana tree, the banana of the gods, giving ritual significance to this area where the king held court (Tardits 1980, 581). After 1912 several portraits of King Njoya, his wives, and his children were taken in the audience courtyard (fig. 45). This courtyard was destroyed on July 8, 1913, when most of the palace burned down (Rein-Wuhrmann 1925, 71). Although Njoya partly rebuilt the palace in later years, the palace fell into decay after 1917 because the king had constructed a new residence. He lived in the new palace until 1931, when the French sent him into exile in Yaoundé.[11]

The palace constructed after 1917, still standing today, is a remarkable structure. It is built from mud bricks and has elaborate relief carvings on doors, windows, and banisters (fig. 88, p. 152). When building it, King Njoya synthesized elements of German colonial architecture that he had seen on the Cameroon coast, Islamic architecture, and Bamum art into a

grand and unique design. At one point, the French colonial administration wanted to have the palace torn down, deeming it structurally unsound. The protest of many Bamum made the French abandon their plan. The three-story building was recently renovated and now serves as the Bamum Palace Museum. Part of it has been set aside as the residence Sultan Seidou Njimoluh Njoya.

Although the images of the palaces in Fumban demonstrate the documentary value of photographs, they also demonstrate the limitations of early photography. The interests and the visions of the foreign photographers shaped the

record. The striving for confirmation of exotic stereotypes and the infatuation with the Bamum court prevented them from capturing certain themes, such as the lives of ordinary Bamum. Additionally, even if photographs on one topic abound, they often focus on a narrow facet of it. The photographs of Bamum palaces are such an example. Pictures of interior courtyards other than the audience courtyard are rare. Furthermore, there are no interior shots of houses, reflecting the technical limitations of photography at that time. Photographers were still unable to photograph inside dark rooms or under the dim lighting conditions in the narrow palace courtyards. The only such effort known is Ankermann's picture of a doorway leading into a Bamum house (fig. 42). Even though the image did not come out well, it has great historical and documentary value. It shows the side of a bed, which is finely carved with a frog motif, and a woman's collection of gourds in various shapes, some of them beautifully incised, hanging on a wall made from raffia ribs. It permits insights into the aesthetic choices a woman made in creating her domestic environment.

The photographic record also reflects the relationship King Njoya had with the Germans. Njoya had advised the Bamum to "leave the matters with the whites to him" (*Histoire* 1952, 43). His strategy when meeting with Germans is a recurrent theme in all written accounts. Njoya was a perfect host and diplomat; at the same time, he protected the palace from unwanted intrusion. Visual and written texts about the palace are therefore testimonies of outsiders merely catching glimpses of the reality

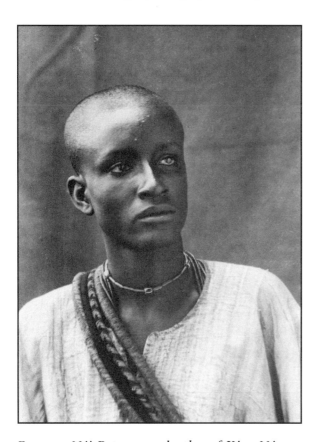

FIG. 43. *Nji Pepuore, a brother of King Njoya. This anthropological photograph is simply captioned "man" in the archival records.* (*Photograph by Bernhard Ankermann, April–May 1908*)

FIG. 44. *Nji Pepuore and his wife, Christina. This image was later embellished with a decorative frame (see fig. 8).* (*Photograph by Anna Wuhrmann, c. 1914*)

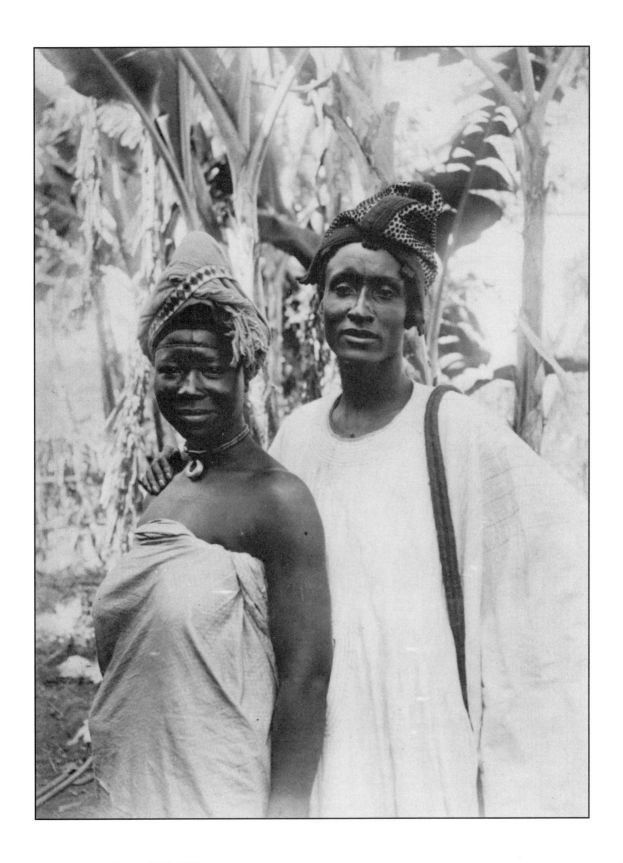

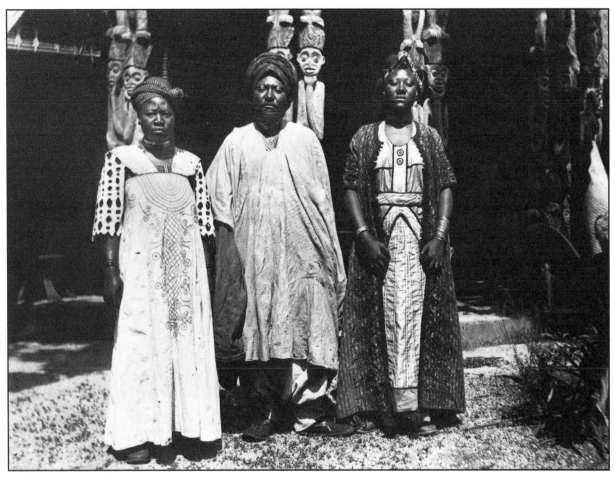

FIG. 45. **Left to right:** *Nji Mongu Ngutane, King Njoya's firstborn daughter; King Njoya; Shimenkpu, Ngutane's mother. They stand in the audience courtyard of the palace.* (*Photograph by Eugen Schwarz, c. 1912*)

of life there.

Because Njoya alone dealt with the foreigners in Fumban, most German visits followed a pattern. Njoya initially either met the visitors on their way into Fumban or received them in front of the palace. The visitors then retired to the well-appointed German rest house (fig. 27). After sending them food, Njoya paid them a visit and later invited them to the palace. When the visitors arrived at the palace, Njoya was gracious but let them see only those parts of the palace he wanted them to see. He enjoyed show-

ing his inventions, such as a mechanical corn mill, ink wells, brass fountain pens cast by his artists, and, in later years, a printing press for the Bamum script, which unfortunately never functioned. In 1912 he built a European-style house for himself in the back of the old palace, a showpiece he proudly displayed to visitors (M. P. Thorbecke 1914, 51–52). Most visitors were entertained with equestrian displays or masquerades.

To most official visitors and researchers passing through Fumban, the life of the royals and

the servant nobility in the palace remained hidden and incomprehensible. For researchers like Ankermann and the Thorbeckes, the powerful persona of Njoya was enthralling. The splendor of Bamum art and architecture and the refined craft techniques also drew their attention. In his diary, for example, Ankermann provides only a cursory description of birth, marriage, political organization, warfare, the calendar, religion, and astronomy. He attributes almost all of his information to Njoya, who obviously served as his main source (Baumann and Vajda 1959, 288–91). Bamum nobles, men and women, remain anonymous in texts and photographs, whether they are pictured with Njoya as soldiers in impressive uniforms or as humble servants surrounding the king (fig. 23).

Ankermann took systematic racial-type photographs of palace inhabitants, placing them in front of the obligatory blanket (fig. 43). Occasionally, familiar faces appear in the detached series of frontal and profile views. The man in figure 43 is Nji Pepuore, a brother of the king, who had become a Christian and had been baptized Paulo. He is the same young man who appears in the wedding photograph that was embellished in Basel (fig. 8) and was published by Wuhrmann in 1931 (fig. 44).[12] Similar to Ankermann's anthropological series on nobles, many of Oldenburg's images, such as one captioned "Bamum with horse," are stereotypical depictions (fig. 33). In figure 33, Oldenburg alludes to preconceived notions of wealth and exotic beauty. Nji Montien, another brother of King Njoya, is portrayed posing elegantly with his spears and horse. He is elaborately dressed in Hausa clothes with amulets sewn to them.

The missionaries had an uneasy relationship with the inhabitants of the palace and the royals. They concentrated their efforts at conversion on the children of King Njoya, because neither the royal wives nor the nobles seemed to be easy

converts. Some of the younger royals, wives, and noble servants did become Christians, although the core of high-ranking retainers, and of course the king himself, did not accept the new faith. Photographs by missionaries Martin Göhring and Eugen Schwarz focus on these converts and their families.

Since the missionaries considered the conversion of important members of the royal family to be the key to their success, they devoted their attention to several royals. Among the most prominent converts was Nji Mongu Ngutane,[13] the eldest titled daughter of Njoya, who became a student at the mission school in 1906 at the age of seven. She was baptized and received the Christian name Margarethe. Ngutane is seen growing up in the missionary photographs. Eugen Schwarz photographed her with her mother, Shimenkpu, and her father standing in the audience courtyard in 1912 (fig. 45). To the great disappointment of the missionaries, she married a non-Christian many years her senior in 1914. Wuhrmann photographed Ngutane's wedding, as well as the weddings of some of Ngutane's sisters (Geary, forthcoming). Only weeks before the missionaries were to leave in December 1915 as a result of the British taking Fumban in the First World War, she portrayed Ngutane tenderly holding her newborn baby, Amidu Munde (fig. 7).

The Basel missionaries approached the royal wives with two conflicting perceptions. On the one hand, they saw the wives as traditionalists who opposed the progress and enlightenment that the Christian faith would bring. According to this view, they were vain, lazy people who commanded their slaves about. "The incredible vanity and indolence that marks the chief's wives, and even the baptized ones are no exception, suffocates any higher interests they might have," wrote missionary Christoph Geprägs in 1912. Perhaps the lack of conversions among

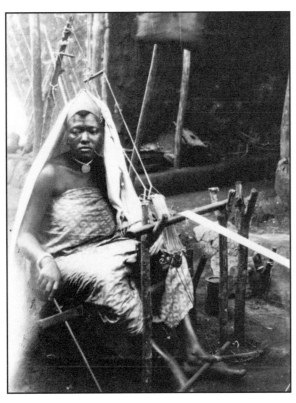

FIG. 46. *Njapndunke Nayi, a royal wife, weaving on a treadle loom. King Njoya introduced this loom to Bamum and had Hausa specialists instruct his wives in its use. In other areas of West Africa, this type of loom is only used by men. The last of Njoya's wives who knew how to weave on a treadle loom died in 1986. (Photograph by Anna Wuhrmann, c. 1912)*

the royal wives brought about this disillusioned remark. Six years after the missionaries began their work in Fumban, only 30 royal wives were among the 245 parish members (Geprägs 1912). On the other hand, some missionaries saw them as unfortunate women who were forced to marry the king and became captives in the palace. The main proponent of this view was Anna Wuhrmann, who had come to know some of the royal wives through her female students and her frequent visits to the palace.[14]

The sphere of the royal women remained mysterious to most visitors who came to Fumban. All men, Bamum and foreign, were forbidden to enter the women's residential quarters. Elsewhere in the palace, the royal wives had to avoid any contact with foreign men (Rein-Wuhrmann 1931, 36). The few images showing royal wives and princesses relaxing in front of their houses or doing chores were taken by the two women photographers in Fumban, Marie-Pauline Thorbecke and Anna Wuhrmann. If casual visitors captured royal wives in photographs, they usually were in group portraits with King Njoya, almost as if they were decoration enhancing the king (fig. 34).

Many of Wuhrmann's photographs show royal women, among them two noblewomen engaging in textile production (figs. 46–47). The women in figures 46 and 47 are using techniques that were new to the kingdom at the time. Figure 46 is fascinating because it is the only image showing a woman using a Hausa treadle loom, which in other parts of West Africa was used only by men. According to recent oral testimony in Fumban, King Njoya convinced some of his wives to learn how to weave. He asked Hausa instructors to teach the wives how to use the treadle loom. Until recently, several old widows of King Njoya in the Bamum palace still wove in this fashion (Geary 1983b, 150, fig. 87). Another innovation is pictured in figure 47. The wives of the Basel missionaries instructed Bamum women in sewing and knitting. They also introduced the spinning wheel to Fumban.

FIG. 47. *Woman with a spinning wheel. Missionary women instructed girls in spinning, knitting, and sewing at school. Bamum women were taught in Christian women's groups. (Photograph by Anna Wuhrmann, c. 1912)*

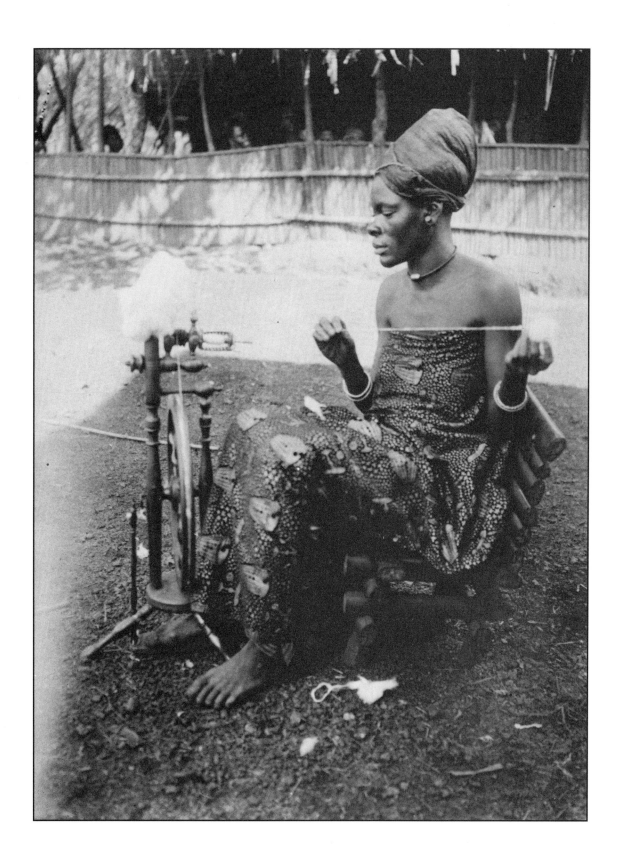

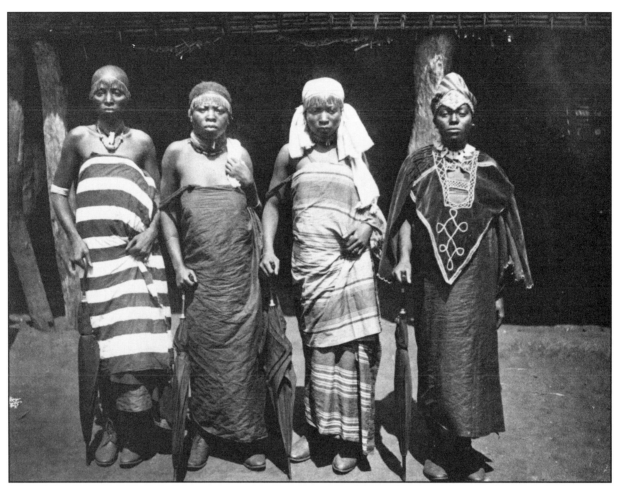

FIG. 48. *Four of King Njoya's wives. Umbrellas and leather shoes were prestigious imports that only the Bamum elite could afford. (Photograph by Adolf Diehl, c. 1906)*

The distance between most visitors and the elite women finds its visual manifestation in Adolf Diehl's early image of four royal wives, taken inside one of the palace courtyards (fig. 48).[15] The women, with anxious expressions on their faces, display new high-status paraphernalia: umbrellas and European-made shoes. Such items could be bought at the Fumban store of the trading concession Gesellschaft Nordwest-Kamerun. The photograph demonstrates the use of attire to express status, the creative ways different elements of dress were combined, and the abundance of cloth available to the elite in Fumban, from African weaves to European velvet, the most cherished material among all European cloth.[16]

Although King Njoya had a large number of wives, his polygamy did not give rise to harem fantasies, which were common in Europe at the time. Such fantasies were noticeably expressed, for example, in imagery of North Africa (Alloula 1986). The Bamum myth—the representation of the enlightened King Njoya—did not lend itself to the inclusion of harem imagery. Furthermore, although polygamy was commonly viewed as an immoral practice that needed to be abolished, German government officials interpreted it in Bamum as an economic necessity and believed that the introduction of monogamous marriage was premature.[17] Women were the primary producers of wealth in the kingdom; they were needed to farm the land and raise the children. Even the missionaries hardly touch on the subject, as if trying to maintain their perception that King Njoya, while not quite a Christian, led a moral life. The only author mentioning the word *harem* in connection with King Njoya is Marie-Pauline Thorbecke, and even then it occurs only in a heading for a one-page discussion. In her text, she does not make a moral judgment, as her contemporaries would have done.

Of these many hundred wives Njoya possesses—he himself gives their number as 450, but I am convinced that there are even more—mostly 20 to 30 stay in the chief's palace, while the other's stay in the women's quarters. The domestic mode of life of this black potentate is demonstrated by the furniture in his bedroom, which he proudly showed to us. Besides two mighty iron tropical beds, whose poles for the mosquito nets have been hung with Bamum emblems, two cots also stand there for two female companions. (M. P. Thorbecke 1914, 52, my translation)

Queen Mother Njapndunke, also referred to as *nafon*, "mother of the king," or *na* by the Bamum, was the only royal woman whom foreigners regularly met without the king being present. She came closest to playing the role of the villain in the Bamum myth. The Germans perceived Njapndunke as a strong woman and a traditionalist who at times influenced her son against what the Germans saw as progress. Lieutenant Sandrock mentions Njapndunke in his first report about Bamum, but he mistakes her for Njoya's "smart, tactful and remarkable sister Yandong, who was obviously strong-minded and participated in governing" (Sandrock 1902). Written accounts about Njapndunke often refer to her considerable political influence, contradicting the stereotypical view of African women as essentially powerless and without influence. Her youthful looks, her large size, and her use of a palanquin are also mentioned frequently. All of these descriptive elements are included in Hutter's report of his first encounter with Njapndunke in 1905.

In [Njoya's] absence, his mother assumes the representational duties; and I must say the reception she prepared for me in Bamum—[Njoya] was not present on the day of my entry into the capital city—was dignified

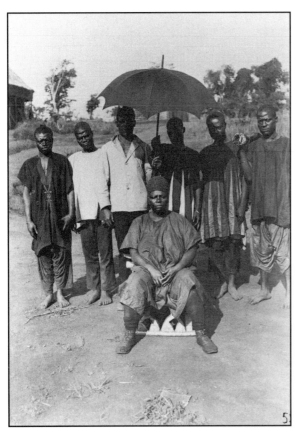

FIG. 49. *Queen Mother Njapndunke sitting on a carved stool. She wears men's clothes and German-made leather shoes.* Far right, *a servant holds a fly whisk with a beaded handle.* (*Photograph by Adolf Diehl, c. 1906*)

features, coifed with hair combed up high in the style of Fulbe women. To her right stood giant slaves with parasols and ostrich feather fans on a long pole. Two large live eagles or vultures that were chained to the foot of the throne, one on either side, fluttered about hissing and beating their wings. The court entourage of several hundred men armed with spears and bows, almost all of them in Hausa costume, glittering from necklaces and wide armbands, stood several rows deep around her in a wide semicircle. (Hutter 1907, 28, translated in Geary 1983b, 60–61)

Hutter goes on to note Njapndunke's "enormous girth," and remarks that "she can walk only a few steps at a time and for longer walks employs six sturdy slaves to carry her on a kind of litter which she . . . rides straddled in a sitting position."[18]

Colonial photographs of Njapndunke, like those of King Njoya, present a conventional image. The creation of this image resulted from a process in which both the photographer and the photographic subject were actively involved. Like her son, Njapndunke carefully chose how to present herself, visually indicating that she had the privileges of a king. In all photographs showing her seated, she takes a stately Bamum pose. Her legs apart and her hands folded in her lap, she looks straight at the camera. As a result, these images project massiveness and balance. Figure 49, taken by Adolf Diehl, indicates Njapndunke's extraordinary status. As usual, she wears men's clothing: a wide embroidered Hausa robe (a garment foreigners often mistook for a woman's dress), European trousers and shoes, and a finely embroidered cap. She sits on a type of seat reserved for a king and is surrounded by male retainers. One retainer holds an umbrella, a cherished possession among palace women.

and impressive. . . . As I galloped around the corner, a picturesque, representative sight appeared before my eyes. To the right lay the huge open main square, to the left the almost 100 meter long front of the palace. . . . In the middle of which, under high wooden posts that formed an arcadelike passage in front of the residence . . . , before a high entrance portal sat the queen mother on a throne. . . . She was dressed in a long billowing white robe made of a dark blue and white indigo fabric trimmed with brocade and velvet. A cotton cap covered the little head with the youthfully fine

The use of dress in the articulation of rank and the projection of self becomes apparent in several missionary reports about Njapndunke's desire for particular types of clothing. Margaretha Göhring, the wife of the head of the Bamum missionary compound, reported about the clothes she had made for the queen mother.

The queen mother and I have become good friends. Often she has herself carried up our mountain on a litter supported by 10 strong men, because she is too heavy to walk. . . . Last Sunday she came already at 8 in the morning with a large entourage and brought me . . . an elephant tusk weighing 5 1/2 kilograms because I had made and presented her with 2 dresses and 3 shirts. When we arrived here [in Fumban], she was wearing a really peculiar dress, according to Hausa fashion, that only reached her knees and had no sleeves. I told her that I would like to make her long dresses similar to mine. First she did not want it. But when I had made her one, and it fit well, she was thrilled about it, and now she wants more such dresses. . . . She had bought a pair of men's swim trunks from a merchant and now wished that I should make her more such trousers. I told her that these were men's trousers and not for ladies; actually, I said, she did not need trousers at all, because it is so warm in Bamum. This did not go over well. . . . If she wants something, one cannot discourage her. Or if one does not let her have her own way, she can be easily offended. I have now made her a pair of trousers, and she judged them . . . as very beautiful. (Margaretha Göhring 1906, 20–21, my translation)

Besides photographing Njapndunke in poses of power and determination, foreigners often accentuated her beautiful face in close-up im-

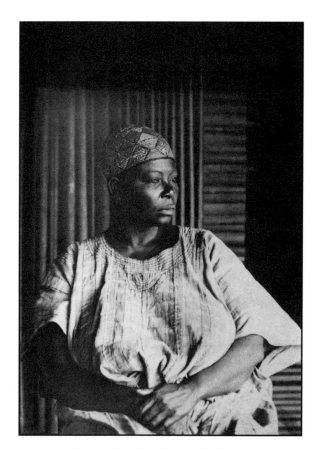

FIG. 50. *Queen Mother Njapndunke.* (*Photograph by Bernhard Ankermann, April–May 1908*)

ages (fig. 3). Bernhard Ankermann took two photographs of her inside the palace on one occasion in 1908 (fig. 50). The first shows Njapndunke seated in her typical masculine pose. The second, figure 50, is a study of a pensive, patient queen mother. The photograph was obviously meant to be a portrait; it is quite unlike the other racial-type photographs Ankermann took of men and women at the court. The softly out-of-focus raffia wall and doorway replace the standard background blanket. The caption "The Nafon" gives the person in the photograph an identity and thus indicates her status in Bamum.

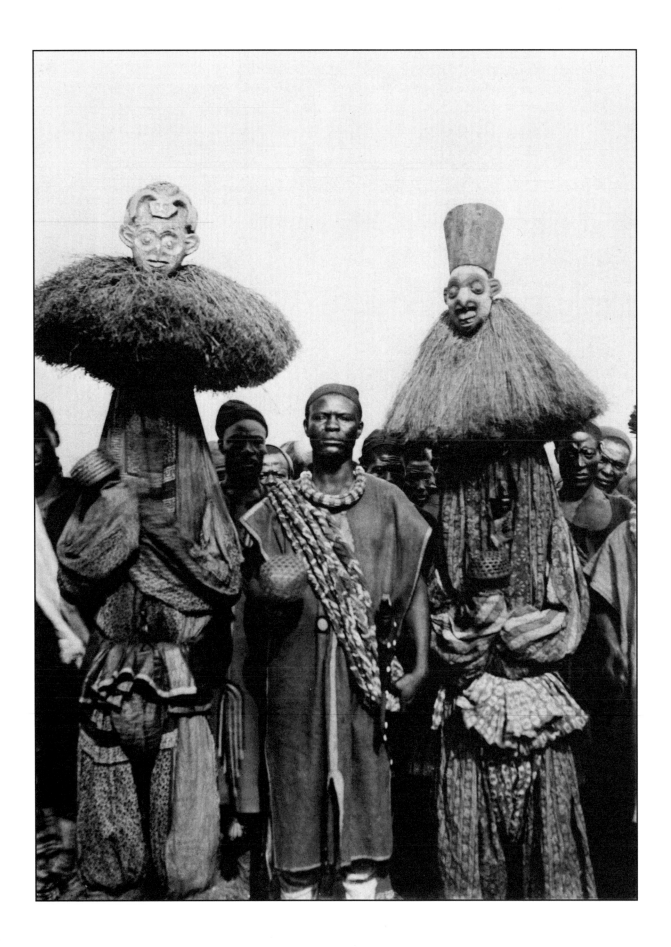

Art and Ritual Recorded
Using Photographs in Research

AT THE TURN OF the century, the major ethnographic museums in the German Empire began expanding their holdings. The development of systematic collections was closely linked with scientific emphases in cultural anthropology and with the colonial experience. In a 1914 publication, Bernhard Ankermann presented the scholarly rationale for ethnographic collecting, describing the task of cultural anthropology as the exploration of the culture of "primitive people." The term *culture* was to be broadly understood as all of the material and intellectual products that humankind had created during its thousands of years of evolution. He called for the collection of everything other peoples had made and used themselves, which, of course, excluded goods imported from Europe. He encouraged systematic, exhaustive collecting to give a complete representation of a

"tribe" and discouraged the mere acquisition of showpieces. According to Ankermann, "[Show-pieces] are, naturally, highly desirable for the museums because they demonstrate the level of artistry to which a particular people has risen. But from a scholarly point of view, it is equally important to compile all pieces typical of the same [people]. One must, so to speak, compile an inventory of their complete cultural possessions" (Ankermann 1914, 8–9, my translation). Ankermann followed these principles during his own research in the Grassfields. He brought back 1,518 objects, including clay pots, sculpture, elaborate brasscastings, and wooden dishes (fig. 52).[1] Museums remained most interested, however, in collecting splendid showpieces that, removed from their time and place of origin, would please museum visitors.

The scholarly view of the world as both a laboratory for anthropological and ethnographic study and a vast repository of materials to be collected in the pursuit of knowledge coincided with the beginning of the era of European colonialism. The acquisition of colonial territory facilitated the acquisition of artifacts with which to build large collections. In the Cameroon Grassfields, a constant flow of collectors visited

FIG. 51. Moafonyam *masqueraders during the wedding of Nji Mongu Ngutane. Both crests represent royal women. The masquerade was associated with female beauty, wealth, and royal privilege. (Photograph by Anna Wuhrmann, 1914)*

those chiefdoms known for prolific carving, brasscasting, pottery, and textile traditions. Military collectors and merchants roamed the area, and even missionaries at times participated in collecting.[2] Military collectors in particular were rewarded for their support of museums, receiving commendations and sometimes medals.

Collecting took many forms, ranging from accepting gifts given graciously by Africans to purchasing objects to looting during military campaigns. In all its forms, the systematic collection of objects in the Grassfields and elsewhere was an expression of imperial domination; the colonial powers were, quite literally, appropriating the world.

Some objects became highly charged symbols of colonial success. They were tangible proof that their creators had been subjugated and were now part of the colonial empire. Most appreciated were intricate objects made from expensive materials, such as beaded figures and thrones from the Cameroon Grassfields. The large German ethnographic museums opened galleries filled with colonial acquisitions. Art from Bamum, including large beaded thrones and stools and precious brasscastings, was particularly sought after. Bamum art became an integral part of colonial propaganda because it was understood as the tangible manifestation of the Bamum myth.

Both the scholarly interest in Bamum art and the meaning of Bamum art in the context of colonialism influenced the photographic record on art and ritual in Bamum. Photographs showing Bamum objects *in situ* played a major role in collecting and, consequently, in turning art objects into commodities. Photography often stood at the beginning of the business process. Collectors in the colony first photographed objects, particularly if they were large, and then sent the images to a museum. Payment for the

costly transportation and the collector's services was arranged after the museum had agreed to a purchase.

Collectors were undaunted by the large size of some objects. Among the frequently photographed objects were the gigantic slit gongs found in several Grassfields chiefdoms.[3] Shipping them, however, was impossible. Although slit gongs never made it to Germany, collectors were able to send other large objects. Captain Hans Glauning, for instance, collected a war drum in Nso and had twenty-one porters carry it to the coast.

Photography was sometimes used to spy on competitors. Glauning and his caravan passed through Nssanakang near Mamfe, where his rival, the merchant Adolf Diehl, was stationed. Diehl immediately photographed the drum for the Museum für Völkerkunde Leipzig so that it would know what the Museum für Völkerkunde Berlin was receiving.[4] There was always a chance that a collector like Glauning could be pursuaded to give some of his acquisitions to another museum. Glauning remained loyal to the institution he collected for, but some other collectors were indeed lured by the highest bidder.

Diehl's correspondence with Leipzig contains interesting remarks about the commercial aspects of collecting and the role of photography. In March 1906, days before the German-Bamum military campaign against the Nso Kingdom, Diehl reached Fumban on one of his collecting trips. He reported to Leipzig about his experiences.

> The transport [of Bamum objects] will be unfortunately rather expensive—even more so since almost all people suitable as porters have been requisitioned by the troops, and [Njoya] demands unconscionable prices under these circumstances. So far I have

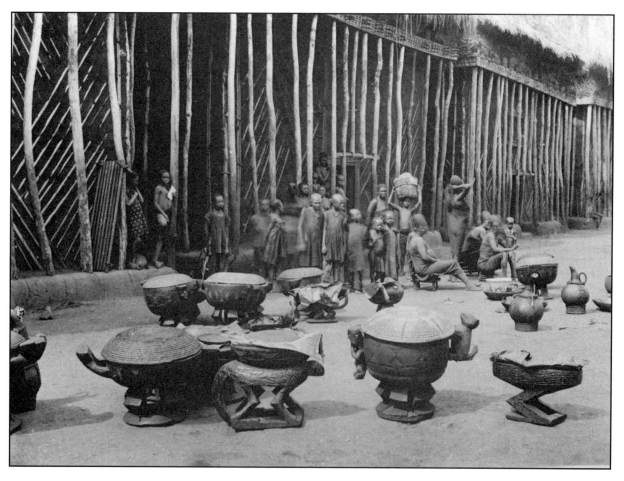

FIG. 52. *Carved wooden bowls and gourd containers in front of the royal wives' houses. They hold food and palm wine for a celebration at the palace. Many of the bowls later went to German museums.* (*Photograph by Bernhard Ankermann, April–May 1908*)

spent nearly 1,600 marks in addition—so that frankly my pleasure in collecting has been rather spoiled. . . . If one sees the splendid drums, idols, and temples, etc. it is regrettable that one does not have the means to get them. Most of these old memorials of ancient times are for sale. I content myself for now to bring you photographs and I recommend you secure some of the most beautiful [objects] as quickly as possible. Some of the splendid drums, temple figures larger than life-size, can be had for 500 to 600 marks per item.

It is, however, out of the question to transport these enormous wooden colossi to the coast via the overland routes. One would have to store them carefully until the railroad reaches Bamum or a place nearby in two or three years. Some of the most beautiful objects unfortunately have already been taken by Captain Glauning—evidently for the museum in Berlin. Captain Glauning has cut a large drum into pieces and transported it to the coast—it represents a life-size hippopotamus. (Diehl 1906b, my translation)

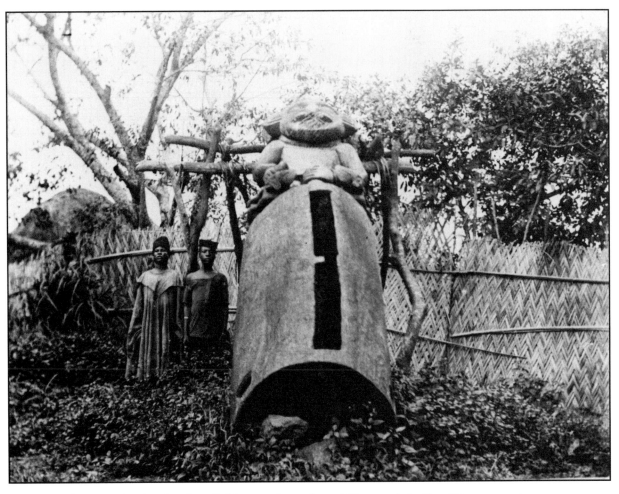

FIG. 53. *Slit gong in the dancing field near the palace.* (*Photograph by Dr. Dietze, 1903*)

Photographs such as Diehl's were taken under circumstances that are repelling by present-day ethics of collecting. Despite their original commercial purposes, however, the photographs are precious documents for art historical research because they show objects in their settings. A photograph may establish a firm provenance for an object and provide information about its use. A photograph may also help an art historian to attribute an object to a specific area or workshop.

Photographs of slit gongs provide an example of the importance of early photographs in art historical research. None of the slit gongs ever left Bamum. The railroad was never built, and contrary to Diehl's letter, King Njoya refused to sell his treasured possessions. The earliest published reports about Fumban mention several remarkable slit gongs, each with an anthropomorphic figure carved at one end. The slit gongs, whose sound carried for miles, were beaten to announce war or call the inhabitants of Fumban together for festivals or in times of need. They lay in the vast dancing field in front of the palace.[5] In 1903 Dietze photographed the gong in the best condition (fig. 53). Five years later, Ankermann made notes on eight gongs in various degrees of decay, photographing three of

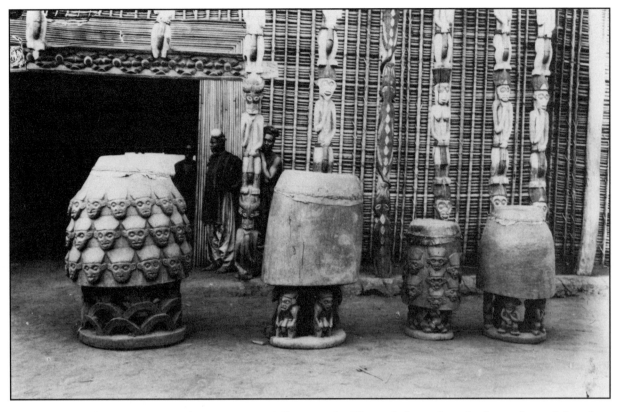

FIG. 54. *Royal drums at a palace entrance. The carved pillars of the palace depict male and female figures, masqueraders wearing buffalo masks, and zoomorphic forms that may be lizards, crocodiles, or leopards. (Photograph by Rudolf Oldenburg, c. 1912)*

them. According to his diary, three gongs ended in female figures, one in a male figure, and four others had decayed beyond recognition. He also took three views of the slit gong that Dietze had photographed five years earlier. He described it in his notes.

> Well-preserved. Male figure with very large sex organs. In the right hand a [drinking] horn; the left placed on the penis. Laterally on both legs (perpendicularly to the longitudinal direction) two little human figures. At the left wrist a number of bracelets on top of each other; at the right a thick ring. . . . Tilted (different from the others, which lie flat). (Baumann and Vajda 1959, 283, my translation)

The 1903 and 1908 images of the gong show how rapidly the carvings decayed when left to the elements. By 1908 the gong already had damage to its body. All eight gongs eventually disintegrated; the photographs therefore are all that remain. Unfortunately, none of the observers investigated the meaning of these instruments. Most likely, during the nineteenth century, a pair of slit gongs was carved whenever a new Bamum king and a queen mother came to power. The gongs, one male and one female, may even have been portrayals of the king and the queen mother (Harter 1986, 84–90). Slit gongs may have symbolized kingship. Their ultimate decay therefore paralleled the life cycle and physical demise of the king and the queen mother.

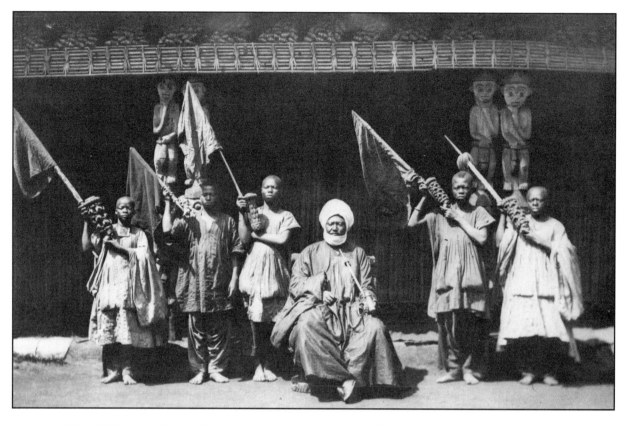

FIG. 55. *King Njoya in the audience courtyard of the palace. His young servants hold prestige pipes with ornate terra-cotta bowls. (Photograph by Rudolf Oldenburg, c. 1912)*

In 1912 Rudolf Oldenburg photographed several large drums in front of the palace, no doubt hoping to procure them for museums (fig. 54). The photograph has obvious documentary value. It demonstrates the diverse styles of one type of object, in this case drums, and the artistic elaboration and profusion of detail that were characteristic of the arts of leadership (Fraser and Cole 1972, 304–5). The most salient features of the drums are the high-relief head motif and the male caryatids. The caryatids, who place their hands either on their knees or, in a reverential gesture, on their stomachs and chins, represent retainers. Unfortunately, Oldenburg provides little information about the function and significance of each of

the drums. Several of these drums were kept at the main entrance of the palace. Beaten when the king had entered the audience courtyard each morning, they announced that the public could enter the upper section of the palace. The head motif compresses several levels of meaning into an important visual symbol of Bamum kingship and domination. The head motif alludes to warfare, the taking of heads as trophies

FIG. 56. *King Njoya and his throne in front of the palace that was built in 1905. Njoya's jacket with beaded epaulets was created by Bamum tailors. The other parts of the uniform were made in Germany. (Photograph by Martin Göhring, November 1905)*

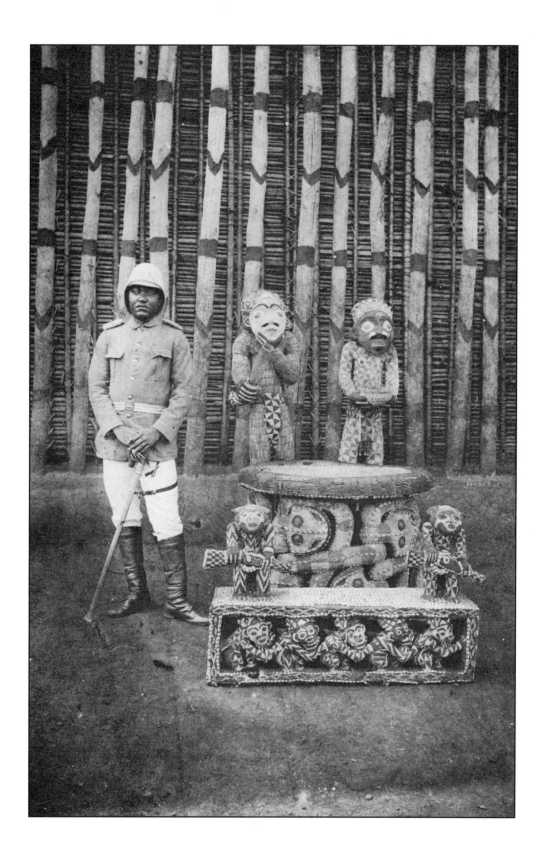

in battle, and the use of these drums as receptacles for the heads of the enemy (Labouret 1935, 121). The head motif additionally refers to the Bamum king's wealth in people, echoing the message of the multiple male figures in supporting poses.

A posed photograph that Rudolf Oldenburg took of King Njoya with several boys in the audience courtyard of the palace is a typical depiction of the noble King Njoya and his wealth that reinforced the Bamum myth. It no doubt served commercial and documentary purposes as well (fig. 55). The young retainers surrounding Njoya hold five prestige tobacco pipes with elaborate terra-cotta bowls. The pipe on the left displays an ornate open-worked headdress on top of a male head with prominent cheeks, a typical Bamum design (Geary 1983b, figs. 33, 45–47). The third boy from the left holds a pipe with a large elongated terra-cotta bowl, a common style of pipe in Bamum. Most prestige pipes of this size served as visual indicators of high rank and were only symbolically smoked on state occasions. Such pipes were displayed mainly by high-ranking servants who had been given the privilege by the king. In the picture, Njoya himself holds a small travel pipe, most likely made from brass.

If a photograph like figure 55 provides information about specific types of art objects, it may also provoke questions that at times cannot be answered. Why, for example, are the tops of the stems of all but one pipe covered with a cloth? The cloths led the Museum für Völkerkunde Leipzig to mistakenly caption the photograph "King Njoya with flag carriers." The answer may never be known. Although German museums encouraged their agents to document the context of their commercial collections in word and image according to official guidelines, detailed written documentation accompanying the images is rare (Luschan 1899). In addition,

written and visual materials have sometimes been separated from each other in archives. Subsequently, researchers often fail to take into account the connection between the two.[6]

Photographs played an important role in the German acquisition of the most famous object from Bamum: King Nsangu's two-figure throne. After Hans von Ramsay reported the beaded throne he saw during the first expedition to Fumban with First Lieutenant Sandrock, the ethnographic museums in Berlin, Leipzig, and Stuttgart discretely inquired through their representatives in Cameroon about acquiring it. In November 1902, Adolf Diehl recommended that the director of the Leipzig museum immediately contact Ramsay and secure some of the materials Ramsay had acquired in Fumban. Furthermore, Diehl informed Ramsay that he would have the Leipzig museum "hound him" until he sold some of his Bamum photographs—which Ramsay later did (Diehl 1902). Until Ramsay actually published a picture of the throne in the 1905 edition of *Globus* (fig. 20), knowledge of the throne was a well-kept trade secret among those museum directors who had heard about it. Only a few months later, the *Evangelischer Heidenbote* illustrated one of its articles with a superb image of Njoya wearing a Bamum version of a German officer's uniform and standing next to the throne (fig. 56) (Stolz 1906b, 36). Once these images were published, the museums began moving quickly to obtain the throne.

Much to the dismay of the museums, King Njoya refused to sell the throne or give it as a symbol of his loyalty to the Germans, although in 1904 he had already presented the emperor with a beautiful beaded stool.[7] Felix von Luschan, the director of the Museum für Völkerkunde Berlin, finally devised a plan. Luschan, who worked with Captain Glauning, suggested to Njoya that he order his artists to

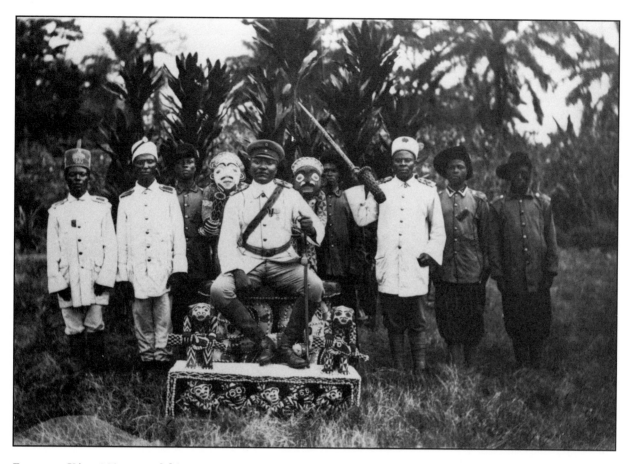

FIG. 57. *King Njoya and his servants in Buea, seat of German governor. Njoya officially presented his father's throne to the governor as a gift for Emperor Wilhelm II. (Unknown photographer, January 1908)*

make a copy of the throne. The Berlin museum would even help to procure the necessary beads (Luschan 1905). Finally, Njoya agreed and the court artists began the copy in 1907. The only permanent government representative in Bamum, a gardener stationed near Fumban named Stössel, monitored the progress of the work (Geary 1983a, 48–49). King Njoya decided to go to Buea near the coast in January 1908 to present the new throne to Governor Theodor Seitz as a gift for the emperor on his birthday. As January drew near, the throne had not yet been completed. Njoya finally decided to present the throne of King Nsangu rather

than go to Buea empty-handed (fig. 57) (Geary and Njoya 1985, 180–91). The spectacular Bamum throne and its footrest eventually went to the Museum für Völkerkunde Berlin, where it became one of the outstanding objects in the permanent exhibition. Njoya's sculptors completed the new throne over the succeeding years, and after 1911 this throne served as Njoya's state throne during official functions (figs. 23, 58, 59). The new throne is now the centerpiece of the collection in the Bamum Palace Museum (Geary 1981; Geary 1983b, 112–16).

For a time, there was confusion about which throne the Berlin museum had been given.

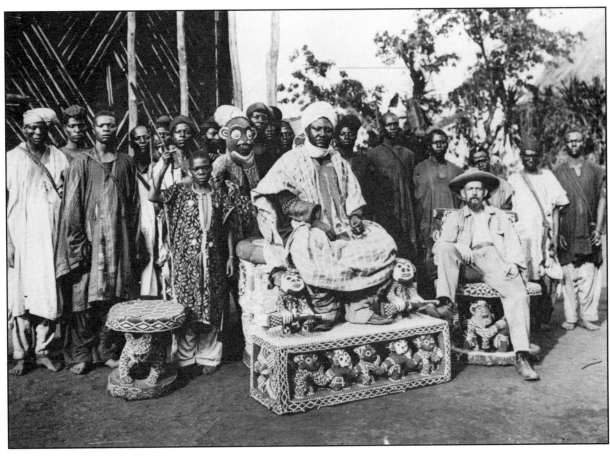

FIG. 58. *King Njoya on his new two-figure throne. Austrian merchant Rudolf Oldenburg breaches rules of Bamum etiquette by sitting on a royal chair and placing a foot on Njoya's throne. The photograph indicates that Oldenburg and King Njoya had an amicable relationship. (Photograph possibly by Helene Oldenburg, c. 1912)*

After the colonial period ended, however, many of the objects from the colonies lost their exalted meaning in Germany. Whether the museum in Berlin possessed Nsangu's throne or Njoya's newer copy became irrelevant over time. The question was forgotten once the principals in the acquisition history had died. The official Berlin catalogue entry gives no indication of the throne's complex history, and simply reads: "Throne stool (a) with step (b) of Sultan Nschoya. Bamum." The words in the throne's file are just as brief: "Present of Sultan Joya of Bamum to Emperor Wilhelm II" (Krieger 1969, 9, my translation).

The photographs that triggered the rush for the throne now can be used to reconstruct the complex story of the almost identical thrones of King Nsangu and King Njoya. A comparison of photographs of the throne used by Njoya over time confirmed the assertion of the Bamum people I spoke with that Njoya had given his father's throne to Germany. In Fumban this gracious and loyal gesture by King Njoya has not been forgotten.

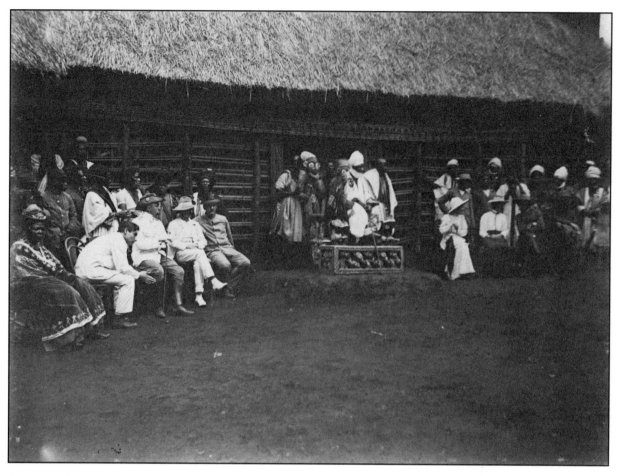

FIG. 59. *German government officials visiting King Njoya. The photograph shows a common seating arrangement for German guests. It was probably taken during a visit by Governor Karl Ebermaier in 1912. (Photograph by Eugen Schwarz, c. 1912)*

Monumental thrones and large beaded stools, the most impressive artworks created by the Bamum court artists, are called *mandu yenu,* "richness of beads" (*ma,* "large"; *ndu,* "beads"; *yenu,* "richness"). The name implies that the lavish bead cover was the salient characteristic of the thrones and stools in the eyes of the Bamum. The nineteenth-century throne in the Museum für Völkerkunde Berlin is carved from one piece of wood and measures 175 centimeters in height. It has three main components: a stool, a male figure, and a female figure. The cylindrical open-worked stool displays an intertwined double-headed serpent motif, as do many Bamum thrones. A separate footrest is 117 centimeters in length. Two warriors crouch on both sides of the footrest and hold guns against their knees. King Njoya would rest his feet on the guns when he sat on the throne (figs. 14, 23). The footrest, resembling a bench, has an open-worked front with a row of figures that look as if they are dancing. Its open-worked side panels depict a spider motif. Both stool and footrest are covered with lavish beadwork in blue, yellow,

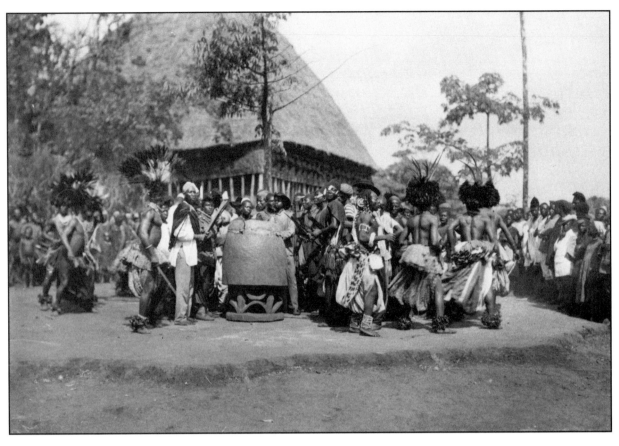

FIG. 60. *Dance of warriors in front of the Bamum-style Basel Mission chapel.* (*Photograph by Bernhard Ankermann, April–May 1908*)

red, black, and white. Small round seeds (*memmi*), valuable dark blue cylindrical glass beads (*ntam*), and cowries (*mbum*) were used for this beadwork.

The thrones are laden with symbolic allusions to Bamum kingship and worldview.[8] The male figure and the female figure at the back of the stool wear nineteenth-century high-status dress. Both wear loincloths with belts, the male has a trapezoidal headdress, and the female has a cylindrical headdress. The male figure holds a drinking horn, and the female holds a receptacle of kola nuts. Although it might be assumed that the figures represent the king and the queen mother, the Bamum have consistently described them as twins, the most cherished retainers at the royal court.

The stool's intertwined double-headed serpent motif is exclusively associated with Bamum art. In the Grassfields, single-headed serpents serve as a general royal symbol. In Bamum the double-headed serpent has a specific historical reference (Geary 1983b, 92; Northern 1984, 46–47). The double-headed serpent refers to the legendary exploits of King Mbuembue, the charismatic warrior who, like a serpent with two heads, was able to strike on two fronts at once. Serpents therefore allude to the strength and power of Bamum kings.

Other motifs occurring on the throne also

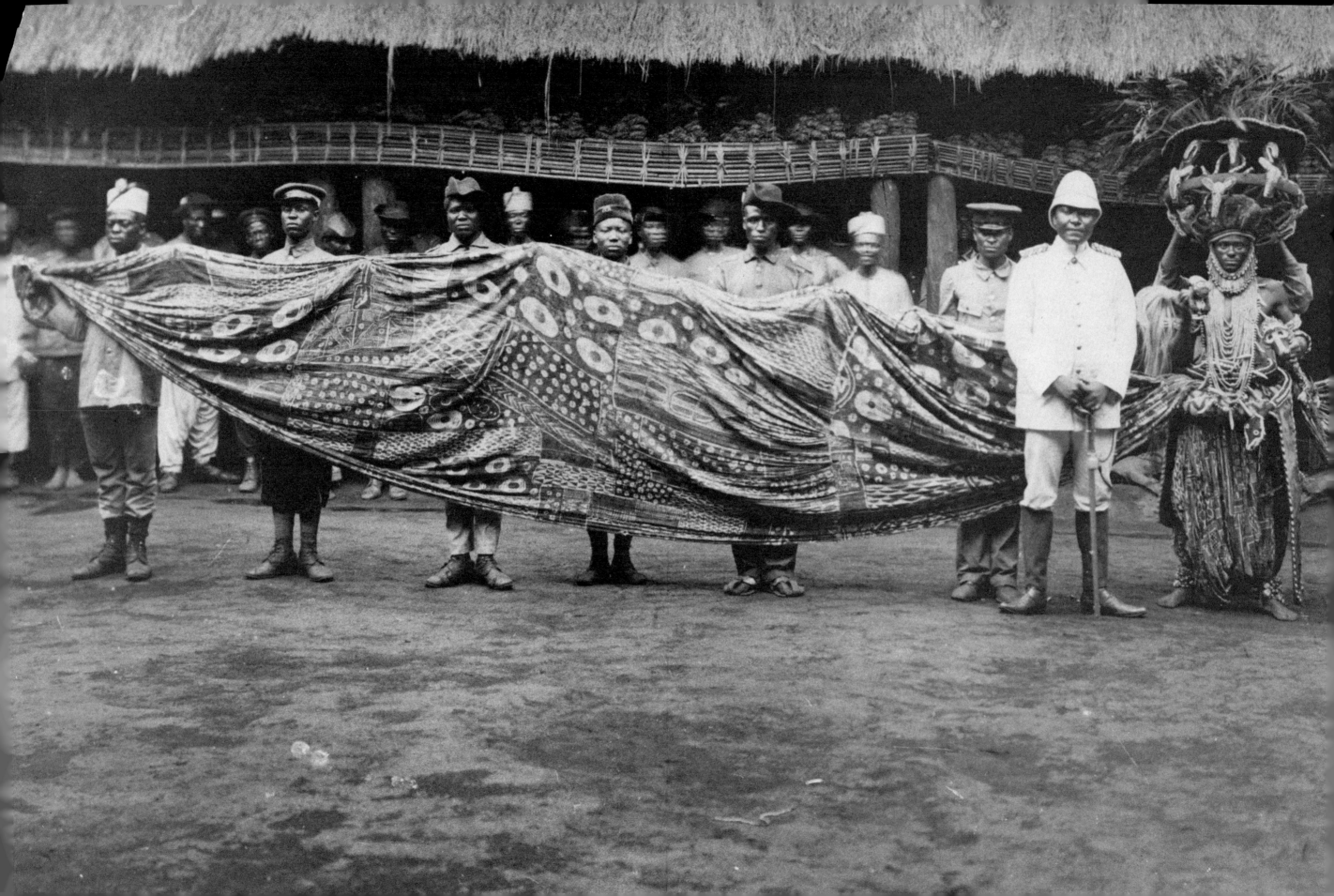

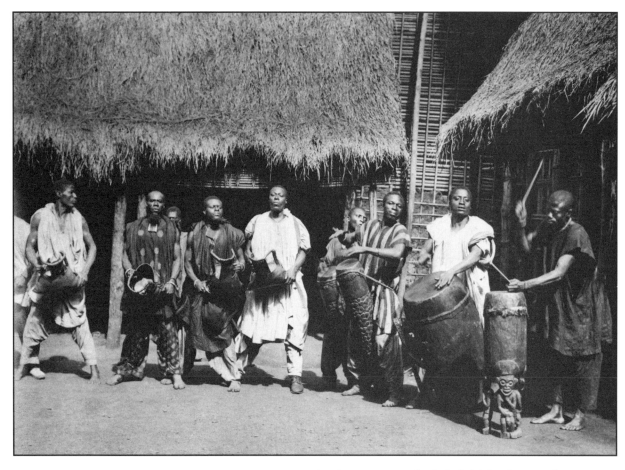

FIG. 61. *Musicians of the Mbansie secret society. The four men on the left hold leather rattle bags.*
(Photograph by Bernhard Ankermann, April–May 1908)

represent Bamum conceptualizations. The stylized frog icon, which occurs on the headdresses of the male and female throne figures (barely visible in fig. 56), alludes to fertility. The spider, carved on the side panels of the footrest (see fig. 23), figures prominently in divination and may therefore refer to wisdom. The jagged-spear motif on the left warrior figure of the footrest alludes once more to warfare (fig. 14). In sum, the two-figure thrones render the essence of Bamum kingship through form and the accumulation of icons: strength in war, cunning and wisdom, power over people, wealth, and fertility.

The most compelling photographs for the study of Bamum art in its setting are images taken during ceremonies at the Bamum court. At royal festivals, splendid masquerades were performed by members of palace organizations upon the king's request. The king himself owned all of the masks, costumes, and paraphernalia for the masquerades.

Photographs of festivals and their masquerades require careful analysis if they are to be used as documents. Three factors that influenced the production of these pictures need to be considered when interpreting their content. First, with the adoption of Islam by the Bamum

court elite about 1896, King Njoya began to integrate Muslim elements into royal performances—such as elaborate equestrian displays—and partly abandoned or restructured some of the nineteenth-century festivals in which many of the masquerades were performed. In the years after 1910—the later part of the German presence in Bamum—he once more brought out the ancient masquerades and celebrated some of the older festivals, as Marie-Pauline Thorbecke observed during her stay in January 1912.

> During the last years, Njoya has resurrected the old dances and festivals of his people, which have not been performed for a long time. His treasure houses still contain wonderful pieces . . . , although our museums already own very many stools and drums decorated with [cowrie] shells and bead embroidery, as well as finely worked large and small bronzes. Now he has taken out the old dancing masks and gowns, and on the large place in front of the chief's palace one can see theatrical performances that, with their incredible wealth of color and the rhythmic movement of the crowd counting into the thousands, are the most gripping spectacle a traveler can dream of. [9] (F. Thorbecke 1914, 20, my translation)

For many years, Njoya strove to mediate between Bamum, Islamic, and European ways of life. His effort to synthesize them and create something entirely original is articulated in his staging of festivals and royal performances.

The second factor to be considered when analyzing the visual record is the manner in which Njoya treated foreign photographers. Most visitors and permanent residents in Bamum witnessed performances and festivals in a well-orchestrated setting. Sitting next to the king and the queen mother in front of the palace,

they were able to photograph spectacular displays (fig. 59). Most of the performances they observed were staged for them. In part, this reflected Njoya's general strategy for dealing with foreigners. By carefully looking after their needs and willingly arranging performances, he was able to maintain some control over their movements. The staging also accommodated the desire of the photographers for situations that would allow them to take their photographs. Since many of the photographs were taken at staged occasions, however, they may not depict the actual sequence of events or choreography.

Third, little recent information and direct observation exist that might help to explain the photographs of festivals and rituals. Soon after the German colonial period ended in 1915, the ties between King Njoya and the Islamic groups to the north became very close, and some of the old festivals were discontinued. In addition, the French, who had taken over from the Germans, implemented a different form of colonial administration. Traditional chiefs were no longer used as administrative agents, which decreased their political autonomy. The French regarded King Njoya as a former German ally and looked unfavorably upon him. By officially dissolving the Bamum palace organization in 1924, they brought an end to all royal festivals.

Do the photographs, then, permit a reconstruction of certain performance aspects of festivals? Do they give insights into the masquerades whose masks are now in museums all over the world? If the images are carefully interpreted, they do provide valuable information for art historians.

At one staged photographic occasion, Ankermann took fifteen pictures with two cameras (fig. 60). He also wrote a description of the event.

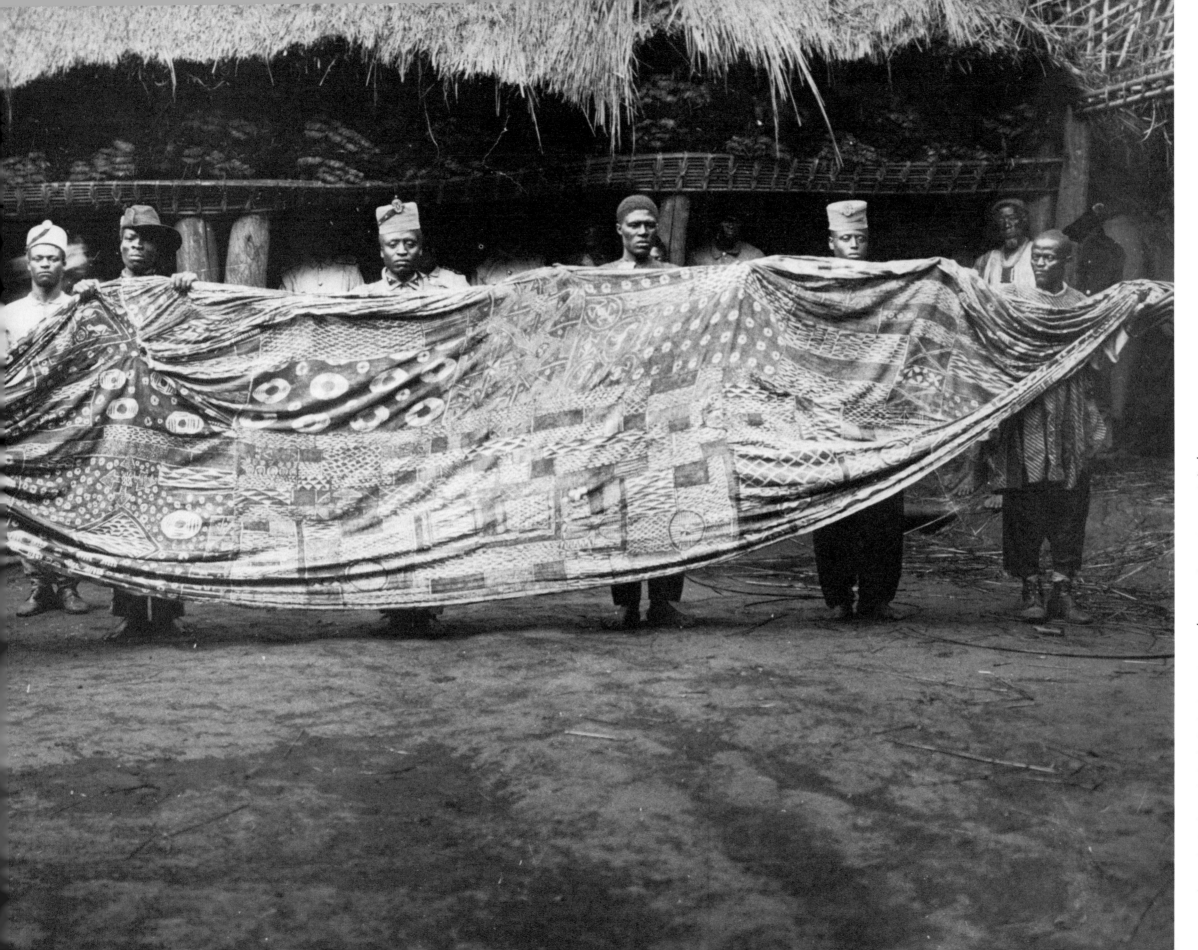

FIG. 62. *A Royal costume for the Nja festival is displayed by King Njoya's chamberlain. Njoya poses in a German officer's uniform. The chamberlain wears a beard made from tubular beads. Around his arms and ankles are beaded rings. Two bead-trimmed otter pelts hang from his hips, and a thin belt ending in a serpent head wraps around his waist. In his right hand, the chamberlain holds a white horsetail fly whisk with a male beaded figure on the handle. Horsetails were reserved for Bamum kings. Two photographs, combined here, were required to show the entire costume.* (Photographs by Bernhard Ankermann, April–May 1908)

102

FIG. 63. *Headdress for the royal Nja costume. It has flying-fox figures made of cloth, beads, and feathers. The photographer placed the headdress on his camera box.* (Photograph by Bernhard Ankermann, April–May 1908)

FIG. 64. *Neck jewelry for the royal Nja costume. It is made from leopard teeth and various kinds of trade beads.* (Photograph by Bernhard Ankermann, April–May 1908)

On April 8 [1908] a large dance in our honor was held on the market square. The dance takes place in a slightly raised round area between the chapel [of the Basel Mission] and the house of the chief. The orchestra consists of a large upright drum with a carved base, two cylindrical drums and some men who hit each other's swords (one had a [European] saw). The cylindrical drums were beaten with the hands, the standing drum with drumsticks (raffia palm ribs), the latter also at the sides (on the wood). There are twenty-four dancers, who do not all dance at the same time. Their

costumes, with one exception, are as follows: On their heads they all wear a feather tuft of short black and long white feathers, or of short red and very long black feathers. (The feathers are fastened to knitted caps.) Around their necks they wear long strings of beads, some of them so long that they hang down to the belly. The upper torso is nude; only one wore a European shirt. The loincloth is most notable, a long, very wide cloth strip, which is pulled in back and in front over a thin string wrapped around the waist and hangs between the legs down to the calves. The ends in front and back are

FIGS. 65–66. *Sections of the royal Nja costume's cloth "wings."* (Photographs by Bernhard Ankermann, April–May 1908)

arranged in numerous folds. Some of these loincloths were still made from bark cloth,[10] partly undyed, partly decorated with a dark ringlike pattern. Around the ankles they wear rattles made from the halves of the shells of some fruits. In addition, they wear bracelets around their wrists and some around their upper arms. Almost all of them carry in their hands the long, narrow leaves with white dots of an aloelike plant. Some carry fur bags on their arms. The dance consists of all of them walking in single file, with legs spread, around the musicians and, with each step, stepping twice with the respective foot. Occasionally, some dancers, mostly three, step out of the row, jump to the edge of the raised area, and stomp for a while, their faces turned toward the palace. (Baumann and Vajda 1959, 283, my translation)

The dance, according to Ankermann, lasted from two o'clock to six o'clock in the afternoon. The royal wives stood in long rows around the dancing field and looked on. Although the photographs and the description give an account of the dance and provide valuable information about dance costumes, the documentation demonstrates how incomplete even the observations

of a well-trained and careful cultural anthropologist can be. The name of the dance, which has not been performed at the Bamum court in decades, and its meaning are not given. The costumes were probably made in the nineteenth century and thus date the dance to that time. The dance was also likely performed by warriors. All of the elements—the participation of men only, the use of swords, the orchestra of drums, and the feather tufts—are typical of warrior dances in other parts of the Grassfields.

Ankermann took four photographs of another group of musicians inside the palace (fig. 61). The captions in the photographic archives of the Museum für Völkerkunde are minimal: either "men with drums" or "men with iron bells." Ankermann's notes contain no references to the event. In this instance, one type of instrument identified the location and the musicians for those in present-day Bamum. Four men on the left hold leather bags made from stiff antelope hide. Filled with small pieces of iron, they functioned as rattles. They were the typical instrument of the Mbansie secret society. Mbansie had its meetinghouses and specially reserved court in the lower part of the palace, where this picture was presumably taken.

Like many other societies at the Bamum court, Mbansie was established during the rule of King Mbuembue. After some Bamum stole the ritual instruments from the neighboring Ti, Mbansie was created and the instruments were incorporated into the society's paraphernalia. By taking the instruments, the Bamum indicated that they intended to subdue and incorporate the Ti. This never happened because the Ti fled the area. Mbansie subsequently developed into a warrior society in which young retainers were prepared for their services at the palace. Princes were barred from participation. The exclusiveness of the society reflected the division of Bamum nobles into retainers and princes. When Mbansie performed in its courtyard once a week, often in the presence of the king, the dance was accompanied by musicians playing iron gongs, vertical drums, and the rattle bags that Ankermann photographed in 1908.[11]

One of the most important annual festivals at the royal court was the festival of Nja, celebrated during the dry season in December or early January. According to the recent testimony in Bamum, it last occurred in the 1920s. Therefore, the information cited here stems from reconstruction, not from direct observation (see also Tardits 1980, 790–98).

The Nja festival was a display of royal riches and a visual representation of the Bamum political and social structure. Groups of dancers and musicians representing particular segments in the Bamum hierarchy performed in elaborate masquerades that featured zoomorphic and anthropomorphic helmet masks and crests. Today, the festival is fondly remembered as the "day of beauty" and the highlight of the year. Compared with the enthusiastic oral testimony recently collected on Nja, the lack of references to the festival in German accounts from the years when it was still taking place is astonishing. Only Wuhrmann mentions Nja in some detail.

FIG. 67. *Sword and scabbard for the royal Nja costume. The sword's beaded hilt depicts a serpent head and, on the end, an animal head. The animal head has been identified as a baboon by present-day Bamum people, but it could also be a ram head. The wooden scabbard is covered with red cloth and decorated with bead spiders. (Photograph by Bernhard Ankermann, April–May 1908)*

On the day of the [Nja], the royal wives and all the seed of the royal house and the court guards adorn themselves and go dancing. Those children that are still very little and can be carried on the shoulders also dance along. The older royal children beat the drum; the royal wives and the free noblemen dance around the earth seat [the slightly raised area in front of the palace]; the king dances, too, and thirty court guards are before him. People come and

sound the trumpets and the king gives them gifts. When he wants to leave, he administers an oath to the free noblemen. Then the [Nja] is over. (Rein-Wuhrmann 1925, 66, translated in Geary 1983b, 127)

The photographic record of Nja by several photographers is an excellent source of information on some of the visual aspects of the festival. When the festival began in the morning, people from all over Bamum country assembled in the dancing field. They were clad in their most beautiful finery and adorned with emblems of rank. The beaded thrones of the king and the queen mother were placed in front of the central entrance of the palace, and soon both of them emerged. The king was dressed in his Nja costume, a most luxurious and lavish ensemble of cloth, beaded jewelry, and prestige weapons. No verbal description matches the photographs of one such costume, which Ankermann photographed and described in the spring of 1908 (fig. 62). In this instance, the combination of inventory-taking photography and a systematic verbal description according to the standards of contemporary German cultural anthropology created a document remarkable in its detail.

Njoya himself possesses some curious dance jewelry, which essentially consists of the following pieces:
1. A crown, very big and so heavy that it has to be held by a man standing behind the dancer. It exhibits several rows of animals one on top of the other, according to Njoya [they are] flying foxes with long ears, above and below a thick horizontal ring. At the top it is closed off by a horizontal round disc, crowned by a large feather tuft. Everything is embroidered with beads [fig. 63].
2. The face is framed by a bead beard.
3. Around his neck he wears a large beaded piece with lion or leopard [teeth] on the outer

border that hangs down over his belly [fig. 64].
4. A very thick bead ring, from which hung two long bead-edged pelt strips, encircled the hips. In addition there hung from this hip ring (a) the dance loincloth which almost touched the ground, similar to those of the dancers, and (b) two very long "wings" of black patterned cotton cloth on either side which have to be carried by many men during the dance [figs. 65, 66].
5. Over the hip band lies a second, thinner bead belt terminating in two serpent heads.
6. He wears bead bands of various forms around the arms and ankles.
7. In his right hand he carries a sword with an openwork blade and a bead-covered handle terminating in an animal head. The scabbard is embroidered with beads in a spider motif with dangling bead strands [fig. 67].
8. In his left hand he holds a fly whisk whose handle terminates in an animal head and is covered with beads. (Baumann and Vajda 1959, 284–285, translated in Geary 1983b, 133)

This stately outfit projected the splendor of kingship. The accumulation of the different materials in extravagant configurations enhanced the persona of the king, making him the ultimate symbol of Bamum success and superiority and transforming him into a work of art. Some parts of the elaborate costume have been preserved in the Bamum Palace Museum, including the sword and its beaded scabbard (fig. 67) and the beaded belt with the huge cloth "wings" (Geary 1983b, 158, 179).

The indigo-dyed cloth of the "wings" is generally called *ndop* in the Grassfields.[12] It is called

FIG. 68. *King Njoya in an Nja costume. He stands in front of the palace. (Photograph by Marie-Pauline Thorbecke, January 1912)*

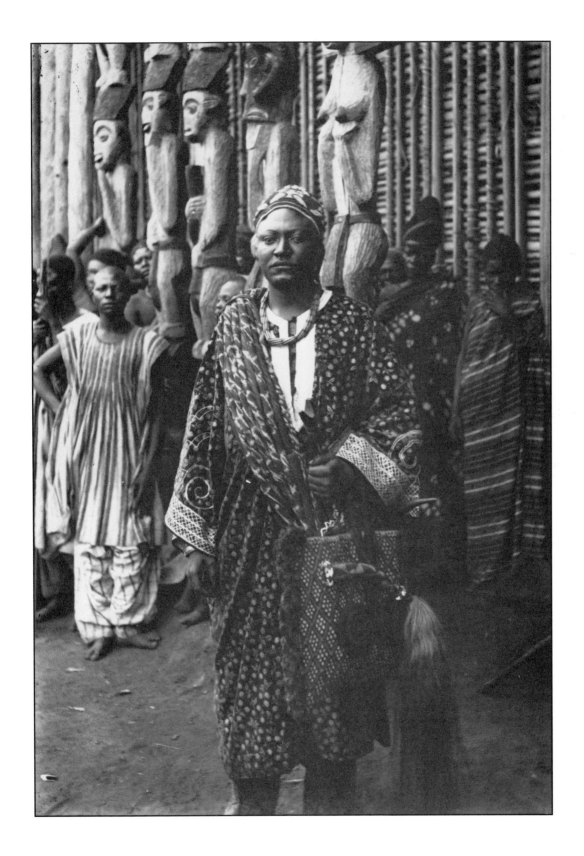

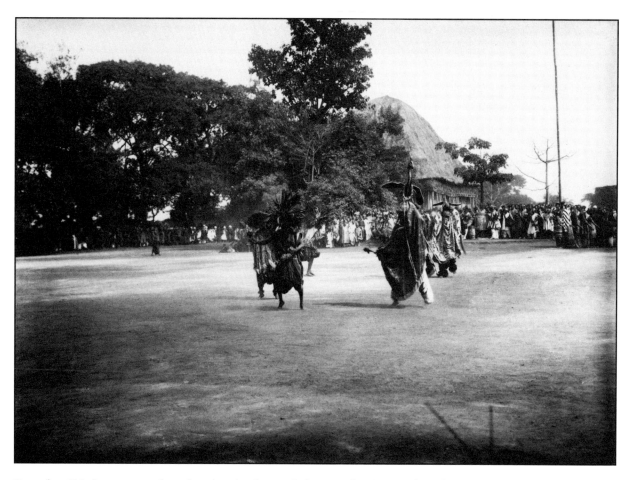

FIG. 69. *Bird masqueraders dancing in front of the Basel Mission chapel during a festival.* *(Photograph by Rudolf Oldenburg, 1912)*

ntieya in the Bamum language Shümom. The cloth is now torn and has faded beyond recognition. Today, elderly Bamum people still remember that it belonged to a royal dance costume and that six retainers on each side supported the cloth as the king moved in a slow and dignified manner.

Ankermann's photographs permit an iconographic analysis of the cloth, which is filled with motifs typical of Bamum design at the turn of the century (figs. 65–66). The motifs appear in squarish or rectangular fields; although the cloth seems cohesive and regular in its overall configuration, it dissolves into an accumulation of irregular patterns upon closer examination. The most prominent motif is the serpent head (fig. 66, center). Other zoomorphic icons represented are the frog, the crocodile, and a four-legged animal, possibly a leopard. They are all depicted to the left of the central square in figure 66. Circles and triangles abound, and a royal bag is represented in the lower center of figure 66. Although not evident from the remnants in the Bamum Palace Museum, this cloth is a masterpiece of Bamum textile production, attesting to the presence of sophisticated dyeing specialists and textile artists at the Bamum court before 1908.[13]

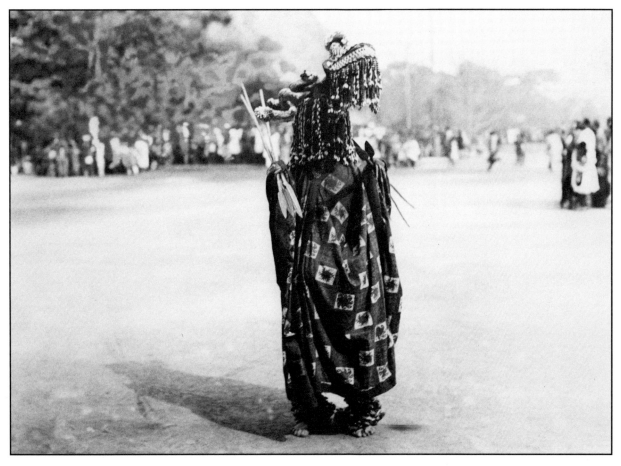

FIG. 70. *Crocodile masquerader during a festival. The crocodile crest is adorned on top with a small male figure. (Photograph by Marie-Pauline Thorbecke, January 1912)*

Puzzles are often encountered in photographic research that may never be solved. Ankermann's series of photographs of the costume certainly is one of them. Why did Njoya not wear the costume himself? Instead, he had a servant model it, who was identified as Njoya's chamberlain, or *shuofo* (*shuo,* "cloth"; *fo,* "king"). The *shuofo* was in charge of the royal garments and supervised the king's intimate servants. Ankermann provides no information about the context of the photographs or about the original owner of the costume. King Njoya himself may have been the original owner. He may have worn it before the conversion to Islam and later discarded it as inappropriate in his strategy to employ dress as a visual articulation of political circumstance. Parts of the costume, with the exception of the indigo-dyed cloth "wings," may have belonged to his father, which would date some of the accoutrements to between 1860 and 1886.

When Marie-Pauline Thorbecke observed Nja in January 1912, King Njoya wore a different lavish outfit more in tone with the changed times (fig. 68). She photographed him in what looks like a velvet gown with a floral pattern embroidered at the sleeves and the neck. Njoya also has a knitted cap with a serpent motif, an

embroidered bag containing his drinking horn,[14] a white-horsetail fly whisk with a beaded handle (white horsetails were reserved for the king), a sword, and a necklace of valuable tubular glass beads.

Ankermann never observed Nja. Thorbecke and Oldenburg, however, provide valuable visual information about the Nja festival celebrated in January 1912. The highlights of the festival were the masks passing in review and the dances of the king, the groups of palace retainers, the nobles known as the councilors of the land, and the princes descended from ancient kings. The palace retainers were the only masked participants. They wore helmet masks or crests on their heads, among them buffalo masks, bird crests (fig. 69), ram crests, elephant masks, a crocodile crest (fig. 70), and anthropomorphic helmet masks (Geary and Njoya 1985, 157). With the exception of the leading buffalo mask and the crocodile crest, most masks could be danced by any retainer. Bird masqueraders moved vigorously, so that the wings of the bird crest, which were only loosely tied to the crest's body, would flap up and down. The masqueraders filed by the king, the queen mother, and the crowd of spectators. The masks, numbering more than one hundred, followed a prescribed sequence, but nowadays there is little information about the choreography.

In Njoya's day, the masquerader at the front of the procession wore a bead-embroidered buffalo mask with a standing male figure on top. Both the masquerader and the figure held a staff in each hand (Geary 1983b, 195, no. 345). Since the staffs were an emblem of the leading masquerader, the male figure on the mask represented an Nja dancer. While he danced, the masquerader rapidly moved his staffs up and down.[15] A son of a sister of the king—sister's sons were preferred retainers at the court—danced the leading mask.

The crocodile crest was reserved for the *shuofo* (fig. 70). This dancer held three spears in each hand. The crest—a beaded naturalistic carving of a crocodile with a standing anthropomorphic figure on its snout and braids of plaited cloth hanging down from the crocodile's mouth and over the head of the masquerader—had from the first attracted the attention of the German collectors. It is no doubt the object that Diehl mentioned in a 1907 letter to the director of the Museum für Völkerkunde Leipzig.

> We can remain friends in spite of it [Diehl complained about the lack of recognition for his services] and I will gladly fulfill your desire for some of the colossal Bamum carvings. I also believe that I will succeed in securing one of the most interesting carvings, one that has a striking resemblance to a Chinese dragon figure. I am presently negotiating about it with the [king] of Bamum. (Diehl 1907, my translation)

Njoya ultimately did not give up the crest, and it is preserved to this day in the Bamum Palace Museum. Unfortunately, the mask is now heavily damaged. The old photograph, however, gives an idea of its original form (Geary 1983b, 194, no. 341).

When all of the masked retainers, the councilors of the land, and the princes had filed by the king in a counterclockwise spiral, the king himself moved in dignified, slow movements around the dancing field. He was followed by the crocodile masquerader dancing in step with him. The king appeared two more times during the day, changing costumes for each of his slow dances. When the festival reached its climax, the princesses danced, carrying their little sisters on their shoulders. Princes diagonally crossed the dancing field, and the populace moved in place to the rhythm of the flutes, drums, and rattles played by royal brothers and

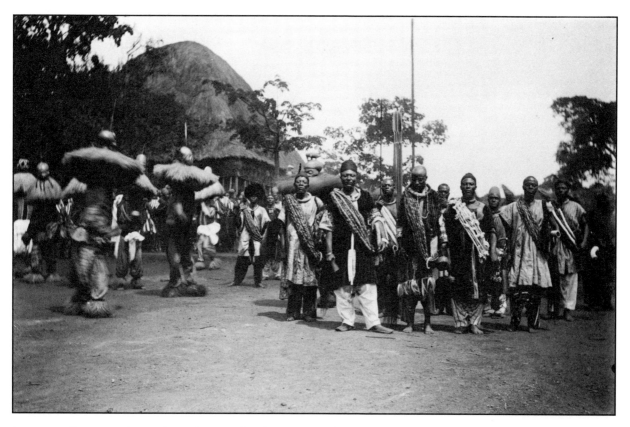

FIG. 71. Center, *King Njoya during the dancing of the* moafonyam *masquerade;* left, *masqueraders with towering anthropomorphic crests.* (*Photograph by Martin Göhring, before 1912*)

princes. The following morning, the king went to the royal graveyard and poured libations to his ancestors.

What was the significance of Nja in the Bamum annual ritual cycle? Tardits links Nja with the large harvest festivals in other states of the Grassfields, even though it took place in the middle of the dry season and seemed to have no direct association with agricultural activities. Such activities ceased with the harvest at the end of the rainy season in October and began again with planting when the new rains fell in April (Tardits 1980, 793–98). Nja celebrated the abundance of food and material wealth, physical beauty, and individual achievement in the Bamum state. It also articulated Bamum political and social structure through the perfor-

mances of specific groups of actors. The elite of the kingdom—the king, the queen mother, the princes and princesses, and the retainers—were represented in this dramatic presentation. The retainers, the pillars of royal power who supported the king against the claims of his brothers, were the only participants disguised with masks.

With the proliferation of zoomorphic and anthropomorphic masks—the latter likely danced in male-and-female pairs—the Nja masquerade can be understood as a symbolic dramatization of the Bamum universe, which is comparable in some ways to the conceptualization of the universe among the inhabitants of the Benin Kingdom of Nigeria (Ben-Amos 1976). Animals are fundamental symbols that may refer to

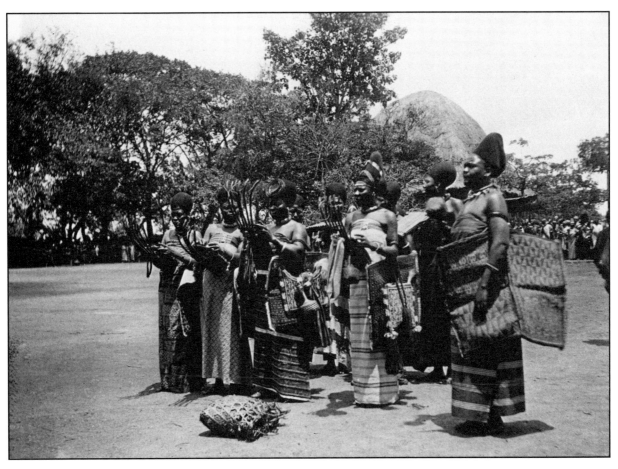

FIG. 72. *Wives of King Njoya singing and playing harps. The women carry large woven raffia bags.* *(Photograph by Eugen Schwarz, c. 1909)*

different qualities. Most peoples in the Grassfields believe that each type of animal occupies a specific sphere in the universe according to its nature and characteristics. In Bamum, animals, like humans, were ranked in hierarchical terms, and associations existed between types of animals and particular groups of people. For example, the buffalo, with its inherent strength and endurance, was associated with the palace retainers. Retainers sometimes received buffalo drinking horns from the king and wore knitted caps displaying the buffalo icon (Geary 1983b, 93–94, 98). The meaning of the crocodile icon, so prominent in the Nja masquerade,

remains enigmatic. Perhaps as an amphibian living in water and on land, it was seen as combining wetness and dryness, both of which are still key concepts in Grassfields symbolism. Dryness is associated with the absence of suppleness and with old age and death. Wetness is associated with moisture and suppleness, which allude to youth, fecundity, and, by extension, female nature.[16]

Different types of masks and crests performed during other important festivals and rituals at the Bamum court and were captured in photographs. Only sometimes, however, is the exact occasion or meaning of these performances

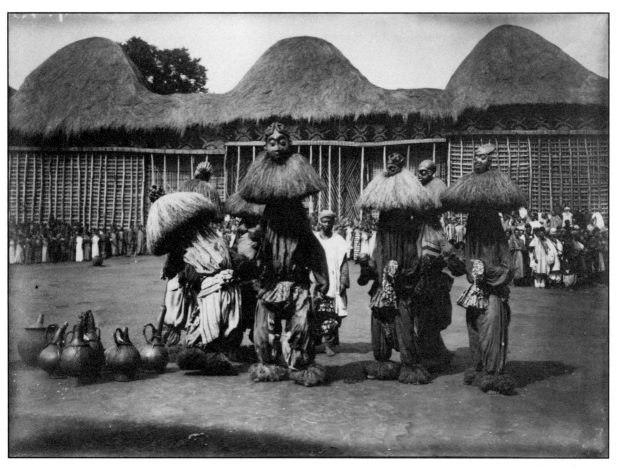

FIG. 73. *Dancers performing during the* patambuo *masquerade.* (*Photograph by Rudolf Oldenburg, c. 1912*)

known. During his first stay in Bamum from May 1906 to April 1911, Göhring took a dynamic picture of several masqueraders with anthropomorphic crests dancing in the exact location where Ankermann had photographed the dance of the warriors (fig. 71; compare with fig. 60). In the center of the image, King Njoya, holding a small bell in his left hand, wears a fine costume with an elaborate sash for his sword. The sash is made from twisted strips of *ndop* cloth. Njoya is surrounded by retainers holding bells and raffia fiber rattles shaped like miniature baskets. On the left, several dancers wearing towering crests perform a vigorous dance.

The general name for the type of towering crest in figure 71 was *tu ngunga* (*tu,* "head"; *ngunga,* a type of dance in which such masks performed). It consisted of a fully sculpted male or female head inserted in a basketry support. Worn on top of the head, the crest was secured with straps that looped under the dancer's shoulders. A raffia fiber cushion protected the wearer's head. A large raffia ruff fell over the basketry support, and a cloth garment covered the head of the dancer, creating the effect of a towering figure. The crest, which was common in Bamum, came to be used in various dances performed during festivals and joyous occasions.

Similar crests exist among the neighboring Tikar and in the Cross River region (Wittmer 1976).

In 1914 Wuhrmann photographed *tu ngunga* crests and a dancer during the wedding of Nji Mongu Ngutane (fig. 51). Ngutane, who in 1988 was close to ninety years old, identified the crests as two of several that performed during the *moafonyam* dance. She explained that the dance had been introduced in Bamum during the rule of King Nsangu (Geary 1983b, 137–39; *Histoire* 1952, 57). The right to perform the *moafonyam* dance and the paraphernalia for it belonged to the king. Danced by retainers, *moafonyam* was associated with female beauty, wealth, and the privileges of the royals. The mask on the right, for instance, represents a royal woman. The cylindrical headdress was worn by high-ranking women (see also fig. 56, female figure on the right). Some of the crests used in the *moafonyam* dance remained in Bamum and are now part of the Bamum Palace Museum collection (Geary 1983b, 192, nos. 329–31).

Another masquerade with towering crests was photographed by Oldenburg (fig. 73). His photograph of a group of masqueraders posing for his camera is one of several classic Bamum images that were widely used in publications and exhibitions. It was identified as the *patambuo* masquerade, one of several new masquerades introduced by King Njoya in the first decade of this century. The *patambuo* masquerade originated in Mambuo, a large plantation the king maintained in the countryside. Once a year, on the occasion of a successful harvest, the king presented his sons and daughters, his wives, and important nobles with food, palm oil, salt, and kola nuts. They in turn distributed the food among their subordinates. Although the festival was discontinued after only a few years, the masks, some of which are now in the Bamum

Palace Museum, and the photograph of the masquerade provide evidence of its existence (Geary 1983b, 135).

Crests for the *moafonyam* and *patambuo* dances exemplify some of the stylistic conventions formulated by the court artists in the mid- to late nineteenth century (see fig. 51, crest on right). The slightly elongated or round face has raised round or oval eyes. The bridge of the nose is flat, sloping toward the cheekbones, while the nostrils flare out. A prominent gaping mouth with the teeth displayed is characteristic of many of these crests. All of them have elaborately carved coiffures or headdresses, occasionally executed in open-worked fashion.

Perhaps one of the most stunning artworks ever produced at the Bamum court is the crest of the *tu panka,* the royal servant who led the army (fig. 74). During his installation he wore this crest, which, like so many other artworks, is now preserved in the Bamum Palace Museum. The crest, a representation of a warrior riding a leopard, has a distinct designation: *tu mola,* "the head of the child of the country." The name alludes to the notion that the *tu panka* personifies the essence of the nation—the success of the Bamum Kingdom had resulted from continual warfare and expansion. The rider is dressed in nineteenth-century high-status apparel—loincloth and trapezoidal headdress—and crouches on top of the animal and bends slightly forward as if moving. The elaborate bead cover in blue, white, and black displays an array of Bamum motifs, including the spear motif and a checkerboard motif resembling the pelt marks

FIG. 74. *Procession of Tu Panka Nyam Pare, leader of the Bamum warriors. He wears a crest depicting a rider on a leopard. Chanting warriors follow him, hitting their swords with raffia sticks. (Photograph by Rudolf Oldenburg, c. 1912)*

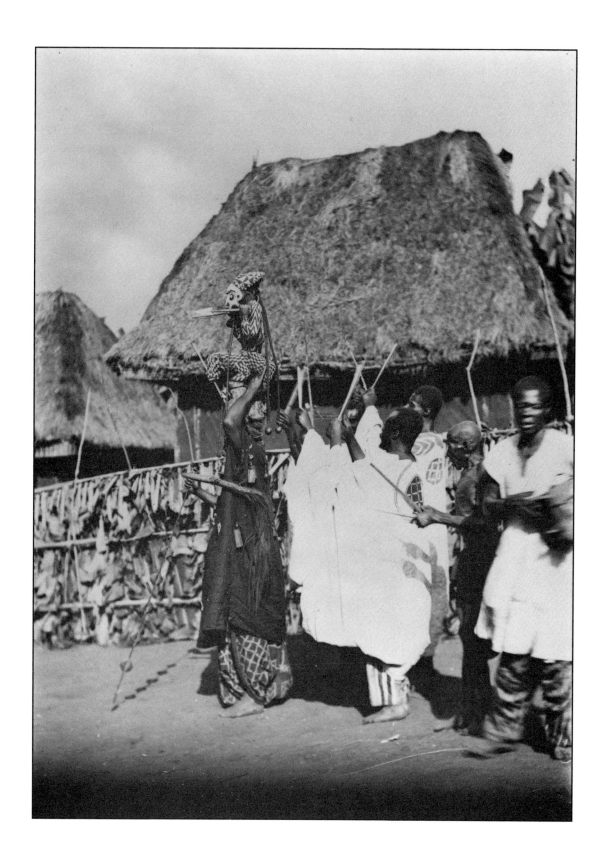

ART AND RITUAL RECORDED

of the leopard, a royal referent. Accoutrements in other media add to the impact of the sculpture. Two long strings of ringlike blue glass beads of African manufacture hang down the figure's back and have small brass bells of European origin on the ends. Bands of padded red fabric dangle over the shoulders of the figure, and in each hand the warrior holds a spear.

Oldenburg photographed the *tu panka* with his headdress during the installation ritual. He captured the new officeholder's slow dance around the dancing field and the market square, one phase of the investiture. The photograph is one of only a few showing motion, and it seems unposed. The *tu panka,* who holds the crest with his left hand, is followed by Bamum warriors in finely embroidered Hausa-style gowns. The warriors are chanting and hitting their swords with raffia sticks.[17]

Another masquerade with crests occurred in settings outside of the palace. Three posed images by Rudolf Oldenburg, one of which appears here (fig. 75), show a masquerade with crests quite distinct from the conventionalized royal masks shown in the other pictures.[18] The context of the masquerade cannot be discerned from Oldenburg's images alone. It had to be reconstructed through interviews. In 1984 Sultan Seidou Njimoluh Njoya himself identified the masquerade as *tu ngunga mopapet,* "the masquerade of the people of Pet." The right to perform the masquerade belonged to one of the subjugated kings, the king of the Pet. The Pet had been subdued by King Nshare Yen in the seventeenth century but retained their identity within the Bamum Kingdom. They had the privilege of maintaining their own royal masquerade. The king of the Pet would at times bring his masquerade to Fumban and pay homage to the Bamum king.

Oldenburg's photographs of the Pet masqueraders do provide interesting data about the masks and the costumes. To the left of figure 75, a man is wearing a feather headdress—possibly an allusion to warfare and the warriors' garments—from which protrudes what perhaps is a twisted antelope horn. He holds what looks like a cane. To the right stands the king of Pet with a smaller masquerader who is wearing a knitted fiber suit with a hood covering his face. On his head he also wears a small feather tuft. This type of knitted costume is rare in Bamum, although it commonly occurs in other areas of the Grassfields. The masqueraders with the crests wear suitlike cotton costumes with raffia fringes around their ankles. The crests represent two male-and-female pairs, recognizable by the hairstyles. The female crests (second and fourth from the left) have elaborately braided coiffures.

The crests bear little resemblance to those carved at the palace. Although they were used in a Pet dance, the masks were probably not made by the Pet. Chiefs commonly commissioned masks from well-known workshops and then used the masks in their own masquerades. It has been suggested that the crests in figure 75 were sculpted in workshops located in subjugated village chiefdoms on Bamum territory, a claim that led Wittmer (1976) to postulate the existence of different village styles in Bamum. Harter (1986, 156–57) goes even further, tracing the two male masks in the photograph to a workshop in Kutam, located east of Fumban. Similar crests from Bamum are in museums in Europe and the United States, where they have frequently been misattributed. The Musée des

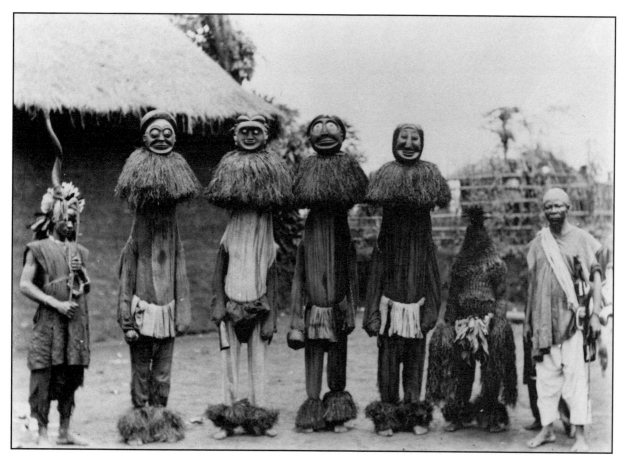

FIG. 75. *Masqueraders wearing costumes for* tu ngunga pomapet, *"the masquerade of the people of Pet." The Pet, who now live east of Fumban, had been subdued by the Bamum. The Pet king paid homage to the Bamum king by presenting his masquerade in Fumban.* (Photograph by Rudolf Oldenburg, c. 1912)

arts et traditions Bamoum in Fumban also possesses several such village masks.

If photographs of art and rituals are to be used as documentary sources for art historical studies, they must be thoroughly researched. The study of photographs, like the study of written documents, requires a refined methodology (Geary 1986). The limitations encountered in photographic research are frustrating at times; perhaps there would be fewer puzzles if some photographers had only turned their cameras in other directions or left notes. Nevertheless, photographs do contain unique information that may lead to new insights.

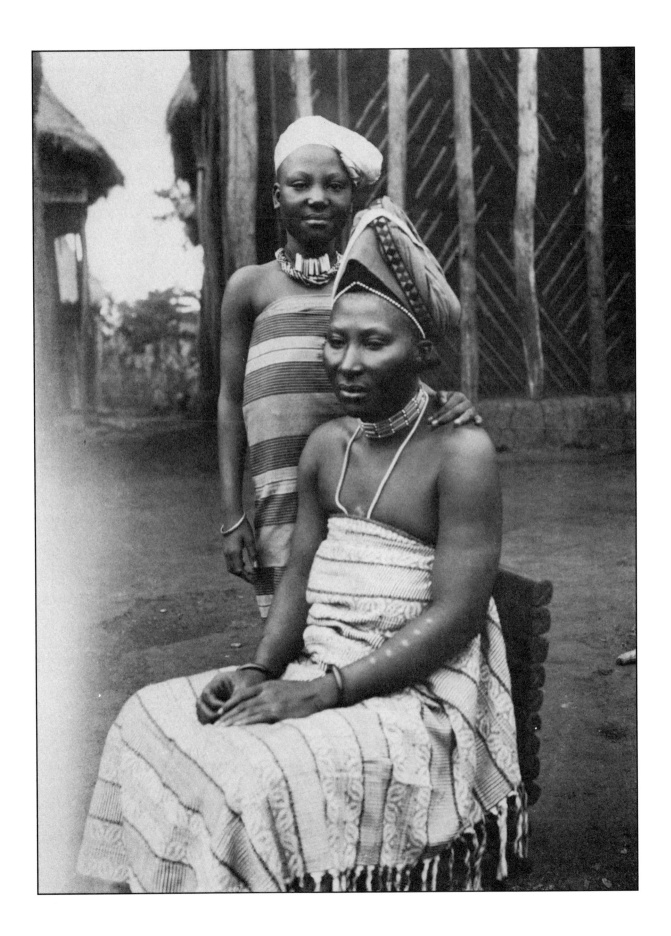

CHAPTER SEVEN

Through a Woman's Eyes
The Images of Anna Wuhrmann

AMONG THE MANY PHOTOGRAPHS from Bamum are some that touch the viewer because they are compassionate, superbly composed works of art. Both Marie-Pauline Thorbecke, an artist who also painted watercolors and oil paintings during her stay in Cameroon,[1] and the merchant Rudolf Oldenburg, who strove for recognition as a scholar, had a natural gift for photography. Working within the prevailing conventions of ethnographic photography, they created lasting images of Bamum, such as the one of King Njoya giving an audience (fig. 23) or another of masqueraders dancing (fig. 73). Thorbecke and Oldenburg, however, remained distant observers who only recorded the subjects of their inquiry. Only one photographer transcended the prescribed relationship between the photographer and the photographic subject and thus overcame the limitations inherent in the ethnographic way of picturing the Other. Anna Wuhrmann, a missionary teacher, developed close friendships with the Bamum people. In her photography,

FIG. 76. *Royal wife Wbete-Gua Bani and her daughter Zaye. (Photograph by Anna Wuhrmann, c. 1913)*

she focused on people and their personalities, creating strikingly intimate images that are almost modern in their conception.

Wuhrmann was an exception among the missionaries in Fumban. A Swiss citizen, she came from a well-to-do Basel family at a time when most missionaries were craftsmen or farmers from the rural areas of what is now the state of Baden-Württemberg in southern Germany. Martin Göhring, the head of the mission at Fumban, had been a farmer in the small town of Leidringen before he joined the Basel Mission in 1895. Eugen Schwarz, a jack-of-all-trades in Bamum, had been a locksmith in Ludwigsburg near Stuttgart before becoming a missionary in 1903.

Wuhrmann enjoyed the usual upbringing of a girl from a prosperous family. Born in 1881 in Marseille, where her father worked, Wuhrmann spent her first years with her grandparents in Winterthur, Switzerland. When her family arrived in Basel in 1888, she joined them and attended an elementary school there and then a girls' school. She later went to a boarding school in the French-speaking part of Switzerland, where she studied to become a teacher. After passing the state teachers' examination in 1902,

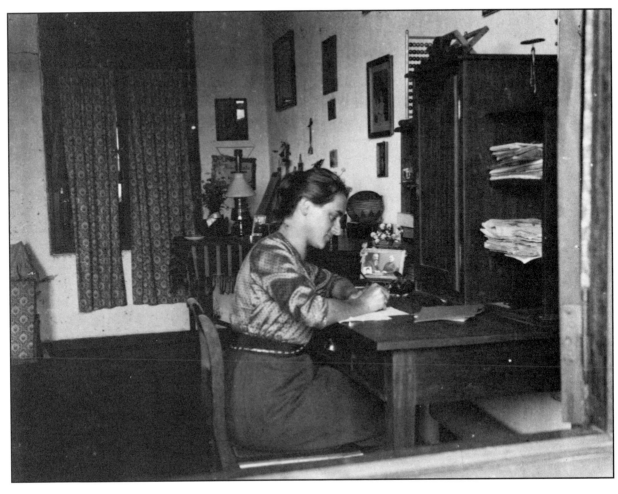

FIG. 77. *Anna Wuhrmann at her desk in the Fumban mission station. This is a rare interior shot.* *(Photograph by Eugen Schwarz, c. 1913)*

Wuhrmann first taught orphans in Bern and then deaf students in Riehen near Basel. In 1905, at the age of twenty-four, she had a permanent teaching position in Basel. Wuhrmann had yet to marry, and by the standards of her time, she was a spinster.

Young Wuhrmann was independent and strong-willed. She sent an application to the Basel Mission, explaining in her precise handwriting why she wanted to become a missionary.

Only slowly have I realized that I should enter the service of the Mission. When years ago life demanded a great sacrifice from me, I first understood that God wanted to have me in *His* service [Wuhrmann's emphasis]. Two years ago, I was close to joining a missionary society, but my parents wanted no part of it and made me promise to wait another two years. Last year, I fell ill and had to take leave for a longer period of time, and many doubted that I would recover. I said to my Lord, "If you want to

use me in your service, make me healthy. Then I will go where you lead me." Soon I became better, and now I feel strong and well, as I have not felt in years. I saw my path clearly in front of me and only had to wait until my parents, too, could recognize God's plans for me. They have now agreed, and I will happily devote my life to Jesus in gratitude for his endless loyalty. (Wuhrmann 1910, my translation)

Wuhrmann was accepted into the Basel Mission as a teacher, and on September 9, 1911, at the age of thirty, she left Hamburg for Douala. She reached Fumban in November 1911 and took over as the sole teacher at the girls' school, replacing Lydia Link, another young teacher who was leaving her position after almost four years in Fumban.

Wuhrmann arrived at an uncertain time for the mission in Bamum. The missionaries increasingly doubted their reliance on King Njoya. Göhring had become disenchanted with the slow progress the mission was making among the Bamum elite, and for the first time he officially expressed his disappointment in Njoya's growing interest in Islam and its trappings. The German myth of Bamum was beginning to lose its strength. Göhring complained that

> Njoya and all his nobles now wear Fulah [Fulbe] dress with turbans and Fulah [Fufulde] pours out of their mouths. Greeting formulas at the court and the praise of sycophants follow the Fulah example, while the Fulah orchestra with trumpets, drums, and pipes plays the rhythm. Njoya is still very well-disposed toward the mission; we have his support in all respects, as we too help and support where we can. . . . In spite of this, our great Grassfields chiefs are sharp, double-edged swords. Everything depends on their favor or disfavor. If the chief whistles, the

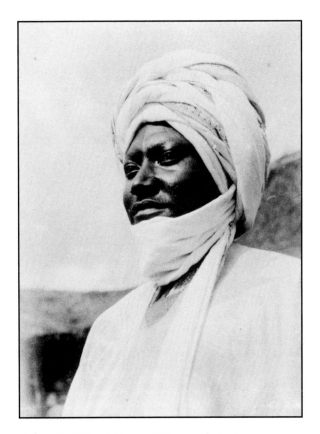

FIG. 78. *King Njoya. (Photograph by Anna Wuhrmann, c. 1912)*

people jump. This has its bright and dark sides. As long as the chief is favorably inclined, one fares well. However, if one falls into disfavor, one is stranded. The subordinates have the nature of slaves and barely dare to think or act independently. The chief must consent to everything. (Göhring 1911, 11–12, my translation)

Wuhrmann, however, was at once enamored of Bamum and its king. Many years after she had returned from Fumban, she described her first encounter with King Njoya in a book for young readers.

> When I saw Njoya for the first time the day after I had arrived in Fumban, on November 10, 1911, he introduced himself to me with

FIG. 79. *Nji Poka', six-year-old daughter of King Njoya.* (*Photograph by Anna Wuhrmann, c. 1913*)

FIG. 80. *Po Puore, a daughter of a Bamum noble.* (*Photograph by Anna Wuhrmann, c. 1913*)

the words, "Me be Njoya!" . . . He spoke the Negro English [pidgin] very well, which one can hear all over Africa. At the beginning, until I knew the Bamum language a little, we always conversed in this language. . . . King Njoya was a very sympathetic Negro and one can say about him that he was every inch a king, in his appearance and also in his behavior. He was very tall and imposing. Mostly he wore dark blue Hausa dress, and when he left the palace, a turban, too. On festive days, he was completely attired in white, and that always befitted him because his skin was dark and the light gown enhanced it. (Rein-Wuhrmann 1948, 57, my translation)

These words seem to have been written from one of Wuhrmann's intimate portraits of a dignified King Njoya looking into the distance (fig. 78).

Wuhrmann greatly admired Njoya. In her writings, she depicts him as a person with both strengths and weaknesses who had lived through great joys and disappointments. To Wuhrmann, Njoya was an equal rather than a noble savage who had fallen short of the epitome of evolution—the civilized European. As evidenced by testimony in present-day Fumban, hints in missionary correspondence,[2] and Wuhrmann's texts, Njoya took an equal liking to her. Wuhrmann moved comfortably among the Bamum people—she had become fluent in the

Bamum language—and was well liked by them. Unfortunately, Wuhrmann's interest in King Njoya and the Bamum way of life led to difficulties with her fellow missionaries. They felt that her independence was inappropriate for a woman.[3]

As a teacher and friend, Wuhrmann maintained relationships with her students, the royal wives, the Christians in the congregation, and even Bamum who never considered becoming Christians. She visited them in their compounds and got to know their families. In her books, she recounts in detail the life histories of some of them. Mose Yeyab, one of the first Bamum teachers at the mission school and later an ally of the French, Johanne Njimonya, Josua Mui'she, and Philippo Pepuere were four Bamum Christians whose paths she continued to follow after she had left Fumban (Rein-Wuhrmann 1948, 149–89).

Wuhrmann was unusual in that she occasionally expressed doubts about whether missionary doctrine had indeed served the Bamum. She criticized, for example, the mission's insistence that Bamum men who converted to Christianity give up all but one of their wives. She observed that some of the women sent back to their families had become promiscuous (Rein-Wuhrmann 1948, 129–30).

Unlike most of her fellow teachers, Wuhrmann held an unprejudiced view of the abilities of her students. In general, other teachers thought Bamum students were inferior to German students. One teacher, Friedrich Boger, complained about the disinterest of his students in arithmetic and their inability to sing German songs properly (Boger 1913, 3). Wuhrmann's evaluation of her students' talents and her perception of teaching were quite different.

I have experienced much joy in school and I see with satisfaction that in regards to

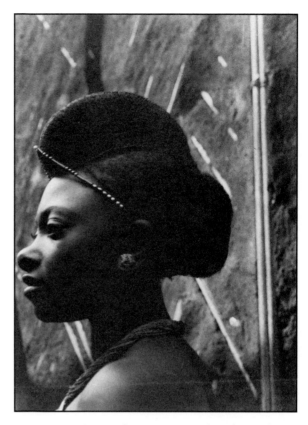

FIG. 81. *Nji Martha Munga, a daughter of King Njoya. Royal women used wigs and small frames to shape their coiffures. The styling technique was borrowed from the Fulbe people, but Bamum women created their own spectacular compositions. (Photograph by Anna Wuhrmann, c. 1913)*

intelligence my black girls are not at all inferior to our children at home. Unfortunately, we had no reading material for the whole year, because they had not yet decided whether one should continue to use the Bali primer.[4] Thus, no books were purchased. Now for 1913, the matter has been decided and German will be the language of instruction at the girls' school, too. My girls are mighty proud that they are now equal with the boys, and I am pleased that I may teach a new language to my intelligent group. (Wuhrmann 1913, my translation)

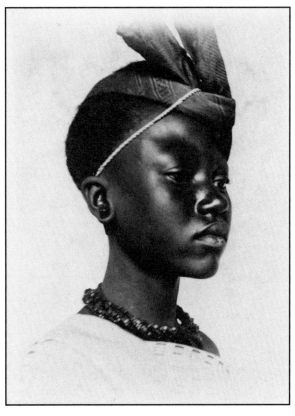

FIG. 82. *Nji Linzuom, a daughter of King Njoya. She wears an elegantly tied cloth band on her head, no doubt inspired by the elaborate head ties worn by women on the Cameroon coast. Many Bamum people worked in Douala and Buea with German traders and became familiar with coastal dress.* (Photograph by Anna Wuhrmann, c. 1913)

Her colleagues did notice how successful she was with her students. They could not deny that she had restructured the school and, as Eugen Schwarz wrote in his diary, raised it to a level never before attained (Schwarz 1917, 104).

Even if Wuhrmann had not left any writings, the numerous photographs she took of her charges, King Njoya, and other Bamum attest in visual form to her perceptions of them. She specialized in portraits. Compared with other images from the same period, her pictures are

warm and touching. She took close-ups of her friends, often with the background out of focus. At times she enhanced the softness of an image by printing it on textured paper. She frequently portrayed children and women at eye level (figs. 79–80) and sometimes from below (figs. 81–82). For photographs of men, she often chose a low camera angle to emphasize their statuesque appearance (figs. 78, 83, 84). Her preference for taking close-up portraits perfectly articulates her closeness to many Bamum and her admiration for their way of life and their beauty.

The various contexts in which Wuhrmann's images have appeared provide insights into how the use of a photograph transforms its meaning. In Wuhrmann's case, information is available about the private and public uses of the same photographs. The relationship between the unpublished and the published image—the change in meaning that visual materials sometimes undergo—is a fascinating area for research on the representation of the Other. Such research is only beginning, because the task is complex and the appropriate data are lacking. The preservation of materials containing Wuhrmann's work is a fortunate accident.

For personal pleasure, Wuhrmann compiled a photograph album, which the Basel Mission received from her estate when she died in 1971.[5] The album is bound in expensive leather and carries the gold-stamped inscription "Kamerun 1." It has the look of a professional product but in many ways is typical of photograph albums kept for personal memories. Small contact prints of the 8.5-by-12-centimeter negatives are glued to dark gray paper, a type of paper commonly used after the 1940s.[6] The photographs have no captions; Wuhrmann needed none, since she knew all of the people.

Between 1920 and 1921, after returning to Bamum as a missionary teacher for the French Mission de Paris, Wuhrmann made a more pub-

lic record. She put together six small loose-leaf albums of her photographs and carefully annotated each in German, treating the photographs as a visual record. To this day, the albums are kept in the missionary station in Fumban, which is now the administrative and residential center of the Eglise Evangelique, a Cameroonian church. Some of the photographs in the albums also appear in this book. Wuhrmann writes that the little girl in figure 80 is Po Puore, the six-year-old daughter of a Bamum noble. She characterizes Nji Linzuom, a daughter of King Njoya, as arrogant but intelligent (fig. 82). Margarete Sha'schempe, the wife of Nji Mama, a loyal servant of Njoya, is described as one of the best Christians in Fumban. On her forehead, the album caption points out, she wears a ring that indicates she is married (fig. 85). Wuhrmann writes that Nji Montien, a brother of the king, is polite but sly, and that his turban is six and a half meters long (fig. 83).

Some of the photographs in the albums also served as illustrations for Wuhrmann's later writings, most notably the portrait of King Njoya (fig. 78).[7] She published this picture twice, once as a frontispiece (1931) and once in an account of her four years in the service of the Basel Mission (1917, 43). In publications, the photographs carry only minimal captions, becoming generalized and representative images of Bamum. The personal, and at times unconventional, was transformed into the detached and conventional. How much of this impersonal presentation was the result of Wuhrmann's own effort to adopt the conventional idiom of her time and how much was simply the outcome of an editorial process will never be known. In any event, in published works Margarete Sha'schempe becomes an anonymous "woman with wedding band on her forehead" (Rein-Wuhrmann 1925, 45). Used to illustrate a description of Bamum women's hairstyles, the

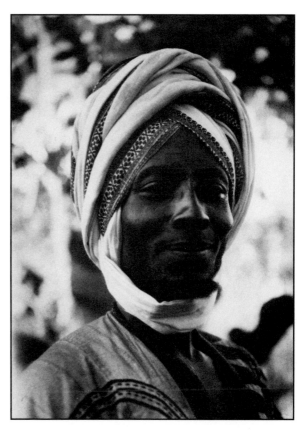

FIG. 83. *Nji Montien, a brother of King Njoya.* *(Photograph by Anna Wuhrmann, c. 1913)*

photograph of coquettish Nji Martha Munga, a royal daughter (fig. 81), is captioned "helmet coiffure" (Rein-Wuhrmann 1925, 42). Nji Montien (fig. 83) represents the archetypal "noble Bamum gentleman" (Rein-Wuhrmann 1925, 40).

The variability of an image's meaning can be further illustrated with other examples from Wuhrmann's oeuvre. At least two of her pictures were turned into postcards and distributed in France, undoubtedly because of her connection with the Mission de Paris. A profile portrait of Po Puore was published as a postcard captioned "Cameroon. Little girl of Fumban—Helena" (UNICEF 1979, 113). Daniel Pam, one of the mission school's students, also graces

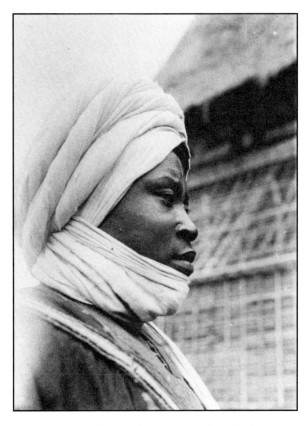

FIG. 84. *Moafon Njikam, a cousin of King Njoya.* (*Photograph by Anna Wuhrmann, c. 1913*)

a postcard captioned by the Missions Evangeliques in Paris "Sans souci [Happy go lucky] one of our students in teacher's training" (UNICEF 1979, 38). Finally, the exhibition of a selection of Wuhrmann's photographs at the National Museum of African Art in 1988 is yet another transformation. The images have become vignettes of the historical encounter between foreigners and King Njoya.

The relationship between the representatives of German colonialism and King Njoya abruptly ended in 1915 as a consequence of the First World War, which had quickly extended to the African colonies. German troops in Cameroon were attacked by British and French troops from neighboring colonies. Each European army was supported by African soldiers. Wuhrmann and Schwarz were in Fumban when the British arrived, and both left diaries describing their experiences during their last months in the kingdom.

The year 1915 was a time of anxiety for both the Germans in Fumban and King Njoya. The British had advanced from Nigeria into the Grassfields. Njoya supported the German war effort, providing porters and food. Wuhrmann taught her girls how to knit socks for the troops, and by October 1915 they had knitted 125 pairs. Wuhrmann, though, realized that her stay in Fumban would soon end. She began systematically to take photographs of the environment. At the same time, she wondered whether the British would confiscate her precious photographic plates (Wuhrmann 1916a, 9). Two of her last pictures in Fumban are her most beautiful. One shows Nji Mongu Ngutane, Njoya's firstborn daughter, holding her first baby, Amidu Munde (fig. 7). The other is a tender portrait of King Njoya proudly holding little Amidu in his arms (fig. 87).

At the beginning of December 1915, the British marched into Fumban and found the small group of missionaries huddled in the mission station. They took the Germans and Swiss citizen Wuhrmann prisoner, had them pack their belongings, and escorted them to the coast for internment. Schwarz wrote about the missionaries' exodus from Bamum.

> When we crossed the market square, the
> Bamum chief sat in front of his house,
> guarded by four soldiers. He saw us coming
> and wanted to get up in order to shake our
> hands and say good-bye, but the soldiers
> held him back and thus we could only wave
> at each other. Many Bamum people we
> knew passed us by and acted as if they had
> never known us. Some of our Christians had
> sneaked to the roadside, but there were only

a few. All of this made us very sad. . . .
The people, as if poisoned by the British in
such a short time, acted in a way that we
could not comprehend, and we were glad
when we were out of town. (Schwarz 1917,
183–84, my translation)

At the beginning of 1916, after a strenuous
march to the coast, Wuhrmann was freed by the
British. Her camera and her photographic
plates, however, had been taken. She wrote let-
ters requesting their return, including one letter
directly to the British general, and waited sev-
eral days before finally receiving them (Schwarz
1917, 194; Wuhrmann 1916, 14). Wuhrmann
was then put on a ship to Fernando Póo Island
off the coast of Cameroon, and from there she
took a steamer to Barcelona, Spain. Upon safely
returning to Basel, Wuhrmann deposited her
photographs and the glass negatives of some of
her fellow missionaries in the mission archives.
The fate of Wuhrmann's original glass negatives
is unknown. They have disappeared.

Cameroon came under French rule in 1916.
Wuhrmann, a Swiss citizen and fluent in
French, returned to Fumban in May 1920 as a
missionary teacher for the Mission de Paris and
stayed until January 1922. She found that King
Njoya had retired to his plantations in the coun-
tryside. As a result of his support of the Ger-
mans, his life under the French had been diffi-
cult from the beginning. In addition, the
French adopted a different colonial policy re-
garding chiefs. Instead of ruling through them
as the Germans had done, the French restricted
their autonomy and, ultimately, abolished
chiefship. In Bamum, the French administra-
tion named local representatives (*chefs superieurs*)
through whom they governed the region. These
new agents often had little connection to the
palace elite; they were outsiders who had come
to power through colonial circumstance. The
conflict between the colonial administrators and

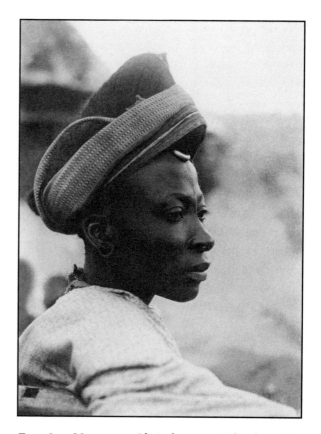

FIG. 85. *Margarete Sha'schempe, wife of royal
servant Nji Mama. The vertical scarification on
her forehead was a Bamum identification mark
in the nineteenth century.* (Photograph by Anna
Wuhrmann, c. 1913)

King Njoya grew in the years to come. In
French reports, Njoya is hardly recognizable as
the same man the Germans wrote about. As
portrayed in a 1923 report by a colonial admin-
istrator named Ripert, for example, Njoya is an
incarnation of the cruel African despot and a
sinister representative of paganism, mistreating
his subordinates and indulging in polygamy.
The myth of the noble savage had become the
myth of the ignoble savage (Tardits 1980, 997–
1003).

The tragic fate of King Njoya is recounted in
Wuhrmann's writings about her second stay in
Fumban. Her efforts to renew her friendship

with King Njoya failed, for he had withdrawn from Europeans. It also put her at odds with members in the Christian congregation who could not understand her concern for the so-called cruel pagan king.[8] She took few portraits of King Njoya between 1920 and 1922. The only close-up preserved in her personal photograph album shows a visibly aged and tired King Njoya, who was about forty-five years old at the time. In an astonishing departure from her usual style, she took several images of Njoya from a distance, including a photograph of him in the central hall of his new palace (fig. 88, p. 152). Standing alone, he is lost in the elegant vastness of the finest palace building he had constructed. The photograph captures the bitter disillusionment and isolation that King Njoya had experienced and that was to be his future.

Wuhrmann was disturbed and disappointed by the situation she found in Fumban during her second stay. She left Cameroon in 1922 and never returned. In 1923, at the age of forty-two, Wuhrmann once again took an unconventional path, marrying Dr. Rein, an educator from Saxony who was twenty-one years her senior. In the following years, she wrote extensively about Bamum and her experiences as a missionary.

Anna Wuhrmann died in Switzerland in 1971 at the age of eighty-nine. She is remembered in Fumban to this day. Na Wuhliman, as she is called there, is familiar not only to those very old Bamum who knew her but also to younger people, who have heard about the European woman who loved the Bamum people.

King Njoya was officially deposed by the French in 1924. He remained in Bamum but was perceived as a threat by the French colonial administration and by those Bamum who had allied themselves with the French, among them the Bamum Christians. Fearing his influence, the French finally exiled him to Yaoundé, where he died in 1933. In Switzerland, Anna Wuhrmann was deeply saddened by the fate of her friend.

> The king more and more turned away from us, and it was almost unbearable to see how he slipped deeper and deeper into misery, especially if one had known him in the old days and knew what an open and happy man he had been. He entered more and more into darkness, a mere shadow of himself. It was very sad. . . . Finally, he was stripped of his dignity, he was deprived of his throne, and then, as a poor, homesick man without a country, he lived and died in exile. "And then you leave him to torment," says Goethe . . . and indeed, King Njoya was left to torment by Europe. (Rein-Wuhrmann 1948, 71, my translation)

To this day, the photographs remain, telling of Bamum and King Njoya, preserving the splendor of the court, and reflecting the relationship between Europeans and the Bamum people at the beginning of the twentieth century.

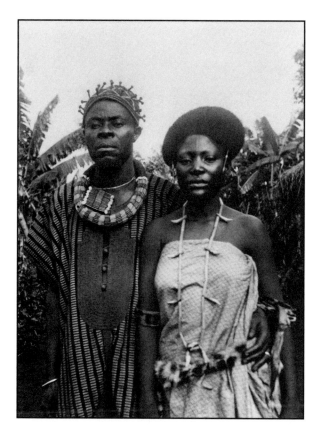

FIG. 86. *Lydia Mambuluene, a daughter of King Njoya, and Nji Tamkuo, a noble servant of the king, during their wedding. The bride wears a leopardskin belt and a necklace of leopard teeth. These two emblems of royalty were worn by all princesses during the public part of the wedding ceremony.* (Photograph by Anna Wuhrmann, c. 1914)

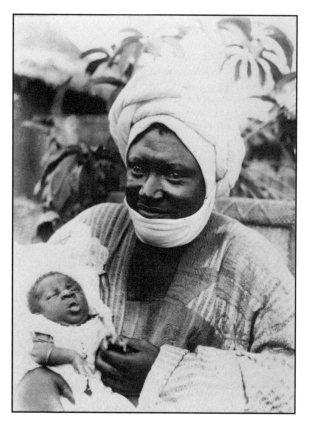

FIG. 87. *King Njoya with his first grandchild, Amidu Munde, the son of his daughter Ngutane. This is one of the last photographs taken of King Njoya before the Germans left Fumban.* (Photograph by Anna Wuhrmann, 1915)

Appendix

ALL OF THE PHOTOGRAPHS in this book were originally created on gelatin dry-plate glass negatives. Unfortunately, most of the negatives have been lost or destroyed, leaving only prints of the photographs. These loses mainly occurred during the two world wars. Some prints were made soon after the photographs were taken. In other cases, however, the only existing prints may be quite recent, even as late as the 1950s.

History has taken an unequal toll on the various collections of glass negatives. Most of Rudolf Oldenburg's negatives are intact and are preserved in the Museum für Völkerkunde Vienna. With one exception, the negatives of the photographs in this book by Marie-Pauline Thorbecke still exist in the photographic archives of the Rautenstrauch-Joest Museum Cologne; the negative of figure 23 was broken after a copy negative had been made. The entire collection of Franz and Marie-Pauline Thorbecke's negatives, however, is now less than a quarter of its original size. Bernhard Ankermann's collection in the Museum für Völkerkunde Berlin is also incomplete. The negatives as well as many of the prints were lost when the museum's photographic archives was destroyed during the Second World War. The photographic archives

of the Museum für Völkerkunde Leipzig was spared complete destruction, but no glass negatives of its Cameroon photographs exist. The Basel Mission Archive has a few negatives taken by its missionary photographers, including some of Eugen Schwarz's. Hanne Eckardt, Schwarz's daughter, has sixty of her father's negatives. Anna Wuhrmann's and Adolf Diehl's glass negatives have not survived.

The following list provides background information about each photograph. A diamond (♦) next to a figure number indicates that the photograph also appeared in the exhibition at the National Museum of African Art. An entry gives the source of the image reproduced in this book (print, original glass negative, or lantern slide), the date it was made, if known, and its size. The size is included because images on glass negatives were often cropped. (Two common sizes for glass negatives were 9 by 12 centimeters and 13 by 18 centimeters.) An entry has the notation "negative" if the original glass negative still exists. For this book, major damage and minor blemishes on some photographs were retouched. If any major retouching has been done, it is noted in the photograph's entry. Finally, the photograph's location and accession number are given.

FRONTISPIECE
Lantern slide
8.5 x 10 cm
Rautenstrauch-Joest Museum
 Cologne
No. 4585

♦ FIG. 1
Silver gelatin print, c. 1955
8 x 11 cm
Negative (no. 219)
Rautenstrauch-Joest Museum
 Cologne
No. 19333

FIG. 2
Silver gelatin print, c. 1924
13 x 18 cm
Negative
Museum für Völkerkunde
 Vienna
No. 49909

FIG. 3
Silver gelatin print, c. 1919
8 x 12 cm
Provided by the Deutsche
 Kolonialkriegerdank picture
 agency to the Museum für
 Völkerkunde Leipzig
No. MAf 2825

♦ FIG. 4
Silver gelatin print, c. 1924
12 x 16.8 cm
Negative
Museum für Völkerkunde
 Vienna
No. 17395

FIG. 5
Deutsches Kolonialblatt, January
 15, 1907, back cover

♦ FIG. 6
Silver gelatin print, 1912
11.5 x 16.6 cm
Basel Mission Archive
No. K 2016

♦ FIG. 7
Silver gelatin print, c. 1930 or
 later
8.3 x 11.2 cm
Basel Mission Archive
Photograph album of Anna
 Wuhrmann, no. RW 33/3

♦ FIG. 8
Silver gelatin print, 1916
Oval, 6.5 x 9 cm
Basel Mission Archive
No. K 2207

FIG. 9
Lantern slide
8.5 x 10 cm
Museum für Völkerkunde Berlin
No. VIII A 3222

FIG. 10
Silver gelatin print, before 1940
11 x 17.2 cm
Museum für Völkerkunde Berlin
No. VIII A 5430

FIG. 11
Silver gelatin print, before 1940
12.2 x 17 cm
Museum für Völkerkunde Berlin
No. VIII A 5431

FIG. 12
Silver gelatin print, before 1940
11.5 x 17 cm
Museum für Völkerkunde Berlin
No. VIII A 5432

FIG. 13
Silver gelatin print from
 stereographic glass negative,
 1906
7.5 x 10.7 cm
Basel Mission Archive
No. K 784

FIG. 14
Silver gelatin print, c. 1902–4
12 x 17 cm
Museum für Völkerkunde
 Leipzig
No. MAf 5097

FIG. 15
Proof from printing plate
10 x 14.6 cm
No photographic print or
 negative exists
Basel Mission Archive
No. Cl. 4176

♦ FIG. 16
Gelatin dry-plate negative,
 c. 1912
11 x 14 cm
Provided by missionary Johannes
 Keller to the Überseemuseum
 Bremen
No acquisition date or accession
 number

FIG. 17
Rein-Wuhrmann 1925, 155
No photographic print or
 negative exists
(Basel Mission Archive proof
 from printing plate: no. Cl.
 497)

FIG. 18
Silver gelatin print, 1916
8 x 11 cm
Basel Mission Archive
No. K 2283

♦ FIG. 19
Silver gelatin print, c. 1955
12.1 x 17.5 cm
Negative (no. 1032)
Rautenstrauch-Joest Museum
 Cologne
No. 19331

◆ Fig. 20
Silver gelatin print, c. 1902–4
12 x 17 cm
Museum für Völkerkunde
 Leipzig
No. MAf 5098

◆ Fig. 21
Silver gelatin print, 1904
8 x 11 cm
Museum für Völkerkunde
 Leipzig
No. MAf 5201

Fig. 22
Silver gelatin print, c. 1905
8 x 10.5 cm
Provided by Miss M. Schultz to
 the Hamburgisches Museum
 für Völkerkunde
Box 67, no. 14

◆ Fig. 23
Silver gelatin print, c. 1955
15.5 x 20 cm
Rautenstrauch-Joest Museum
 Cologne
No. 19336

Fig. 24
Rohrbach, n.d., frontispiece
No print or negative exists

◆ Fig. 25
Gelatin dry-plate negative,
 c. 1912
12.5 x 17.5 cm
Retouched
The Field Museum of Natural
 History, Chicago
Temporary no. 34854

◆ Fig. 26
Silver gelatin print, c. 1919
8 x 12 cm
Provided by the Deutsche
 Kolonialkriegerdank picture
 agency to the Museum für
 Völkerkunde Leipzig
No. MAf 2826

◆ Fig. 27
Silver gelatin print, before 1918
12 x 17 cm
Linden-Museum Stuttgart
No. Kam 68

◆ Fig. 28
Silver gelatin print, 1906 or
 later
9 x 10.5 cm
Provided by Lieutenant von
 Putlitz to the Linden-
 Museum Stuttgart
No. Kam 201

◆ Fig. 29
Silver gelatin print, 1924
11.2 x 16.2 cm
Negative
Museum für Völkerkunde
 Vienna
No. 17169

Fig. 30
Silver gelatin print, before the
 First World War
6 x 10 cm
Provided by Miss M. Schultz to
 the Hamburgisches Museum
 für Völkerkunde
Box 67, no. 64

Fig. 31
Silver gelatin print, before the
 First World War
10.2 x 16 cm
Provided by Miss M. Schultz to
 the Hamburgisches Museum
 für Völkerkunde
Box 67, no. 64

Fig. 32
Rein-Wuhrmann 1925, 115.

◆ Fig. 33
Silver gelatin print, c. 1924
11.2 x 17.2 cm
Negative
Museum für Völkerkunde
 Vienna
No. 17351

◆ Fig. 34
Silver gelatin print, c. 1924
8.5 x 14 cm
Hamburgisches Museum für
 Völkerkunde
Box 67, no. 10

Fig. 35
Silver gelatin print, c. 1904
10.5 x 15.8 cm
Retouched across top and on left
Linden-Museum Stuttgart
No. Kam 26

◆ Fig. 36
Silver gelatin print, c. 1924
13.2 x 18 cm
Negative
Museum für Völkerkunde
 Vienna
No. 17470

Fig. 37
Silver gelatin print, 1906
12 x 17 cm
Negative
Basel Mission Archive
No. K 936

◆ Fig. 38
Silver gelatin print, c. 1912
13 x 18 cm
Museum für Völkerkunde
 Leipzig
No. MAf 1525

◆ Fig. 39
Silver gelatin print, c. 1955
9 x 12 cm
Negative (no. 952)
Rautenstrauch-Joest Museum
 Cologne
No. 19339

♦ FIG. 40
Silver gelatin print, c. 1924
12 x 16 cm
Negative
Museum für Völkerkunde
 Vienna
No. 17174

♦ FIG. 41
Silver gelatin print, c. 1924
11.7 x 17.2 cm
Negative
Museum für Völkerkunde
 Vienna
No. 49878

FIG. 42
Silver gelatin print, before 1940
13 x 18 cm
Museum für Völkerkunde Berlin
No. VIII A 5417

FIG. 43
Silver gelatin print, before 1940
8 x 12 cm
Museum für Völkerkunde Berlin
No. VIII A 6742

FIG. 44
Silver gelatin print, c. 1930 or
 later
7.8 x 12.6 cm
Basel Mission Archive
Photograph album of Anna
 Wuhrmann, no. RW 25/1

♦ FIG. 45
Gelatin dry-plate negative,
 c. 1912
9 x 12 cm
Private collection of Mrs. Hanne
 Eckardt, Ludwigsburg

FIG. 46
Silver gelatin print, c. 1930 or
 later
8 x 10 cm
Basel Mission Archive
Photograph album of Anna
 Wuhrmann, no. RW 11/1

FIG. 47
Silver gelatin print, c. 1930 or
 later
8.8 x 11.1 cm
Basel Mission Archive
Photograph album of Anna
 Wuhrman, no. RW 10/5
(1916 print: no. K 2316)

♦ FIG. 48
Silver gelatin print, before the
 First World War
12.3 x 16.3 cm
Linden-Museum Stuttgart
No. Kam 67

♦ FIG. 49
Silver gelatin print, c. 1914
13 x 18 cm
Museum für Völkerkunde
 Leipzig
No. MAf 2028

♦ FIG. 50
Silver gelatin print, before 1940
12.5 x 17.5 cm
Museum für Völkerkunde Berlin
No. VIII A 5426

♦ FIG. 51
Silver gelatin print, 1916
8.1 x 11.2 cm
Basel Mission Archive
No. K 2265

♦ FIG. 52
Silver gelatin print, before 1940
11.2 x 17 cm
Museum für Völkerkunde Berlin
No. VIII A 5405

♦ FIG. 53
Silver gelatin print, 1904
8 x 11 cm
Museum für Völkerkunde
 Leipzig
No. MAf 5198

♦ FIG. 54
Silver gelatin print, c. 1918
12 x 17.7 cm
Hamburgisches Museum für
 Völkerkunde
Box 66, no. 7

♦ FIG. 55
Silver gelatin print, c. 1924
11.6 x 17 cm
Negative
Museum für Völkerkunde
 Vienna
No. 17425

♦ FIG. 56
Silver gelatin print, 1906
7 x 10.5 cm
Negative
Basel Mission Archive
No. K 782

♦ FIG. 57
Silver gelatin print, before the
 Second World War
11.5 x 17 cm
Provided by the Lohmeyer
 picture agency to the
 Museum für Völkerkunde
 Berlin
No VIII A 1736

♦ FIG. 58
Lantern slide
8.5 x 10 cm
Basel Mission Archive
No. K o.N. 30

♦ FIG. 59
Silver gelatin print, 1912
8.2 x 11 cm
Basel Mission Archive
No. K 1735

FIG. 60
Silver gelatin print, before 1940
12 x 16.6 cm
Museum für Völkerkunde Berlin
No. VIII A 5344

FIG. 61
Silver gelatin print, before 1940
8.5 x 11.5 cm
Museum für Völkerkunde Berlin
No. VIII A 6765

FIG. 62
Composite from two silver
 gelatin prints, before 1940
11.5 x 17 cm
Museum für Völkerkunde Berlin
Nos. VIII A 5331 and 5332

FIG. 63
Silver gelatin print, before 1940
12 x 17 cm
Museum für Völkerkunde Berlin
No. VIII A 5424

FIG. 64
Silver gelatin print, before 1940
12 x 17 cm
Museum für Völkerkunde Berlin
No. VIII A 5422

FIG. 65
Silver gelatin print, before 1940
11 x 17 cm
Museum für Völkerkunde Berlin
No. VIII A 5419

FIG. 66
Silver gelatin print, before 1940
12 x 17 cm
Museum für Völkerkunde Berlin
No. VIII A 5420

FIG. 67
Silver gelatin print, before 1940
12 x 17 cm
Museum für Völkerkunde Berlin
No. VIII A 5421

♦ FIG. 68
Silver gelatin print, c. 1955
13 x 18 cm
Negative (no. 293)
Rautenstrauch-Joest Museum
 Cologne
No. 19334

♦ FIG. 69
Silver gelatin print, c. 1924
12 x 17.2 cm
Negative
Museum für Völkerkunde
 Vienna
No. 17482

♦ FIG. 70
Silver gelatin print. c. 1955
9 x 12 cm
Negative (no. 307)
Retouched background on upper
 left
Rautenstrauch-Joest Museum
 Cologne
No. 19308

♦ FIG. 71
Silver gelatin print, 1912
10.8 x 16.6 cm
Basel Mission Archive
No. K 1994

♦ FIG. 72
Silver gelatin print, 1912
8 x 11 cm
Basel Mission Archive
No. K 1726

♦ FIG. 73
Silver gelatin print, c. 1924
12.2 x 17 cm
Negative
Museum für Völkerkunde
 Vienna
No. 49900

♦ FIG. 74
Silver gelatin print, c. 1924
12.3 x 16.4 cm
Negative
Museum für Völkerkunde
 Vienna
No. 17466

♦ FIG. 75
Silver gelatin print, c. 1924
12 x 17 cm
Museum für Völkerkunde
 Vienna
No. 17358

♦ FIG. 76
Silver gelatin print, 1916
8.2 x 11 cm
Basel Mission Archive
No. K 2240

FIG. 77
Silver gelatin print, c. 1930 or
 later
8 x 10.6 cm
Basel Mission Archive
Photograph album of Anna
 Wuhrmann, no. RW 22/1

♦ FIG. 78
Silver gelatin print, c. 1930 or
 later
8.2 x 11 cm
Basel Mission Archive
Photograph album of Anna
 Wuhrmann, no. RW 41/3
(1916 print: no. K 2205)

♦ FIG. 79
Silver gelatin print, c. 1930 or
 later
8.5 x 11 cm
Basel Mission Archive
Photograph album of Anna
 Wuhrmann, no. RW 18/5
(1916 print: no. K 2258)

♦ FIG. 80
Silver gelatin print, c. 1930 or
 later
8 x 11 cm
Basel Mission Archive
Photograph album of Anna
 Wuhrmann, no. RW 19/2
(1916 print on textured paper:
 no. K 2232)

♦ FIG. 81
Silver gelatin print, 1916
8.5 x 11.2 cm
Basel Mission Archive
No. K 2252

FIG. 82
Silver gelatin print, 1916
8.5 x 11.6 cm
Basel Mission Archive
No. K 2257

♦ FIG. 83
Albumen or gelatin print, 1916
5.5 x 11 cm
Basel Mission Archive
No. K 2219

FIG. 84
Silver gelatin print, 1916
8.5 x 11 cm
Basel Mission Archive
No. K 2236

♦ FIG. 85
Silver gelatin print, 1916
8.2 x 11.2 cm
Basel Mission Archive
No. K 2273

♦ FIG. 86
Silver gelatin print, 1916
8.5 x 11.2 cm
Basel Mission Archive
No. K 2231

♦ FIG. 87
Silver gelatin print, c. 1930 or
 later
8.5 x 10.6 cm
Basel Mission Archive
Photograph album of Anna
 Wuhrmann, no. RW 33/2
(1916 print: no. K 2266)

FIG. 88
Silver gelatin print, c. 1930 or
 later
6.5 x 9 cm
Basel Mission Archive
Photograph album of Anna
 Wuhrmann, no. RW 8/1

Notes

INTRODUCTION

1. A typical example of such an impressionistic approach is Timm's 1981 book on photography in the German colonies, *Deutsche Kolonien*. He intended to let the pictures speak for themselves. Without a critical evaluation and without providing a context, however, the photographs maintain the very stereotypes that the author wanted to reveal.

2. The scholarly study of North American Indian photographs has enjoyed great popularity among anthropologists and sets standards for research on cross-cultural photography. Among the major contributors to this field are Margaret B. Blackman and Joanna Cohan Scherer.

3. A recent study of an aspect of the photographic oeuvre of one photographer is a book about Hugo Bernatzik, an Austrian anthropologist and journalist who photographed in Africa. His daughter, Doris Byer, explored his depictions of foreign women (Byer 1985).

4. The photographs were provided by the following:
Basel Mission Archive, Switzerland
Collection of Mrs. Hanne Eckardt, Ludwigsburg, Federal Republic of Germany
The Field Museum of Natural History, Chicago
Frobenius-Institut Frankfurt, Federal Republic of Germany
Hamburgisches Museum für Völkerkunde, Federal Republic of Germany
Linden-Museum Stuttgart, Federal Republic of Germany
Museum für Völkerkunde Berlin, Federal Republic of Germany
Museum für Völkerkunde Leipzig, German Democratic Republic
Museum für Völkerkunde Vienna, Austria
Rautenstrauch-Joest Museum Cologne, Federal Republic of Germany
Überseemuseum Bremen, Federal Republic of Germany

CHAPTER ONE
Bamum before 1900: The History of a Kingdom

1. Throughout the text, I use the English spelling for names of places and ethnic groups rather than the French spelling that is common in Cameroon. Thus, I use *Bamum* instead of *Bamoum* and *Fumban* instead of *Foumban*. I have furthermore standardized the spelling of African names. In the German, French, and English literature, for example, the name of King Njoya is spelled many ways, among them Ndschoya, Joja, Yoya, and Nzueya. For the sake of readability, I use *Njoya*.

2. Mose Yeyab worked as a translator and administrator for the French. He was a Bamum Christian who had attended and taught at the Basel Mission school (Rein-Wuhrmann 1948, 149–68). His collection of Bamum art became the foundation for the museum.

3. In Shümom, the Bamum language, the ruler's title is *mfon*. This word is also used for the ruler of other kingdoms in the region. More generally, it applies to leaders of political units, not all of which are kingdoms. The present-day Bamum ruler is addressed as *sultan* because the court and many members of the Bamum elite have converted to Islam. In German sources on Bamum, one occasionally finds the designation *lamido*, a Fufulde term common in the neighboring Fulbe kingdoms.

4. Scholarly literature on the Bamum script abounds. See, for example, Dugast and Jeffreys 1950; Göhring 1907a, 1907b; *Histoire* 1952, 41; Schmitt 1963; and Tardits 1980, 211–12.

5. Henri Martin, a missionary who lived in Fumban, translated the chronicle of the Bamum Kingdom into French. I am referring to the French translation throughout this book.

6. The Bamum themselves maintain that Nshare Yen ruled from 1394 to 1418, but these dates cannot be substantiated. One of the most difficult tasks for the historian studying Africa is the establishment of chronologies. Many African kingdoms have existed for centuries, yet frequently there are no written records to aid in determining accurate dates for events. The rich oral traditions found in Africa, albeit excellent sources for research, may prove to be unreliable when it comes to dating. An indigenous chronology, such as that of Bamum, reveals the concept a people has about the past more often than it provides the facts that outside researchers are so keen to know. The Bamum dates for Nshare Yen's rule, for example, express that the kingdom is ancient and therefore give it legitimacy. In the flow of Bamum history, specific dates have little importance. Yet, to give those of us who were trained in a different tradition an idea of the time spans, Claude Tardits' work is helpful. Tardits, who has written the most comprehensive study of the

Bamum Kingdom, estimates that the kingdom was founded either in the second half of the sixteenth century or at the beginning of the seventeenth century.

7. The Bamum word *Femben*, transcribed by the Germans as *Fumban*, literally means "the ruins [or gravestones] of the Mben" (*Histoire* 1952, 260; Tardits 1980, 112).

8. Tardits was able to verify the information in the chronicle describing the defeat of eighteen chiefdoms. In fact, he found that more populations were absorbed into the kingdom (Tardits 1980, 102).

9. Once more, the authors of the chronicle omitted many small groups that the Bamum defeated. Tardits found evidence that twenty-one more groups were subdued or driven away by the Bamum (Tardits 1981, 410–11).

10. The traditional Bamum week has eight days: six workdays, a day of rest, and a market day.

11. The Islamic Hausa, a people of traders and craftsmen, spread from their empires in what is now northern Nigeria to many areas of West Africa.

12. In the Grassfields, cloth was woven from the fibers of the raffia palm, which grows in swampy river valleys. The raffia palm also provides building materials, and palm wine is made from its sap.

13. A number of saltwater snails with glossy shells are known as cowries. The cowrie in this case, *Cypraea annulus*, is found in the Indian and Atlantic oceans, and its white shell was traded throughout West and East Africa. Cowrie shells were commonly used in the arts and as money.

14. Several objects from this palace workshop can be seen in photographs. In this book, the crest to the right in figure 51 and the crest in figure 74 were created by carvers from the workshop. Other pieces, such as a throne, a large bell-shaped iron gong with a handle in the shape of a male figure, and a crest, are pictured in Geary 1983b, pls. 25, 118, 127. One of the workshop's best-known brasscastings is a small war gong with a handle in the shape of a human head (Geary 1982).

15. *Ardo* is the Fufulde word for "leader" or "king."

CHAPTER TWO
Photography in Cameroon: Applying a New Technology

1. The history and development of photography have been frequently recounted. A standard work is Newhall's *History of Photography* (1964). Crawford (1979) discusses early photographic processes. In a similar book, Cornwall (1979) focuses on the development of early photography in Germany.

2. One of the most popular early photographic techniques was the collodion, or wet-plate, process, invented in the 1850s. The photographer had to prepare the emulsion on a glass plate, shoot the photograph before the emulsion dried, and immediately develop the photograph in a darkroom. In contrast, the gelatin dry plate was already sensitized and could be stored after exposure and processed later. The dry plate was hailed as an important innovation, because photographers could devote their full attention to composing the picture rather than struggling with chemicals and equipment (Lichtwark 1894, 6–7).

3. In an 1898 photography manual, the author describes at length the different types of lenses available for the amateur. They included, for example, "portrait lenses," which admitted the most amount of light to the detriment of depth of field and sharpness, and slightly wider angle "landscape lenses" for use outdoors (Vogel 1898, 17–35). The amateur now had to make educated choices regarding lenses.

4. There were a number of techniques to improve photographic plates after the original development process had been completed. As explained in an 1899 booklet addressing "failures in photography," the techniques required a sound knowledge of chemistry. Most likely, however, Diehl referred to retouching the negative, a process in which an expert used a fine brush made from marten hair to apply India ink mixed with some rubber compound or egg white. Regular writing pencils served to cover blemishes (Müller 1899, 71–73).

5. Mansfeld later published a classic study titled *Jungle Documents: Four Years among the Cross River Negroes of Cameroon* (1908). It is richly illustrated with his photographs.

6. Freund (1980, 75) discusses the role of photography in the nineteenth-century debate about realism that raged among art historians and artists. In general, the attitude toward photography was positivistic, because photography was believed to imitate nature more completely and directly than any other process. Accurate imitation was the highest goal of the photographer, although by the turn of the century, it had been recognized that the photographic process could lead to distortions (Hübl 1898, 9–11). Recent discussions of the subjective and culture-bound nature of photography include Sekula 1975, Adams 1987, and Alloula 1986. Alloula explores the creation of stereotypical imagery of North Africa.

7. In some cases, missionary photographers kept their pictures of African life, or missionary society personnel selected only those images that suited their purposes. Thus, it is difficult to judge the oeuvre of a photographer by what can be found in missionary archives. A photographer's involvement with the African societies may not be obvious from the public record. The photographs of Eugen Schwarz are a typical example. He kept many of his pictures of everyday life in the Fumban missionary station and of the Bamum people who were his friends. Sixty original glass plates, including the plate for figure 45, are held by his daughter, Mrs. Hanne Eckardt.

8. *Kolonie und Heimat in Wort und Bild (Colony and Homeland in Word and Picture)* was typical in this respect. This official monthly organ of the women's chapter of the German Colonial Society illustrated all of its stories with photographs.

9. Not all of the negatives went to Vienna. Other museums have some Oldenburg photographs that are not in the Vienna collection. Among them is figure 54.

10. Decree no. 620, July 21, 1907. Cited in Ruppel 1912, 1154.

11. Kolonialkriegerdank, almost untranslatable, means "Thanks to the Colonial Warrior." The organization was established to support former colonial soldiers and their dependents. It also helped the families of those soldiers who had died in the colonies. Kolonialkriegerdank believed one of its duties was to collect the "valuable but scattered pictorial material" from the colonies and make it available to those interested in "flawless technical execution." It offered series of images to museums, charging 1.20 marks for a 13-by-18-centimeter photograph and 0.96 marks for a 9-by-12-centimeter photograph ("Letter of the Kolonialkriegerdank" 1911).

12. Ankermann must have spoken from experience. In his diary, parts of which were published posthumously by cultural anthropologists Baumann and Vajda (1959), he added a few rather clumsy line drawings. Unfortunately, Baumann and Vajda lost the diary, so the material not published in their paper will never be known.

13. Before the First World War, cultural anthropologists had ample opportunity to publish their photographs. Steiger and Taureg (1985, 117), who have done research on published images, attribute the flood of photographs in the literature of the period to the attraction of the new medium, the public's desire for pictorial information, and the growing emphasis on photography in anthropological research.

14. Personal communication of Professor Kurt Krieger, director emeritus of the Museum für Völkerkunde Berlin, who reestablished the photographic archives after 1945.

15. Literature on exoticism and Eurocentric fantasy about the Other exists in various disciplines and national scholarly traditions. One of the most relevant texts is Said's treatise on orientalism (1978). Said found it manifested in many ways, including fantasies about the Orient in literary form. Although Said does not deal with pictorial imagery, his analytical framework is equally relevant for pictorial production. Bitterli (1970, 79–105) discusses the discovery of the black African and the creation of stereotypes about Africa. An exemplary case study of British perceptions of

North American Indians in Virginia is Sheehan's *Savagism and Civility* (1980). Sheehan explores how reigning European ideas about American Indians influenced the perceptions of those who lived in the colony and shaped the political reality there. By extension, his findings can be applied to pictorial imagery. Finally, a 1987 exhibition cycle in Stuttgart should be mentioned. It focused on exoticism in a variety of European forms of expression, ranging from theater to architecture to posters. In their wealth of information and beautiful design, the eight catalogues accompanying the exhibitions are stunning. The main catalogue, titled *Exotische Welten: Europäische Phantasien* (1987), contains forty-five short essays, among them one on photography (Krauter 1987). Degenhard (1987) analyzes book illustrations in the same series.

CHAPTER THREE
Prestigious Images:
The Acceptance of Photography in Bamum

1. The English translation of passages from the Bamum chronicle is as close as possible to the French translation, because there is no direct translation of the chronicle from Shümom, the Bamum language, into English. Some of the nuance and meaning of the original text has probably been lost in the double translation.

2. In December 1901, for example, the kingdom of Bafut and its ally the kingdom of Mankon, both located near Bamenda, were attacked by the Germans. Bafut was destroyed and the palace was burned down; Mankon was ransacked. Captain Kurt Pavel's published report in the *Deutsches Kolonialblatt* paints a vivid picture of the German victory (Pavel 1902). The brutal reality of the attack, however, only becomes obvious in Pavel's unpublished official report. In the attack, 1,062 Bafut and 218 Mankon men, women, and children were killed, and 366 Bafut and 217 Mankon were taken as prisoners. Three hundred Bafut and 200 Mankon were forced to become laborers (Ruger 1960, 197).

3. Statistics regarding the white population in the Bamenda District at the beginning of 1907 are telling. Bamenda Station and the surrounding settlement had a population of eight Prussians: five in the military and three merchants. Bamum had a total of sixteen foreigners: eight from Prussia, one from Bavaria, three from Württemberg, one from Alsace, one from Switzerland, and two from England. Only one of the Bamum residents, a gardener who cared for an experimental farm, was a government representative. Of the others, eight were merchants and the rest missionaries, including a missionary's wife and child ("Übersicht über den Stand der weissen Bevölkerung," 1907). This is not to say the military administration had no influence in the region. The missionaries often acted as government agents, keeping Bamenda Station informed of the latest events. The merchants on the whole had a less than amicable relationship with the station, mainly because they often offended the missionaries by mistreating Africans and keeping mistresses. These statistics demonstrate the type of infrastructure existing at the time and also attest to Bamum's popularity among Germans and other Europeans.

4. For a discussion of the German colonial administration in the Cameroon Grassfields, see Chilver 1963.

5. Shortly after the arrival of the first Germans in Bamum, the colonial administration announced grand plans for the kingdom's future. Fumban was to become the final stop of a northern railroad line linking the Cameroon coast with the Grassfields. In October 1903, First Lieutenant Hirtler sought to interest King Njoya in the venture. He described the usefulness of the railroad and showed him several illustrated journals. In return for making Fumban a major trading center in the interior, Njoya was to provide workers for the ambitious project (Hirtler 1904, 587). The plans were never fully carried out. The Germans did, however, build a narrow-gauge railroad to Nkongsamba. Railroad and road construction in Cameroon claimed the lives of thousands of African workers who were pressed into service.

6. Steiger (1982) analyzes some of the Njoya photographs, in particular those in the Basel Mission Archive, the Museum für Völkerkunde Berlin, and several publications.

7. Personal communication of Dr. Aboubakar Njiasse-Njoya, son of Sultan Seidou and grandson of King Njoya.

8. The photograph and three other Bamum pictures were given to the Überseemuseum Bremen by a missionary named Keller, very likely Jakob Keller of the Basel Mission. He worked in Bali from 1904 to 1907 and again from 1909 to 1914.

9. Photographing deceased persons was not an unusual practice at the time. There are several examples of early photographs taken in Cameroon showing deceased chiefs. Indeed, at the turn of the century, photographing the dead before burial, particularly if they were children, was common in rural North American communities (Lesy 1973).

10. A magic lantern was a device with a set of lenses and a light source used to project an image onto a screen or wall. Numerous models were available. Some used an electric light, and others had a bright light such as a limelight inside the apparatus. Most commonly, standard-size commercial lantern slides were projected, but photographers also made their own photographic positives to use in magic lanterns. Photographic positives were easy to make. A negative was placed on a fresh glass plate in a special copy frame and exposed. Then the plate was developed (Vogel 1898, 264–67).

11. The various types of new images from Europe necessitated the introduction of a new word: *fitu*, a term derived from the German *Foto* (Rein-Wuhrmann 1925, 114).

12. Whether actual portraits of kings and queens are among Bamum sculptures has never been satisfactorily determined. A tradition of representing high-ranking retainers and warriors seems to have existed. These portraits surrounded the king, enhancing his power and symbolizing his wealth in people (Geary 1983b, 45–46, 202).

13. Such assumptions about the acceptance of photography are at this point hypothetical. It

would be interesting to look at the acceptance of photography in other hierarchically organized African states with salient representational traditions in their arts. Ample photographic documentation exists, for example, on the Asante Kingdom in Ghana. The Basel Mission Archive and the Commonwealth Library in London have fine collections from southern Ghana (Jenkins and Geary 1985, 56–60; McLeod 1981). Given that the Asante Kingdom was attacked and destroyed by the British, the nature of the interaction between photographers and photographic subjects and the reasons for the large photographic record are ripe areas for exploration.

CHAPTER FOUR
A Myth Comes to Life:
King Njoya in Photographs

1. Information about some government and military photographers can be found in the *Deutsches Kolonialblatt* listings of departures, arrivals, and promotions of personnel in the colonies. Since the listings usually supply only the family name and the rank of the officials, the first names of most of them remain unknown. According to the *Deutsches Kolonialblatt*, Dietze served in Cameroon from September 1900 to September 1903. He then returned to Saxony.

2. The photographs were given by a Miss Schultz to the Museum für Völkerkunde Hamburg before 1905. Reference to a merchant by the name of Schulz (probably a misspelling) occurs in the very first missionary reports from Bamum. He represented the Gesellschaft Nordwest-Kamerun, a large trading concession (Göhring 1906b, 26).

3. See the similar poses of Yoruba men in photographs reproduced in Sprague 1978a, 52–53.

4. See, for example, the seminal paper by Joanna Scherer (1975) that discusses inaccuracies in North American Indian photographs.

5. The photograph has been widely reproduced. It was published, for example, in Bernatzik (1939, 356) without attribution. Recently, it has been used in Geary (1983b, 32) and as a mural in the Museum für Völkerkunde Berlin.

6. Rohrbach used the same image and provided a more extensive caption. It contains all the elements of the Njoya myth occurring in German literature. "Njoya, the ruler of Bamum, in richly embroidered Hausa garments at the door of his palace. He is unusually intelligent, has invented his own script, built a school, and promotes the crafts, loves and maintains the native culture appropriate for his people, and wants to adopt the foreign only if it serves his people" (Rohrbach, n.d., frontispiece, my translation).

7. To my knowledge, this is the only original photograph of King Njoya in a North American archives. It came to the Field Museum of Natural History in Chicago in 1924, when Berthold Laufer, a curator, bought a huge collection of Cameroonian artifacts from Germany. With it he also received 332 of Schröder's glass negatives without charge. The artifacts and the photographic plates, all dating from before the First World War, were acquired from the J. F. G. Umlauff company, a self-styled museum and ethnographic institute in Hamburg that provided museums with objects from all over the world. Umlauff also sold enlargements of this picture of Njoya. The Basel Mission, for example, has a large cardboard mounted print of the portrait, which was published in Geary and Njoya 1985, 85. Unfortunately most of the 13-by-18-centimeter gelatin dry-plate negatives in Schröder's collection were deaccessioned by the Field Museum, reducing the collection to a mere forty-seven plates.

8. Captain Glauning was the head of the Bamenda military station until his death during a military campaign on March 5, 1908. Governor Ebermaier held his post from 1912 to the end of the German presence in Cameroon in 1916.

9. The lantern slide was distributed during the Third Reich by the nationalistic Deutsche Reichskolonialbund, an organization composed of several former colonial associations. Founded in 1933 and dissolved in 1943, it advocated the return of the colonies to Germany (Gründer 1985, 228–31). The photographic archives of the Reichskolonialbund has been transferred to the Frobenius-Institut in Frankfurt. The thousands of

glass plates, lantern slides, and films, however, still await indexing and documentation. Most of the Cameroon material in this collection predates the First World War.

10. Under the guidance of several prominent Bamum scholars, among them historian Dr. Aboubakar Njiasse-Njoya, many of these writings have been transcribed by Nji Fifen, an old noble who learned the Bamum script under King Njoya and then taught it, and by Ndayou Njoya Emmanuel, personal secretary of the present sultan of Bamum.

11. Reports can be found in F. Thorbecke 1914, 19–20, and Rein-Wuhrmann 1925, 89–90. A photograph of the weaving workshop has been published in Geary and Njoya 1985, 146.

12. Njoya's efforts as a cartographer were stimulated by a visit to Fumban by Max Moisel, who created the standard maps of the colony (Moisel 1908). The king soon had maps of Fumban and Bamum country drawn by Nji Mama, one of the courtiers. Some of these maps are discussed in Schmitt 1966 and Savary 1977, 126–29.

CHAPTER FIVE
Glimpses of Reality:
The Palace and Its Inhabitants

1. For a comprehensive discussion of Bamum political structure and the roles of the palace inhabitants, as well as an explanation of the layout and symbolism of the palace, see Tardits 1980, 572–601, and Tardits 1985.

2. A photograph without a caption is often useless in research. Even assigning it to the correct continent may be impossible. Scholars specializing in particular areas can identify some of the odd images. This was the case with figure 16, for example, which I found among general West African imagery at the Überseemuseum Bremen.

3. See Ernst 1903, Ernst 1904, Lutz 1906, and Stolz 1906a. Ernst's report on the palace was published in the *Evangelischer Heidenbote* in 1904, but there is also an original report in the Basel Mission Archive. In those instances in which the original handwritten report has been preserved, I

refer to the primary source. Frequently, the version of a report published in the *Evangelischer Heidenbote* was abbreviated and heavily edited. This was not the case, however, with Ernst's report.

4. See *Histoire* 1952, 33, 55, and Tardits 1980, 573. Nji Mama, a servant of King Njoya, drew a plan of the central part of the palace in 1917 or 1918, which was published much later by Labouret (1935, 123) in an essay on the old palace of Fumban. Alfred Schmitt (1966) discussed this plan of the palace. Tardits used the plan for his analysis of the palace and interviewed contemporaries of King Njoya to annotate and correct Labouret's findings (Tardits 1980, 572–601; Tardits 1985).

5. Seeing photography as part of his missionary activities, Martin Göhring wanted to create documents for the congregation at home (Geary and Njoya 1985, 34). According to one of his letters to a friend, he wrote an essay titled "My Camera in the Service of the Mission" (Göhring 1907c). Paul Jenkins, the archivist at the Basel Mission, and I were unable to find the essay.

6. Bernhard Ankermann and his wife spent most of their time in Cameroon doing research in Bali. They visited Bamum at the end of March 1908, returning to Bali by the middle of May. In February 1909 they again spent seven weeks in Fumban (Ankermann 1910a, 290–91).

7. The friezes are made from grass that is twisted together in longish bundles. The tips of some bundles are blackened with fire. The bundles are placed on top of each other, alternating light and dark bundles to create the design.

8. Rohrbach (1907, 7) first published figure 40 in late 1907 in a paper about the Bamum Kingdom. The photographer is identified as B. Rengert. The negative, however, is part of the Oldenburg collection at the Museum für Völkerkunde Vienna. Sometimes photographers claimed the images of others as their own. Copyright restrictions were not yet in place.

9. When I did research on the photographs in Bamum in 1984, only three traditional houses with raffia-pole construction and grass roofs were left in all of Bamum. Houses are now constructed either with mud bricks and corrugated tin roofs or, if the family can afford it, with concrete blocks.

10. King Njoya enjoyed experimenting with new vegetables and fruits. According to German reports, he kept his own gardens (Stössel 1907). His interest in introducing vegetables and fruit trees was no doubt one of the reasons for growing papaya trees in the audience courtyard.

11. The huge palace buildings, constructed with ribs from raffia fronds and grass thatching, were always in danger. During the rainy season, the wet grass roofs at times became so heavy that they threatened to crush the buildings. During the dry season a spark could cause devastating fires.

12. The 1931 book contains an account of Wuhrmann's work as a schoolteacher and short stories about Christians and pagans in Bamum. Figure 44 accompanied an essay titled "To Move Stones," which describes the long suffering of Margarete Scha'schempe (fig. 85). She was a Christian wife whose husband, Nji Mama, had abandoned Christianity (Rein-Wuhrmann 1931, 79–80).

13. *Nji mongu* is the title of the firstborn daughter and means "the daughter of the land" (*nji*, title of nobility; *mo*, "child"; *ngu*, "land").

14. Wuhrmann frequently wrote about women and girls in Bamum. In particular, see the chapter "The Women of the Bamum Tribe" in Rein-Wuhrmann 1931, 30–50.

15. Figure 48 is one of three photographs Adolf Diehl took at the same session, most likely during a visit in March 1906. All three are preserved in the archives of the Museum für Völkerkunde Leipzig. Two show Njoya with his wives (nos. MAF 1529, MAF 2029). Only figure 48 depicts four of the wives by themselves, although it is nevertheless captioned "Lamido Joia with wives and entourage" (no. MAF 2006).

16. Travelers were well aware of the popularity of velvet in the Cameroon Grassfields and would trade it for ethnographic objects. Ankermann, for example, ordered cheap velvet to give to King Njoya. He was toying with the idea of giving the king a picture of Emperor Wilhelm II but decided that velvet would keep its value. Other barter articles much in demand were mirrors and spoons (Ankermann 1908).

17. In a confidential quarterly report for 1908, Göhring notes the opinion of First Lieutenant Menzel, head of the Bamenda Station. "Regarding polygamy, he is of the opinion that the introduction of the monogamous marriage is premature; polygamy has its roots in the economy, and only if people have improved their economic situation is monogamous marriage appropriate" (Göhring 1908, 4, my translation).

18. Njapndunke's use of a palanquin is unprecedented in the Cameroon Grassfields. No other instance of palanquin use has been documented. Although the German interpretation that the palanquin served as a means of transportation for this very heavy woman seems to be accurate, it also signified her rank by placing her above everybody else.

CHAPTER SIX
Art and Ritual Recorded: Using Photographs in Research

1. Tragically, the Museum für Völkerkunde Berlin lost the greater part of this well-documented collection during the Second World War. Only 405 objects remain, according to my count.

2. Until recently, for example, the Basel Mission, maintained its own ethnographic collection. The missionaries in Bamum contributed some objects, such as tobacco pipes and a headdress that was owned by Queen Mother Njapndunke. The collection was transferred to the Museum für Völkerkunde Basel in 1980.

3. Slit gongs, at times also called slit drums, are idiophones made from hollowed-out tree trunks. The player can produce at least two tones by hitting the wood on either side of the central slit. Besides slit gongs, the Bamum have membranophone drums of various sizes (see fig. 61).

4. The photograph had not yet dried when it was sent from Nssanakang, located near Mamfe (Diehl 1906a). Perhaps this is the reason it is not in the Leipzig museum today.

5. Ramsay (1905, 273) mentions a slit gong in his *Globus* report about Bamum. Hutter (1907, 29) includes a sketch in his more detailed account about Bamum art and material culture. He also gives the dimensions of the gong. The diameter measured one meter; the length of the actual gong section, five meters; and the length of the figure, two meters.

6. It is typical, for example, that the photographic records of Bernhard Ankermann were not consulted when Baumann and Vajda edited his field notes. In several instances, the photographs are depictions of objects and events described in Ankermann's diary (Baumann and Vajda 1959).

7. A caryatid supports the round seat of this colorful stool, which is now in the Museum für Völkerkunde Berlin. It depicts a male servant in a submissive pose who holds a receptacle (Geary 1981a, 43; Krieger 1969, 11).

8. For a more detailed interpretation, see Geary 1981 and Geary 1983a.

9. Another remark by Marie-Pauline Thorbecke is informative. According to her observations, an old man revived and practiced an almost forgotten Bamum "play" with other Bamum (M. P. Thorbecke 1914, 56). The word *play* is a pidgin expression meaning "festival" that was commonly used in the German literature.

10. Bark cloth was produced primarily from the bark of the *Ficus mucosus*. The bark was peeled off in strips and then beaten into a thin fibrous tissue with a smooth rock. Sometimes, small portions of the cloth were gathered and tied off. The cloth was then dyed in mud; the tied areas resisted the color. This created the circular patterns visible on two loincloths in figure 60. Loincloths made from bark cloth were widely worn during the nineteenth century before cotton fabrics were imported on a large scale. After 1900 they were still worn by some common people in the Bamum countryside.

11. The secret Mbansie society no longer exists at the Bamum court, but its vigorous and exciting music and dances have not been forgotten. In 1984 a group under the guidance of Dr. Aboubakar Njiasse-Njoya recreated the music and dance of Mbansie in the palace. The group used rattle bags, iron gongs, and drums, including the drum with a base of anthropomorphic figures that is pictured on the far right of figure 61.

12. The cloth consists of cotton strips that were sewn together and dyed in indigo. The dyeing technique, introduced at the Bamum court by King Njoya, has been frequently described. An intricate pattern is outlined on a cloth and then sewn over with thread made from raffia fiber. During the dyeing process, the tightly stitched areas resist the dye. When the raffia thread is removed, a whitish pattern appears (Lamb and Lamb 1981, 26–28).

13. Rein-Wuhrmann (1925, 90) and Ankermann (Baumann and Vajda 1959, 286) briefly mention dyeing at the royal court. Dyeing was likely introduced about the turn of the century by Hausa specialists at the request of King Njoya. Venice and Alastair Lamb (1981, 32) suggest that *ndop* production in Bamum lasted for only a short period after the First World War. Using some photographs as evidence, they erroneously claim that *ndop* did not occur in images taken before 1914. This error, no doubt caused by unsystematic work with photographs, demonstrates that photographic research requires methodological sophistication and diligence.

14. A similar bag is in the Bamum Palace Museum collection. According to older people in present-day Bamum, it was the bag Queen Mother Njapndunke used during the Nja festival (Geary 1983b, 169, no. 112).

15. In 1984 I was able to observe the dancing of this masquerader during the performance of several Bamum dances for a television film.

16. These remarks are a simplified version of Rowlands's complex discussion of Grassfields material symbolism in a recent paper about Grassfields palaces (1985, 204–5).

17. For a detailed discussion of the crest and the ritual, see Geary 1988.

18. Oldenburg, a merchant, dreamed of being recognized as a cultural anthropologist in Vienna, where he returned in 1913 after his stay in Cameroon. He published one paper on Bamum in which he included a photograph taken during the same session as figure 75. The photograph shows the first and third crests from the left in figure 75 (Oldenburg 1930, 162). It was the great disappointment of his life that his work was never fully recognized by the Viennese university establishment.

CHAPTER SEVEN
**Through a Woman's Eyes:
The Images of Anna Wuhrmann**

1. Marie-Pauline Thorbecke painted several oil paintings and watercolors, including a picture of King Njoya that is now in the Rautenstrauch-Joest Museum Cologne. Most of her works are preserved in the Völkerkundliche Sammlungen der Stadt Mannheim at the Reiss-Museum. Some of her watercolors have been published in F. Thorbecke 1914.

2. One of the few references to her acceptance in Fumban is contained in a note that Martin Göhring added to Wuhrmann's annual report for 1914. He wondered whether Njoya would be as generous toward any other missionary sister as he was toward her (Wuhrmann 1914).

3. Hanne Eckardt, the daughter of missionary Eugen Schwarz, knew Anna Wuhrmann. According to recollections about life in Fumban told to Eckardt by her parents, Wuhrmann had all the privileges of an unmarried male missionary. She did not keep house, and instead of cooking, she ate with the Schwarz family. Mrs. Schwarz, herself a trained teacher, often resented Wuhrmann's independence and her privileged position among the missionary women in Fumban.

4. The colonial administration mandated that the mission schools use German as the language of instruction. In the Cameroon Grassfields, however, the Basel Mission refused for a long time to adopt German. Instead, the mission promoted Mungakka, the Bali language, as a lingua franca and as the language to be used in all schools.

5. Late in life, Wuhrmann lived near the Basel Mission's main headquarters in Basel. She was no longer on good terms with the mission's administration, because she felt her work had gone unappreciated. Considering the long-standing rigid structure of the mission and the second-class role of women in it, Wuhrmann indeed had valid reasons for her sentiments. When she died in 1971, her family gave the photograph album and some papers to the mission archives. Unfortunately, many of her Bamum photographs were discarded with the trash when her apartment was vacated.

6. It is difficult to date this album. I assume that Wuhrmann put it together in the 1940s or 1950s. If she made a "Kamerun 2" album, it has not been deposited in the Basel Mission Archive.

7. Steiger's 1982 thesis contains an interesting analysis of the use of Bamum pictures in Basel Mission publications.

8. When the German missionaries left, Njoya became an ardent Muslim. He prosecuted the Fumban Christians because he believed that they would undermine his authority.

Bibliography

Adams, Monni. 1987. "Commentary: Looking Beyond the Photographic Image." *Visual Resources* 4:273–81.

Alloula, Malek. 1986. *The Colonial Harem.* Minneapolis: University of Minnesota Press.

"Ankauf der Sammlung Oldenburg." February 13, 1929. Archives of the Museum für Völkerkunde Vienna. Post X, 1929.

Ankermann, Bernhard. 1908. "Letter to Felix von Luschan." January 23, 1908. Archives of the Museum für Völkerkunde Berlin. E 436/08.

———. 1910a. "Bericht über eine ethnographische Forschungsreise ins Grasland von Kamerun." *Zeitschrift für Ethnologie* 42:288–310.

———. 1910b. "Über die Religion der Graslandbewohner Nordwest-Kameruns." *Korrespondenzblatt der Gesellschaft für Anthropologie, Ethnologie und Urgeschichte* 41:81–82.

———. 1914. *Anleitung zum ethnologischen Beobachten und Sammeln.* Berlin: Georg Reimer.

Banta, Melissa, and Curtis M. Hinsley. 1986. *From Site to Sight: Anthropology, Photography, and the Power of Imagery.* Cambridge, Mass.: Peabody Museum Press.

Baumann, Hermann, and Lazlo Vajda. 1959. "Bernhard Ankermanns völkerkundliche Aufzeichnungen im Grasland von Kamerun 1907–1909." *Baessler Archiv* N.F. 7 (2): 217–317.

Ben-Amos, Paula. 1976. "Men and Animals in Benin Art." *Man* n.s. 2 (2): 243–52.

Bensusan, A. D. 1966. *Silver Images: History of Photography in Africa.* Cape Town: Howard Timmins.

Bernatzik, Hugo A. 1939. *Die grosse Völkerkunde: Sitten, Gebräuche und Wesen fremder Völker.* Vol. 1, *Europa, Afrika.* Leipzig: Bibliographisches Institut.

Bertillon, Alphonse. 1895. *Die gerichtliche Photographie.* Halle a.S.: Wilhelm Knapp.

Bitterli, Urs. 1970. *Die Entdeckung des schwarzen Afrikaners.* Zurich: Atlantis.

Boger, Friedrich. 1913. "Second Quarterly Report." July 3, 1913. Basel Mission Archive. E-2, 43, item 49.

Borgatti, Jean M. 1980. *Levels of Reality: Portraiture in African Art.* Working Papers, no. 36. Boston: African Studies Center, Boston University.

Byer, Doris. 1985. *Fremde Frauen: Photographien des Ethnographen Hugo A. Bernatzik.* Vienna: Verlag Christian Brandstätter.

Chilver, Elizabeth M. 1963. "Native Administration in the West Central Cameroons 1902–1954." In *Essays in Imperial Government*, edited by Kenneth Robinson and Frederick Madden, 89–139. Oxford: Basil Blackwell.

———. 1966. *Zintgraff's Explorations in Bamenda, Adamawa and the Benue Lands, 1889–1892*. Buea: Government Printer.

Collart, R., and G. Celis. 1984. *Burundi: Trente ans d'histoire en photos, 1900–1930*. Namur, Belgium: Collart; Brussels: Celis.

Cornwall, James E. 1979. *Die Frühzeit der Photographie in Deutschland 1839–1869*. Herrsching/Ammersee: Verlag für Wirtschaft und Industrie.

Crawford, William. 1979. *The Keepers of Light: A History and Working Guide to Early Photographic Processes*. New York: Morgan and Morgan.

David, Philippe. 1978. "La carte postale sénégalaise." *Notes africaines* 157:3–12.

———. 1982. "La carte postale ivoirienne de 1900 à 1960." *Notes africaines* 174:29–39.

Degenhard, Ursula. 1987. *Entdeckungs- und Forschungsreisen im Spiegel alter Bücher*. Stuttgart: Edition Cantz.

Diehl, Adolf. 1902. "Letter to the Director of the Museum für Völkerkunde Leipzig." November 20, 1902. Archives of the Museum für Völkerkunde Leipzig. 1903/45.

———. 1903a. "Letter to the Director of the Museum für Völkerkunde Leipzig." January 18, 1903. Archives of the Museum für Völkerkunde Leipzig. 1903/45.

———. 1903b. "Letter to Director of the Museum für Völkerkunde Leipzig." August 20, 1903. Archives of the Museum für Völkerkunde Leipzig. 1903/58.

———. 1906a. "Letter to the Director of the Museum für Völkerkunde Leipzig." February 4, 1906. Archives of the Museum für Völkerkunde Leipzig. 1906/51.

———. 1906b. "Letter to the Director of the Museum für Völkerkunde Leipzig." March 10, 1906. Archives of the Museum für Völkerkunde Leipzig. 1906/51.

———. 1907. "Letter to the Director of the Museum für Völkerkunde Leipzig." August 10, 1907. Archives of the Museum für Völkerkunde Leipzig. 1910/3.

Dinkelacker, Ernst. 1911. "Neues aus der Graslandstadt Fumban und dem König Ndschoya." Basel Mission Archive. E-2, 34, item 62.

Dugast, Idelette, and M. D. W. Jeffreys. 1950. *L'écriture des Bamum: Sa naissance, son évolution, sa valeur phonétique, son utilisation*. Mémoires de l'Institut Français d'Afrique Noire, Centre du Cameroun. Série: Populations, no. 4.

Edwards, Elizabeth, and Lynne Williamson. 1981. *World on a Glass Plate: Early Anthropological Photographs from the Pitt Rivers Museum, Oxford*. Oxford: Pitt Rivers Museum, University of Oxford.

Eine Reise durch die Deutschen Kolonien. 1910. Vol. 2, *Kamerun*. Berlin: Verlag kolonialpolitischer Zeitschriften.

Ernst, Ferdinand. 1903. "Reisebericht von Bali nach Bamum." Basel Mission Archive. E-3, 16, item 223. (Unpublished version of Ernst, "In einer afrikanischen Festung.")

———. 1904. "In einer afrikanischen Festung." *Evangelischer Heidenbote* 77 (3): 19–22.

Evangelischer Heidenbote. 1913. 86 (1): 4.

Exotische Welten: Europäische Phantasien. 1987. Stuttgart: Institut für Auslandsbeziehungen und Württembergischer Kunstverein, Edition Cantz.

Forlacroix, Christian. 1970. "La photographie au service de l'histoire de l'Afrique." *Cahiers d'Etudes Africaines* 10:125–43.

Fraser, Douglas, and Herbert M. Cole. 1972. *African Art and Leadership*. Madison: University of Wisconsin Press.

Freund, Gisèle. 1980. *Photography and Society*. Boston: David R. Godine.

Gann, L. H., and Peter Duignan. 1969. "Reflections on Imperialism and the Scramble for Africa." In *Colonialism in Africa. 1870–1960*, vol. 1, edited by L. H. Gann and Peter Duignan, 100–131. Cambridge: Cambridge University Press.

Geary, Christraud M. 1981. "Bamum Thrones and Stools." *African Arts* 14 (4): 32–43.

———. 1982. "Casting the 'Red Iron': Bamum Bronzes." In *The Art of Metal in Africa*, edited by Marie-Thérèse Brincard, 71–78. New York: The African-American Institute.

———. 1983a. "Bamum Two-Figure Thrones: Additional Evidence." *African Arts* 16 (4): 46–53.

————. 1983b. *Things of the Palace: A Catalogue of the Bamum Palace Museum in Foumban (Cameroon).* Studien zur Kulturkunde, no. 60. Translated by Kathleen M. Holman. Wiesbaden: Steiner Verlag.

————. 1984. "Mandu Yenu: A Bamum Throne." *Bulletin de l'association des amis du Musée Barbier-Mueller* 24.

————. 1986. "Photographs as Materials for African History: Some Methodological Considerations." *History in Africa* 13:89–116.

————. 1988. "Messages and Meaning of African Court Arts: Warrior Figures from the Bamum Kingdom." *Art Journal of the College Art Association of America* (Summer). Forthcoming.

————. Forthcoming. "Images of the African Past: Interpreting Ethnographic Photographs from Cameroon." *Visual Anthropology.*

Geary, Christraud, and Adamou Ndam Njoya. 1985. *Mandou Yénou: Photographies du pays Bamoum, royaume ouest-africain, 1902–1915.* Munich: Trickster Verlag.

Geprägs, Christoph. 1912. "Annual Report 1911." January 16, 1912. Basel Mission Archive. E-2, 34, item 63.

Glauning, Hans. 1906. "Bericht des Hauptmanns Glauning in Bamenda über die Bansso-Expedition." *Deutsches Kolonialblatt* 17:705–7.

Göhring, Margaretha. 1906. "Einen Gruss aus Bamum an die Leser des Heidenfreunds!" July 18, 1906. Basel Mission Archive. E-2, 22, item 280a.

Göhring, Martin. 1906a. "Letter from Fumban." May 13, 1906. Basel Mission Archive. E-2, 22, item 279.

————. 1906b. "Letter from Fumban." November 25, 1906. Basel Mission Archive. E-2, 22, item 281.

————. 1907a. "Der König von Bamum und seine Schrift." *Evangelischer Heidenbote* 80 (6): 41–43.

————. 1907b. "Die Bamumschrift." *Evangelischer Heidenbote* 80 (11): 83–86.

————. 1907c. "Letter to Reverend Würz." May 29, 1907. Personal Folder. Basel Mission Archive. Brüder-Verzeichnis 1305.

————. 1908. "Quarterly Report." October 2, 1908. Basel Mission Archive. E-2, 28, item 64.

————. 1911. "Annual Report for the Year of 1910." January 29, 1911. Basel Mission Archive. E-2, 32, item 64.

Gründer, Horst. 1985. *Die Geschichte der deutschen Kolonien.* Paderborn: Ferdinand Schöningh.

Harter, Pierre. 1986. *Arts anciens du Cameroun.* Arnouville: Arts d'Afrique Noire.

Hirtler, Oberleutnant. 1904. "Bericht des Oberleutnants Hirtler über eine Erkundungsreise von Bamum nach Jabassi." *Deutsches Kolonialblatt* 15:587–91, 610–13.

Histoire et coutumes des Bamum. 1952. Rédigées sous la direction du Sultan Njoya. Traduction du Pasteur Henri Martin. Mémoires de l'Institut Français d'Afrique Noire, Centre du Cameroun. Série: Populations, no. 5.

Hübl, Arthur Freiherr von. 1898. *Die photographischen Reproductionsverfahren.* Halle a.S.: Wilhelm Knapp.

Hutter, Franz. 1907. "Bamum." *Globus* 91:1–47.

Jeffreys, M. D. W. 1947. "The Capture of Fumban." *African Studies* 6 (1): 35–40.

Jenkins, Paul, and Christraud Geary. 1985. "Photographs in the Basel Mission Archive." *African Arts* 18 (4): 56–63.

Krauter, Anne. 1987. "Imagination und Dokument: Die eigene Kultur im fotografischen Abbild der fremden Kultur." In *Exotische Welten: Europäische Phantasien,* 202–9. Stuttgart: Institut für Auslandsbeziehungen und Württembergischer Kunstverein, Edition Cantz.

Krieger, Kurt. 1969. *Westafrikanische Plastik III.* Berlin: Veröffentlichungen des Museums für Völkerkunde Berlin.

Labouret, Henri. 1935. "L'ancien palais royal de Foumban." *Togo-Cameroun* (April–July): 121–26.

Lamb, Venice, and Alastair Lamb. 1981. *Au Cameroun: Weaving—Tissage.* Hertingfordbury, Hertfordshire, England: Roxford Books.

Lang, Karl. 1925. "Rudolf Oldenburg: Zur Sonderausstellung der Sammlung Oldenburgs im Wiener Naturhistorischen Museum." *Völkerkunde* 1:118–22.

Lesy, Michael. 1973. *Wisconsin Death Trip.* New York: Pantheon Books.

"Letter of the Kolonialkriegerdank to the Museum für Völkerkunde Berlin." January 6, 1911. Archives of the Museum für Völkerkunde Berlin. E 36/11.

Lichtwark, Alfred. 1894. *Die Bedeutung der Amateur-Photographie.* Halle a.S.: Wilhelm Knapp.

Luschan, Felix von. 1899. *Anleitung für ethnographische Beobachtungen und Sammlungen.* Berlin: Gebrüder Unger.

———. 1905. "Letter to Captain Glauning." December 15, 1905. Archives of the Museum für Völkerkunde Berlin. E 2303/04.

Lutz, Friedrich Wilhelm. 1906. "Bericht über die Bali-Bamum Reise." May 1906. Basel Mission Archive. E-2, 20, item 385a.

Mansfeld, Alfred. 1905. "Letter to F. von Luschan, the Director of the Museum für Völkerkunde in Berlin." July 6, 1906. Archives of the Museum für Völkerkunde Berlin. E 1501/1905.

———. 1908. *Urwald-Dokumente: Vier Jahre unter den Crossflussnegern Kameruns.* Berlin: Dietrich Reimer.

McLeod, Malcolm. 1981. *The Asante.* London: Thames and Hudson.

Menzel, Oberleutnant. 1909. "Die Soldatenspielerei der Häuptlinge von Bamum und Bali." National Archives Yaoundé. Fonds Allemands 1/110, 36–37.

Moisel, Max. 1908. "Zur Geschichte von Bali und Bamum." *Globus* 93:117–20.

Monti, Nicolas. 1987. *Africa Then.* New York: Knopf.

Müller, Hugo. 1899. *Die Misserfolge in der Photographie und die Mittel zu ihrer Beseitigung.* Halle a.S.: Wilhelm Knapp.

Mveng, Engelbert. 1963. *Histoire du Cameroun.* Paris: Editions Présence Africaine.

Newhall, Beaumont. 1964. *History of Photography.* New York: Museum of Modern Art.

Njiasse-Njoya, Aboubakar. 1981. "Naissance et évolution de l'Islam en pays Bamum (Cameroun)." Thesis (Doctorat du troisième cycle), Université Paris I—Panthéon Sorbonne.

Njoya, Adamou Ndam. 1977. *Njoya, réformateur du royaume bamoum.* Paris: ABC; Dakar: NEA.

Northern, Tamara. 1984. *The Art of Cameroon.* Washington, D.C.: Smithsonian Institution Traveling Exhibition Service.

Oldenburg, Rudolf. 1930. "Bamum, ein Negerreich im Innern Kameruns." *Atlantis* 2:161-64.

Pavel, Oberstleutnant. 1902. "Expedition des Oberstleutnants Pavel." *Deutsches Kolonialblatt* 13:90–92, 162–63.

Petschull, Jürgen. 1984. *Der Wahn vom Weltreich: Die Geschichte der deutschen Kolonien.* Hamburg: Gruner and Jahr.

Pöch, Rudolf. 1910. "Das Photographieren auf anthropologischen Forschungsreisen." *Photographische Correspondenz* 57:106–17.

Poignant, Roslyn. 1980. *Observers of Man: Photographs from the Royal Anthropological Institute.* London: Royal Anthropological Institute.

Pollig, Hermann. 1987. "Exotische Welten: Europäische Phantasien." In *Exotische Welten: Europäische Phantasien,* 16–25. Stuttgart: Institut für Auslandsbeziehungen und Württembergischer Kunstverein, Edition Cantz.

Ramsay, Hans von. 1905. "Bamum." *Globus* 88 (17): 272–73.

———. 1925. "Entdeckungen in Nordwest-Kamerun." In *Das deutsche Kolonialbuch,* edited by Hans Zache, 288–93. Berlin-Schmargendorf: Wilhelm Andermann Verlag.

Rein-Wuhrmann, Anna. 1925. *Mein Bamumvolk im Grasland von Kamerun.* Stuttgart: Evangelischer Missionsverlag.

———. 1931. *Liebes und Leides aus Kamerun: Erlebnisse im Missionsdienst.* Stuttgart: Evangelischer Missionsverlag.

———. 1948. *Fumban, die Stadt auf dem Schutte: Arbeit und Ernte im Missionsdienst von Kamerun.* Basel: Basler Missionsbuchhandlung.

———. 1949. "Njoya, der König von Bamum." *Der Wanderer von Land zu Land* 23 (July): 17–34.

Rohrbach, Paul. 1907. "Aus dem Hinterland von Kamerun: Ein Besuch in Bamum." *Kolonie und Heimat* 1 (7): 6–7.

———. n.d. *Die Deutschen Kolonien*. Dachau: Der Gelbe Verlag Mundt und Blumentritt.

Rowlands, Michael. 1985. "Notes on the Material Symbolism of Grassfields Palaces." *Paideuma* 31:203–12.

Rüger, Adolf. 1960. "Die Entstehung und Lage der Arbeiterklasse unter dem deutschen Kolonialregime in Kamerun (1895–1905)." In *Kamerun unter deutscher Kolonialherrschaft*, edited by Helmuth Stöcker, 149–242. Berlin, German Democratic Republic: Rütten und Löhning.

Ruppel, Julius, 1912. *Die Landesgesetzgebung für das Schutzgebiet Kamerun: Sammlung der in Kamerun zur Zeit geltenden völkerrechtlichen Verträge, Gesetze, Verordnungen und Dienstvorschriften mit Anmerkungen und Registern*. Berlin: Ernst Siegfried Mittler und Sohn.

Said, Edward. 1978. *Orientalism*. New York: Random House.

Sandrock, Leutnant. 1902. "Bericht über den Marsch nach Bafu (Bamum)." National Archives Yaoundé. Fonds Allemands 1/112, 36–46.

Savary, Claude. 1977. "Situation et histoire des Bamum." *Bulletin annuel* (Musée d'ethnographie, Geneva) 20: 117–38.

———. 1978–79. "Situation et histoire des Bamum (II)." *Bulletin annuel* (Musée d'ethnographie, Geneva) 21–22: 121–61.

Scherer, Joanna Cohan. 1975. "You Can't Believe Your Eyes: Inaccuracies in Photographs of North American Indians." *Studies in the Anthropology of Visual Communication* 2 (2): 67–79.

Schmitt, Alfred. 1963. *Die Bamum-Schrift*. 3 vols. Wiesbaden: Harassowitz.

———. 1966. "Ein Plan der Stadt Foumban: gezeichnet und beschriftet von einem Bamum-Mann." *Anthropos* 61:529–43.

Schwarz, Eugen. 1917. "Bamum in Friedens- und Kriegszeiten." Diary. Collection of Mrs. Hanne Eckardt, Ludwigsburg, Federal Republic of Germany.

Sekula, Allan. 1975. "On the Invention of Photographic Meaning." *Artforum* 13 (5): 36–45.

Sheehan, Bernard W. 1980. *Savagism and Civility: Indians and Englishmen in Colonial Virginia*. Cambridge: Cambridge University Press.

Sprague, Stephen. 1978a. "Yoruba Photography: How the Yoruba See Themselves." *African Arts* 12 (1): 52–59.

———. 1978b. "How I See the Yoruba See Themselves." *Studies in the Anthropology of Visual Communication* 5 (1): 9–28.

Soulillou, Jacques. 1982. *Douala: Un siècle en images*. Paris: Jacques Soulillou.

Steiger, Ricabeth. 1982. "Bilder aus Bamum: Frühe Fotografien aus dem Kameruner Grasland als Spiegel europäischer Interessenrichtungen." 2 vols. Master's thesis, University of Basel.

Steiger, Ricabeth, and Martin Taureg. 1985. "Körperphantasien auf Reisen: Anmerkungen zum ethnographischen Akt." In *Das Aktfoto, Ansichten vom Körper im fotografischen Zeitalter: Ästhetik, Geschichte, Ideologie*, edited by Michael Köhler und Gisela Barche, 116–36. Munich: Bucher.

Stolz, K. 1906a. "Reise nach Bali und Bamum." January 22, 1906. Basel Mission Archive. E-2, 20, item 382.

———. 1906b. "Audienzen beim König von Bamum." *Evangelischer Heidenbote* 79 (5): 36–37.

Stössel, [?]. 1907. "Report on the Cultivated Plants and the Agriculture in the Bamum Area." National Archives Yaoundé. Fonds Allemands 1/68, 561–63.

Struck, Bernhard. 1908. "König Ndschoya als Topograph." *Globus* 94:206–9.

Tardits, Claude. 1980. *Le royaume Bamoum*. Paris: Armand Colin.

———. 1981. "Le royaume Bamoum: Chronologie—Implantation des populations—Commerce et économie—Diffusion du maïs et du manioc." In *Contribution de la recherche ethnologique à l'histoire des civilisations du Cameroun*, vol. 2, 401–20. Colloques Internationaux du C.N.R.S., no. 551. Paris: Editions du C.N.R.S.

———. 1985. "Le palais royal de Foumban." *Paideuma* 31:65–83.

Thorbecke, Franz. 1914. *Im Hochland von Mittel-Kamerun*. Vol. 1, *Die Reise: Eindrücke und Beobachtungen*. Abhandlungen des Hamburgischen Kolonialinstituts, no. 21. Hamburg: L. Friedrichsen.

Thorbecke, Marie-Pauline. 1914. *Auf der Savanne*. Berlin: Mittler.

Timm, Uwe. 1981. *Deutsche Kolonien*. Munich: AutorenEdition.

"Übersicht über den Stand der weissen Bevölkerung nach Wohnort, Staatsangehörigkeit, Beruf, Geschlecht, Alter unter über 15 Jahre und Konfession im Bezirk Bamenda." 1907. National Archives Yaoundé. Fonds Allemands 1/69, 93.

UNICEF. 1979. *Mères et enfants de l'Afrique d'autrefois*. Abidjan: UNICEF, Bureau régional pour l'Afrique occidentale et centrale.

Viditz-Ward, Vera. 1985. "Alphonso Lisk-Carew: Creole Photographer." *African Arts* 19 (1): 46–51.

———. 1987. "Photography in Sierra Leone, 1850–1918." *Africa* 57 (4): 510–18.

Vogel, E. 1898. *Taschenbuch der praktischen Photographie*. Berlin: Gustav Schmidt.

Vollbehr, Ernst. 1912. *Mit Pinsel und Palette durch Kamerun*. Leipzig: List und von Bressensdorf.

Wirz, Albert. 1982. "Beobachtete Beobachter: Zur Lektüre völkerkundlicher Fotografien." In *Fremden-Bilder*, edited by Martin Brauen, 44–60. Ethnologische Schriften Zürich. Zurich: Völkerkundemuseum der Universität Zürich.

Wittmer, Marcilene K. 1976. "Bamum Village Masks." Ph.D. diss., Indiana University.

Wuhrmann, Anna. *See also* Rein-Wuhrmann, Anna.

Wuhrmann, Anna. 1910. "Lebenslauf." Personal Folder. Basel Mission Archive. Schwestern-Verzeichnis 105.

———. 1913. "Annual Report for the Year 1912." February 5, 1913. Basel Mission Archive. E-2, 37, item 70.

———. 1914. "Annual Report for the Year 1913." February 3, 1914. Basel Mission Archive, E-2, 40, item 111.

———. 1916a. "Krieg 1914 bis 1916." Diary in Personal Folder. Basel Mission Archive. Schwestern-Verzeichnis 105.

———. 1916b. "Schroffe Gegensätze: Königskind und Sklavin." *Evangelischer Heidenbote* 89 (12): 184–86.

———. 1917. *Vier Jahre in Grasland von Kamerun*. Basel: Basler Missionsbuchhandlung.

Zintgraff, Eugen. 1895. *Nord-Kamerun*. Berlin: Gebrüder Paetel.

Fig. 88. King Njoya in the central hall of the palace he built after 1917.
(Photograph by Anna Wuhrmann, 1920–21)

FIG. 88. *King Njoya in the central hall*
of the palace he built after 1917.
(Photograph by Anna Wuhrmann, 1920–21)